THE LIGHTING COOKBOOK FOR
FASHION AND BEAUTY PHOTOGRAPHY

The

LIGHTING COOKBOOK

for

FASHION

and

BEAUTY PHOTOGRAPHY

Foolproof Recipes for Perfect Portraits

JENNI BIDNER AND ERIC BEAN

AMPHOTO BOOKS

AN IMPRINT OF WATSON-GUPTILL PUBLICATIONS

NEW YORK

ACKNOWLEDGMENTS

We would like to thank all the models who appear in this book. It's been a pleasure to work with these beautiful and talented professionals. Our special thanks to model agent David Grilli and makeup artist Cyrus. Our gratitude also goes to Dr. Fred J. Heinritz for his insights on the text; Victoria Craven for her continued support; Patricia Fogarty for her editorial contributions; and the editorial, production, and design staff at Amphoto for pulling it all together.

Eric Bean would like to personally thank Bryan Norton for his considerable help in his career. He would also like to acknowledge all his teachers, with special thanks to his first art teacher, Kathy Kamholtz, who started him on his artistic quest.

First published in 2005 by
Amphoto Books, an imprint of Watson-Guptill Publications
a division of VNU Business Media, Inc.
770 Broadway, New York, New York 10003
www.amphotobooks.com

Senior Acquisitions Editor: Victoria Craven
Senior Developmental Editor: Patricia Fogarty
Senior Production Manager: Ellen Greene
Designer: Leah Lococo Ltd

Library of Congress Control Number: 2005926381

Copyright © 2005 Jenni Bidner (text)
Copyright © 2005 Eric Bean (photographs)

ISBN: 0-8174-4231-6

Manufactured in China

1 2 3 4 5 6 7 8 / 09 08 07 06 05 04

ABOUT THE AUTHORS

ERIC BEAN is a fashion photographer based in New York City. Eric started his career in photography sixteen years ago and has worked for such distinguished clients as Harry Winston Jewelers, Salvatore Ferragamo, Avon Products, and W Hotels. Through his mastery of light and composition, he continues to deliver compelling images for large fashion companies and cutting-edge designers. His online portfolio can be viewed at www.EricBean.com.

JENNI BIDNER has more than twenty years of experience in the photo industry as an editor, author, Internet content manager, public relations professional, and photographer. She is the author of more than a dozen books, including *Amphoto's Complete Book of Photography, The Lighting Cookbook, Making Family Websites, The Complete Guide for Models,* and *Dog Heroes: Saving Lives and Protecting America.* Jenni is a volunteer canine handler for ILL-WIS Search & Rescue Dogs (www.illwissardogs.org), helping to find lost and missing people in Illinois and Wisconsin.

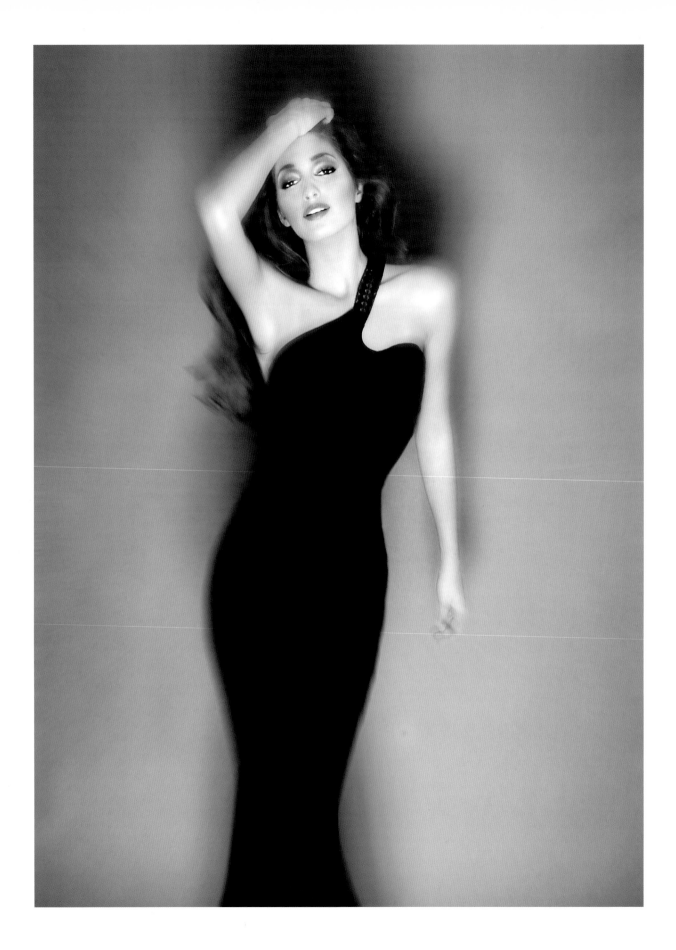

CONTENTS

Preface 9

CHAPTER 1: Technical Considerations 11
The Quality of the Light 11
Color Temperature 12
EV & Lighting Ratios 14
Correct Exposure 15
Lighting Ratio 16
Background Treatment 17
Cameras & Lenses 18
Photo-editing Software 21
Light Meters 22
Lighting Sources 23
Light Modifiers 26
Camera Supports 29
Set & Studio Equipment 30
Other Useful Items 32

CHAPTER 2: Beauty Lighting 35
Posing for Beauty 35
Simple Beauty Lighting 36
Modified Beauty Lighting 38
Variations with Reflectors 40
On-Location Beauty 43
Beauty on the Road 44
Beach Location 46
U-Bank Beauty 47
Jewelry Adds Complications 48
Vellum Variation 51
Single Hard Light 52
Ring Flash 55
Bold Makeup 56
Head Shots 58

CHAPTER 3: Fashion Lighting 61
The Fashion Specialty 61
Flexible Fashion Lighting 62
Simple Catalog Lighting 68
Softbox Background Variations 70
Glamorizing a Scarf 72
Playing with Shadows 74
Managing Different Surfaces 77
Warm & Cool Combination 78
Fashion Makeup 80

Difficult Fabrics 81
Jewelry Fashion 83
Exaggerated Set 84
White on White 85
Paying Homage 86

CHAPTER 4: Glamour Lighting 89
Harlow Homage 89
A New Color Palette 92
Using Gels 94
Tungsten Glamour 95
Glamorous Nudes 96
Experimenting on the Set 99
Conceptual Variations 101
Simplicity on Location 102
Rock 'n' Roll Glamour 102
Stage Light Variation 104

CHAPTER 5: Lighting for Men 107
Male "Beauty" Lighting 107
Basic "Beauty" Lighting for Men 108
The Sun as Main Light 108
Ring Flash on Location 110
Men's Fashion 111
Using Flare to Advantage 113
Softbox as Background 114
Modified "Copy Light" 116
Compositional Light & Shadow 119
Fitness Fashion 120
Fitness with a Hard Light 124
Gelled Fill Light 126
Emphasizing the Silhouette 127
Shadow Treatment 128
Film Noir Fashion 130
Hollywood Variation 133
Male Head Shots 134
Head Shot Variation 135

CHAPTER 6: Building Your Portfolio 137
Test, Test, Test! 138
Four Types of Models 140
Starting a Head Shot Business 143

Index 144

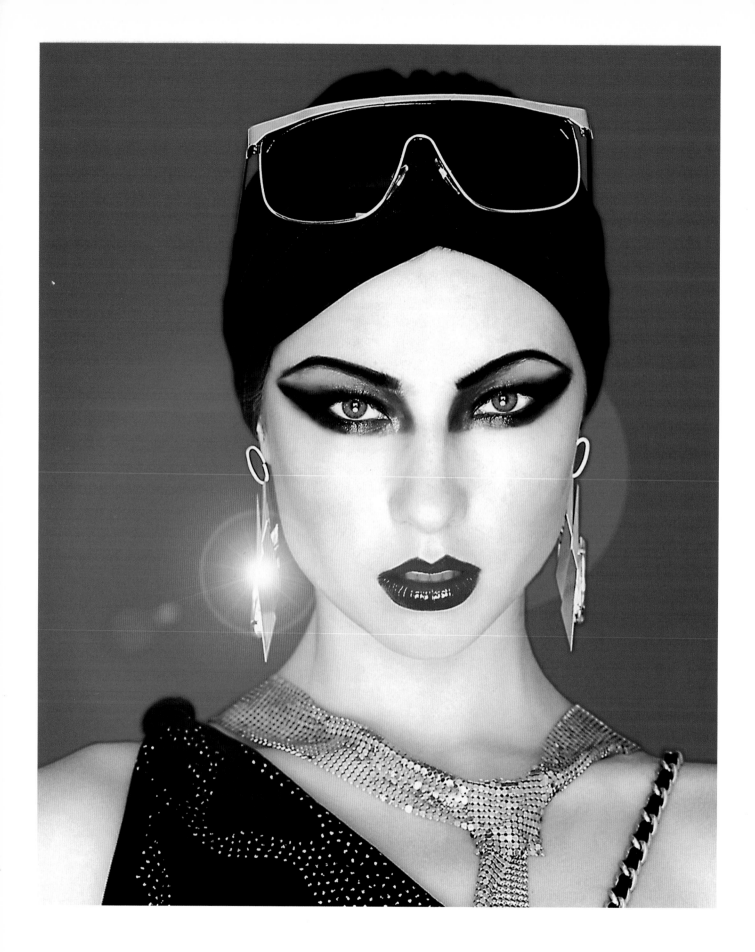

PREFACE

The concept for this book comes from the earlier *Lighting Cookbook*, which covered forty different studio photography lighting techniques. For this book we decided to concentrate on the specialties of beauty, fashion, and glamour photography, using both female and male models.

We hope that after reading the book and experimenting with the techniques it discusses, you will have a better understanding of the "hows" and "whys" of lighting. Whenever possible, we have laid out the creative thought process that went into the lighting and other choices. The goal is to help you achieve consistently successful results.

The book consists of numerous lighting "recipes" designed to get you started quickly. The cookbook metaphor is a good one. We are showing you how to bake a basic cake, but once most cooks become skilled and confident in the kitchen, they use recipes only as a starting point, adding and subtracting ingredients to make their own special creations.

Photography is far more than just lighting. You'll need to control every aspect of a shoot. This includes choosing the right equipment and selecting and directing the models, stylists, and hair and makeup artists. The set must be carefully thought out, even if it is a simple seamless paper background—opting for simplicity is a choice in and of itself.

This book should not be seen as a list of unbreakable rules. Dozens of images by top photographers break our guidelines. However, our advice is a solid starting point.

Replicating the lighting described here is a great way to learn. Models and other factors will be different in your own studio, so you'll need to tweak the lighting for each situation. As you achieve successes, and your confidence as a photographer and as an artist grows, you will probably begin breaking the "rules" for creative reasons as well. At that point, we say, "Congratulations!" You're well on your way to creating your own personal photographic style!

ERIC BEAN AND JENNI BIDNER

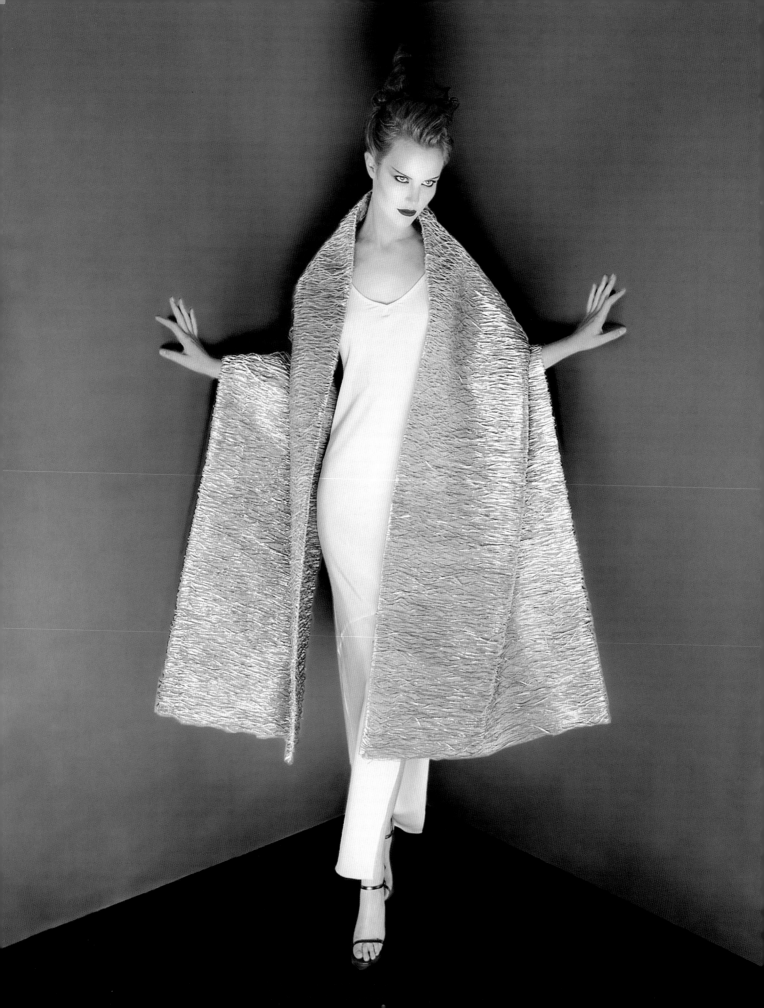

TECHNICAL CONSIDERATIONS

Understanding Your Equipment & Technique

BEFORE WE DESCRIBE and you try any of the lighting setups discussed in this book, it is important that you (the reader) and we (the authors) speak the same language. People working in different photographic specialties and photographers from different parts of the globe often use different or conflicting terms. There are also several technical issues (such as EV measurements) that you need to fully understand before embarking on your first shoot.

As for the necessary equipment, don't despair. Most photographers who are starting out think they need every photographic gadget imaginable to create great images. The good news is that this is not true. You can produce most of the images in this book even if you are armed with just a camera and quality lenses, a studio flash unit with at least three heads, one large softbox, and a few large reflector panels. If you want to be even more economical, you can substitute hot lights for many of the setups.

Normal and wider than normal lenses, combined with camera position, can alter the perspective for interesting fashion photos.

THE QUALITY OF THE LIGHT

Lighting is the heart and soul of beauty, fashion, and glamour photography. Whether the lighting is from natural sunlight or created in the studio with studio flash or hot lights (tungsten or quartz-halogen light sources), it must be completely controlled by the photographer to achieve the desired artistic effect.

Different types of lights can produce radically different effects. Probably the biggest consideration is the *quality* of the light—more specifically, whether it is *hard* or *soft*. A hard light, such as a bare-bulb light used at a distance, produces hard-edged shadows. Without fill from another light or a reflected surface, these shadows will be very dark. The sun is a hard light. Flash units and hot lights that are not bounced or shone through diffusion material are generally hard lights. They tend to produce darker shadows if fill light is not added.

A soft light produces soft-edged shadows. The rays have been scattered so the shadows are less distinct. The sun diffused through heavy cloud cover is a soft light. A softbox over a flash unit makes the light softer. You can also soften the light by bouncing it off umbrellas and reflectors. The softness can be altered depending on the materials used in the softbox, umbrella, or reflector, as well as the distance of the light head from these materials.

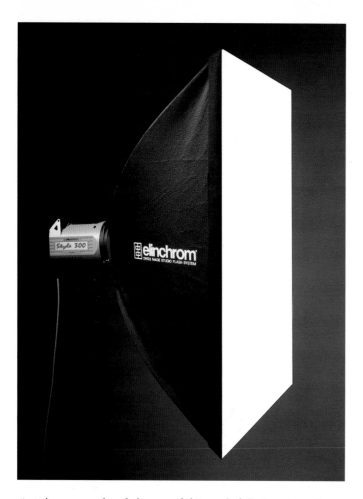

A softbox surrounds a flash unit and diffuses the light through its white front panel.

COLOR TEMPERATURE

Every light source has a specific color temperature that affects the color cast the light will appear to have with a specific film or, in the case of digital photography, at a specific "white-light balance" setting. The color temperature can cause the image either to look neutral (natural) or instead to have a minor or drastic color shift. Digital photographers have an advantage here: They can automatically or manually correct for this color shift with white-light balance controls. Conventional film photographers can use color-correction and color-compensation filters to correct it. And some corrections can be made with photo-editing software. However, in general, it is better to get as close as you can to the desired color balance while you are shooting.

Differences in color temperatures are measured in degrees Kelvin (K). They're hard for us to see because the human brain has "automatic white-light balance," which causes us to automatically see slight variations in the color of light as neutral. For example, if you are wearing greenish sunglasses (which create a filtered color cast), everything will look pink for the first few moments after you take them off, until your brain gets used to the new (unfiltered) color cast and "corrects" it.

Film doesn't have this capability. It can't readjust itself, so the various colors of light create distinct color casts on film. Filters can be used to correct some of this color cast. You can also match the type of film (daylight- or tungsten-balanced) to the type of light you are using for a neutral color result. Flash is balanced to daylight, or a color temperature of about 5500K. Tungsten, halogen, and general household bulbs look yellower; they are balanced to about 3200K.

You can also shoot with the "wrong" film for unusual effects. Shooting tungsten lights with daylight film creates a strong yellow-orange color cast. See page 95 for an example. Shooting tungsten films illuminated by daylight or flash results in a pale-bluish cast.

The image on page 80 uses a gelled blue flash with a gelled orange hot light for an unusual effect. The two colors cancel each other out for a relatively neutral color result at the points where they both hit; blue or orange shadows occur where only one hits. On pages 93 and 136, lights gelled to three different shades of blue and cyan create an interesting color palette for a glamour image.

Most digital cameras have an auto white-light balance feature that automatically tries to neutralize any color cast caused by the color temperature of the light. Better digital cameras allow for manual white-light balance control as well, for times when you might prefer the color cast. A good example is sunset, when the yellow glow is often desirable.

Hair, makeup, and clothing all come together for a dramatic fashion image.

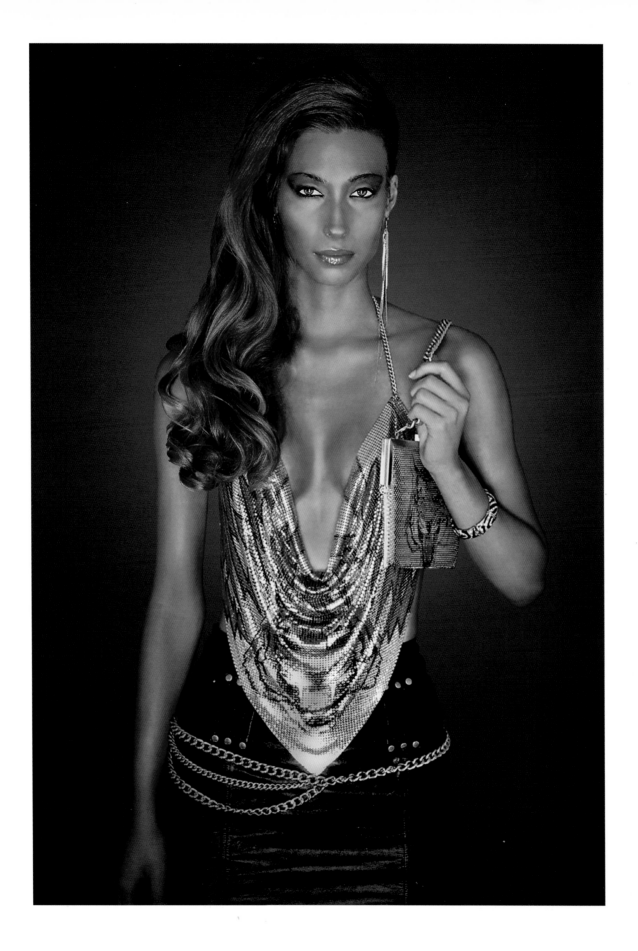

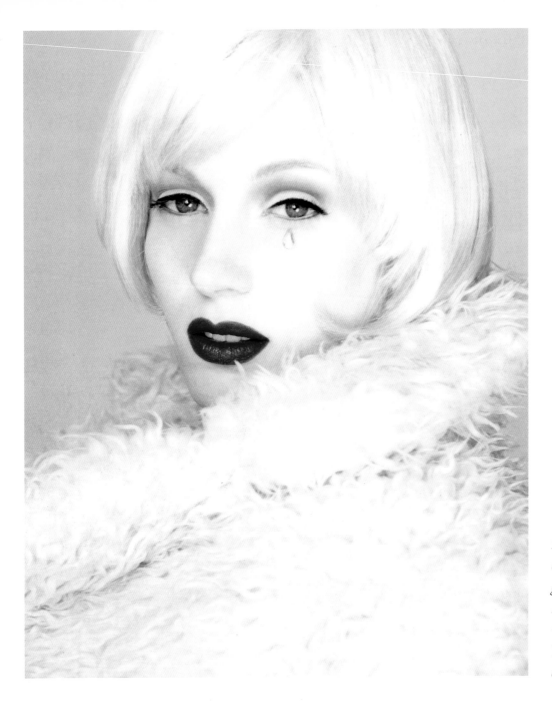

Sometimes glamour images are overexposed to give an effect of greater fantasy and flawlessness. In this example, the lighting is +1.5 EV over normal exposure. The eyes and lips were later darkened with Photoshop software.

EV & LIGHTING RATIOS

In photography, light is measured in increments of EV (exposure value). One EV unit on a light meter is equal to one *stop* of light ("one f-stop" or one aperture setting). In this book we discuss under- and overexposure, and lighting ratios or relationships, in terms of EV differences—that is, the difference between a "correctly" exposed image and one that is under- or overexposed, or the difference between the exposure value of the highlights and the shadows in the image you are creating. This ratio or relationship is far more important than the actual aperture or shutter speed settings, which

will vary depending on the individual strength and precise placement of your lights.

Regardless of how strong your lights are or where you place them, you will find success by striving to achieve the EV relationships we describe.

Most often, the EV ratio is altered by increasing or decreasing the power of your fill lights in relation to the main lights. You can achieve this by increasing or decreasing the power of your flash units, if they provide this option. Or you can strengthen or weaken a light in relation to the other lights by moving it closer or farther away from the model. Be careful with this last-mentioned method, however, because moving a light closer or farther away from the model can also affect the *quality* of the light.

CORRECT EXPOSURE

In this book, we refer to "correct" exposure as what you'd get if you were to use an incident-light (ambient-light) meter to read the most important part of your subject, or if you take a reflected light reading from camera position of a gray card in front of this same important section of the subject. (See pages 22–23.)

Again, the exact aperture and shutter speed combination will vary with your lighting equipment and setup. So we will *not* give actual exposure settings. Instead, we will assume the "correct" exposure (according to the light meter) to be 0.0 EV and tell you to adjust your exposure accordingly. For example, skin tones often look better when they are overexposed, so the photo may be shot at +1.0 EV. In this case, find out what your "correct" exposure should be according to the meter (0.0 EV) and then set your aperture and shutter speed so the camera will overexpose by one stop.

For example, take a light meter reading of 1/125-second at f/8 (0.0 EV). Overexposing by one stop would require that you set the camera to 1/60 at f/8 or 1/125 at f/5.6 (or any equivalent setting). A second option on automatic cameras would be to set the camera's Exposure Compensation control to +1.0 EV.

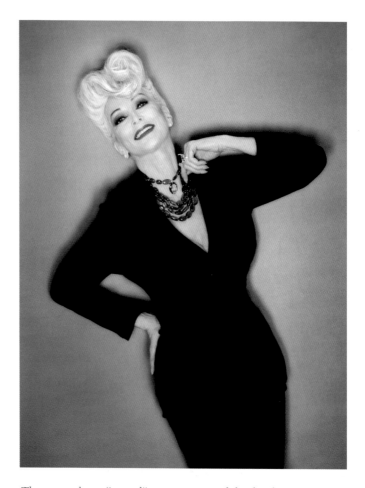

This image, shot at "normal" exposure, captured detail in both the model's white hair and her black suit.

LIGHTING RATIO

To determine your lighting ratio, take precise readings of the shadow side of the face and the part of the image that is illuminated by the main light. The easiest way to do this is with an incident-light meter, described in detail on pages 22–23.

If your light meter has an EV scale, compare the readings. If it doesn't, you can figure it out through the suggested aperture selection (or shutter speed, if you're using hot lights). Shutter speeds and apertures are mathematically related; each jumps in increments of "stops," or exposure value (EV) units. One full stop (1.0 EV) difference is equivalent to jumping a full aperture setting in flash photography, or doubling/halving the shutter speed in ambient-light (non-flash) photography.

Each full aperture change halves or doubles the area of the hole in the lens, so that half or twice the amount of light is allowed through during a set period of time (as determined by the shutter speed). Apertures are more difficult to sort out because the numbers aren't as simple as shutter-speed numbers. Common full-aperture increments (from widest to narrowest) are: f/2, f/2.8, f/4, f/5.6, f/8, f/11, f/16, f/22, and f/32. Some lenses have apertures of f/3.5 or f/4.5, but these are actually half or partial apertures, not full-stop increments.

In flash photography, the flash is so quick that the shutter speed is not very important so long as it is not set to be faster than the camera's maximum synch speed (usually 1/250-second on 35mm cameras, but check your instruction manual). Instead, you can control the lighting by increasing or decreasing the flash's power or its distance from the subject. All else being equal, a flash at full power yields one stop more light than half power and two stops more light than quarter power.

Alternately, you can leave the flash power as is, but open up to a wider aperture (from f/5.6 to f/4, for example) to lighten the image overall (+EV). Or you can change to a narrower aperture (from f/8 to f/11, for example) to darken the overall image (–EV).

Don't forget that aperture settings affect depth of field—how much of your picture in front of and behind the focusing point is in sharp focus. If you have modeling lights or hot lights on, slow shutter speeds can cause a blurring of your subject (see page 80).

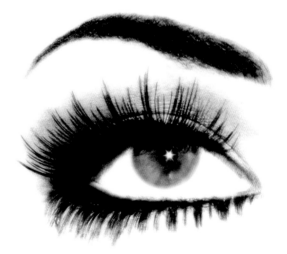

To create this high-contrast graphic image with blown-out skin tones, the photographer exposed the image at +1.0 EV (one stop overexposed when compared to "normal" exposure).

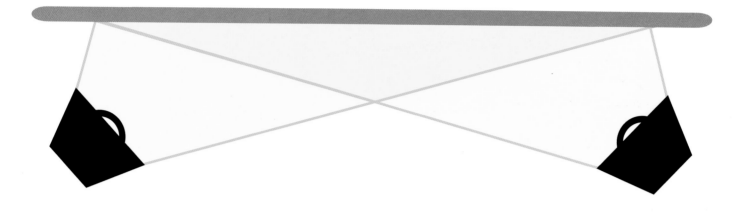

BACKGROUND TREATMENT

In many photos throughout this book, the background is evenly lit by two flash units placed at 45-degree angles to the background.

Most of the photos in this book have a simple background. A 9-foot roll of white, gray, or black seamless paper was hung from autopoles and unrolled toward the ground. This backdrop was then lit with two flash units, one from each side at approximately a 45-degree angle. The goal was to aim the light so that it was even across the entire portion of the background visible from the camera. Unless otherwise noted, this is how the background was treated in all the studio images in this book.

The lightness or darkness of a background can be controlled by its exposure relative to the exposure of the main subject. For example, reducing the power of background flash units reduces the amount of light hitting the background compared to the light on the model's face, causing white paper to appear gray and gray paper to appear black. You can add color to the background by placing a colored gel over the background flash units or choosing a colored seamless paper.

CAMERAS & LENSES

Optical quality is one of your most important technical considerations. Without good glass lenses, your images will not look crisp and sharp. If you're on a budget, you should allocate most of your hardware spending to lenses, rather than fancy bodies and accessories.

FILM FORMAT Many beauty, fashion, and glamour photographers shoot with medium-format cameras, such as the Hasselblad, with its 6x6cm film format, or the 6x4.5cm and 6x7cm Mamiya series. This larger film, which is 6cm (2.25 inches) tall, can be enlarged to much larger sizes than 35mm film, which is only 1 inch tall.

Most medium-format cameras also accept Polaroid and digital backs, which make proofing and previewing your images easy.

Some photographers use 35mm SLR film cameras. Most clients and stock agencies find the quality of slow-speed transparency films (100 ISO and slower slide film) acceptable for most professional applications.

DIGITAL CAMERAS With digital cameras you eliminate film and processing expenses, and you can nearly instantly review your pictures to be sure you "got the shot" before calling it a day. However, high-resolution images are needed for professional work.

While a 6-megapixel image can be blown up to the size of a magazine page, it's really too limited for anything larger, especially if you do any cropping. Stock agencies such as Getty Images consider a 17-megapixel image as the bare minimum in terms of necessary resolution.

You can convert your slides and negatives into digital images with a film scanner.

SCANNERS If you shoot film, you can still digitize your images. Drum scans produce the highest-quality digitizations but can cost $25 to $250 per image. If you're scanning your film yourself, don't buy a scanner based only on its maximum resolution. In addition to high-resolution scanning capability, you also need a high dynamic range (such as 4.8), which tells you the tonal range the scanner can produce.

LENSES Whether you use a 35mm, a medium-format, or a digital camera, you'll need several lenses to work in beauty, fashion, and glamour photography. By far the most useful lens for beauty is in the 105mm–135mm range in the 35mm film format (200mm in 6x4.5cm medium format). The moderate telephoto lens in the 75mm–85mm range in 35mm film format (135mm in 6x4.5cm medium format) and the normal 45mm–50mm lens in 35mm film format (80mm in 6x4.5cm medium format) will come in handy for fashion and glamour as well.

The majority of the photographs in this book were shot with 80mm and 135mm lenses on a 6x4.5cm Mamiya camera.

Knowing how to modify equipment to change the quality of the light it delivers is one of the most important skills a photographer can learn.

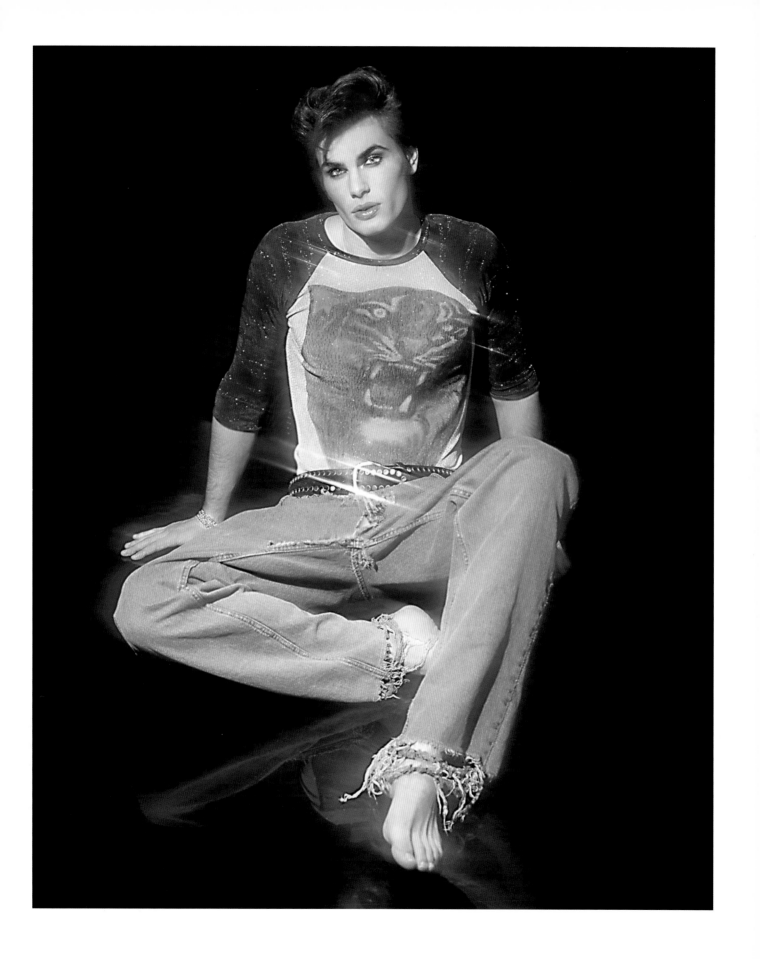

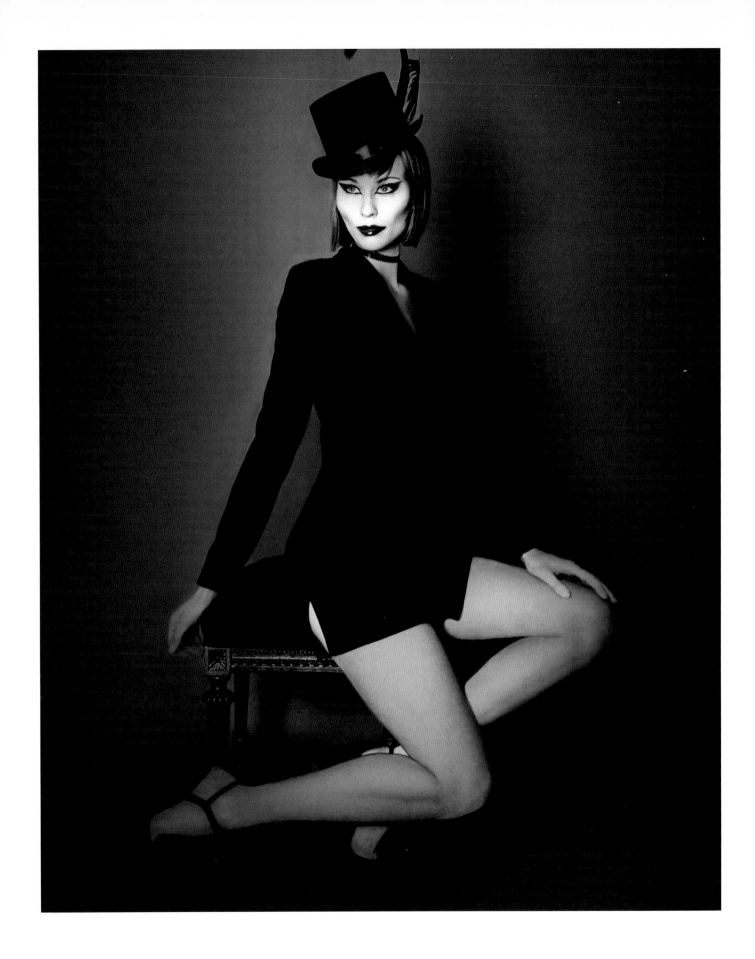

PHOTO-EDITING SOFTWARE

Few professional beauty, fashion, or glamour images are sent to the client without at least some improvement through the use of computer software. At the very least, images are cropped, color and contrast are tweaked, and skin blemishes are removed. Based on aesthetic decisions, you can selectively enhance the saturation or hue of portions of the image (such as the lips), and you can dodge or burn areas to emphasize or de-emphasize them, or even blur, sharpen, or transform other parts of the image.

By far the most popular and powerful photo-editing software is Adobe® Photoshop.® Though expensive, it offers photographers everything they need to perfect and transform their images. Less-expensive software packages can achieve many of the same effects that you can get with Photoshop, but to date none have completely challenged Photoshop in terms of overall capabilities.

Photoshop is far more than just a retouching tool. It gives the photographer a whole new set of creative choices.

The text will clearly point out when a photograph has been modified in Adobe Photoshop, with the exception of the following very basic changes that are made to almost every photo (unless the change is not wanted for creative reasons):

- Correcting a slight color-balance shift caused by film processing or picked up in the scanning process.
- Correcting minor skin blemishes on the model.
- Making slight improvements in the overall contrast of the image for the purposes of reproduction.

Later in the book we describe other Photoshop modifications. The healing-brush tool in Photoshop 7.0 and in later versions has been a wonderful addition. It is used to even out the skin *tones* without sacrificing skin *texture*. For the beauty, fashion, and glamour photographer this feature alone is worth the price of an upgrade.

The photographer did minor corrective retouching to reduce the appearance of wrinkles in the jacket and to even out the skin tone on the face and legs.

LIGHT METERS

If you're planning to use studio-style flash units, you'll need a flash meter. Especially for the beauty specialty, even slight variations between the main light and the fill light need to be monitored carefully. In many cases you'll be dealing with less than a half-stop difference between the two, so a quality meter is essential.

REFLECTED-LIGHT METER A reflected-light meter reads the light reflected off the subject, as opposed to the light falling on the subject. The light meter in most cameras is a reflected-light meter. Hand-held reflected-light meters are also available, some with spot-metering functions (see below). Both are designed to be used from the camera position.

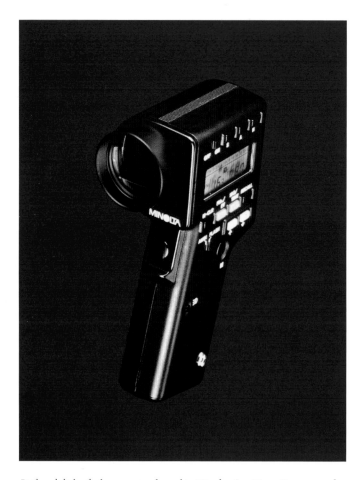

Reflected-light flash meters, such as this Minolta SpotMeter F, measure the light reflected off the subject. They are generally used from camera position.

The important thing to understand about reflected-light meters is that they are limited: They assume the subject is 18% gray in tone; accordingly, they base their recommended exposure to make the subject look 18% gray in the picture. If the subject is lighter than 18% gray, the result will be underexposure. If the subject is darker than 18% gray, the result will be overexposure. (Cameras may apply algorithms in an attempt to improve this result, but a hand-held meter will not.)

Most photographers either learn to automatically apply +EV or −EV exposure compensation based on the subject (about +1.0 EV for the average Caucasian skin tone), or they place an 18% gray card in front of the model and take the reading of the gray card from the intended camera angle. Then they manually set their camera's shutter speed and aperture to achieve the exposure they want.

INCIDENT-LIGHT METER Far easier for the studio photographer to use is an incident-light meter (also known as an ambient-light meter). This hand-held device measures the light falling on its sensor (usually a small white dome), rather than the light reflected off the subject. When in flash mode, the meter will ignore ambient (non-flash) illumination and give the reading only for the flash.

These meters are designed to be used on the set, with the dome pointed at the camera, at the lights, or somewhere in between, depending on the photographer's metering technique. The trick is that, when you take the reading, you need to hold the meter as close as possible to the part of the model you are metering, such as the face. (Be careful not to block any of the light with your body.) The meter reads the light that is actually falling on the face. This means that when you are using flash you will need to synch the flash to the meter so you can fire it from the set—or you'll need an assistant to manually trip the flash.

In beauty photography, where the fill and main lights are often less than one stop apart, you may have to take several readings of the face alone to check that shadows under the chin or on the side of the face are not too strong.

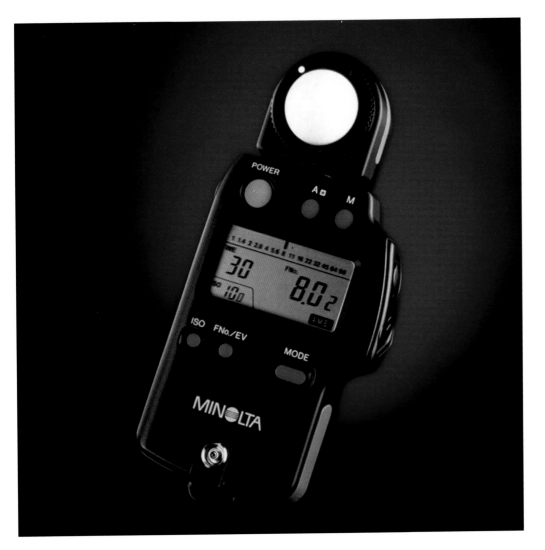

Incident-light flash meters measure the light falling on the subject. The meter reading is taken at the subject, with the white dome pointed at the camera, at the light, or somewhere in between.

Incident-light meters are also excellent for checking that your background lights are creating an even amount of illumination across the entire background (or at least across the background visible in the viewfinder), if that is the effect you want. It is very easy for the light that hits the background to drop off along the periphery. It may be hard for the human eye to detect a 1/4- or 1/2-stop difference in the light, but the difference will be very visible in the final image.

SPOT METER A spot meter is a light meter with a narrow field of view, such as 3 degrees. It permits you to take reflected light readings of a subject that is far away or small. These meters are most commonly used when you're shooting outdoors and can't approach your subject. Some studio photographers use them to take readings of specific parts of their subject from camera position, but for this purpose an incident-light/ambient-light meter (see above) is more commonly used.

LIGHTING SOURCES

Beauty, fashion, and glamour photographers generally use studio-style flash units, but similar results—as well as radically different results—can be created with the various types of light sources.

STUDIO-STYLE POWER-PACK FLASH This is by far the most popular type of studio flash unit. It consists of a

power pack that supplies the power and one or more flash heads that attach to the pack via cables. The flash head is the portion of the unit that includes the flash tube, and sometimes a cooling fan, a modeling light, and a small reflector. Popular brands include Broncolor, Dyna-Lite, Elinchrom, Norman, Novatron, Photogenic, Profoto, and Speedotron.

MONOLIGHTS These are portable versions of the studio flash designed for location work. The main difference is that the power unit is built into the head, so a monolight can be plugged directly into a wall outlet. In some cases, they run on battery power.

MODELING LIGHT A modeling light is an incandescent bulb installed in the middle of the flash tube on a studio-style flash head. Because flash units fire for just an instant, it is hard for photographers to preview the lighting that will be produced. Instead, they can turn on the incandescent bulb to see an approximation of the illumination of the flash. Most modeling lights have three options: off, on, or on until the moment of exposure, when they turn off (so as not to record in the image).

Modeling lights have the advantage of keeping the studio brightly lit between shots. This gives the photographer light to work in and keeps the model's eyes from becoming overly dilated in a dark room. Because they can be set to turn off during the exposure, their warmer color temperature (compared to flash) will not record in the image.

HOT LIGHTS This is the common slang term for continuous (non-flash) man-made lights, such as tungsten, quartz-halogen, and HMI (metal-halide) lamps. HMI lights are daylight-balanced (see the color temperature section on page 12); tungsten and quartz halogen lights are yellower in color. Most of the images in this book were created with studio-style flash units, but most of them could have been created with hot lights.

RING FLASH A ring flash or ring light is a lighting unit that surrounds the camera lens. It is most commonly used in macro photography but has applications in beauty, fashion, and glamour photography as well. It consists of a ring with one or more small flash heads that encircle the sides, top, and bottom of the lens.

When ring flash is used on a distant subject, the light travels on virtually the same axis as the camera lens. This results in an image in which the shadows spread outward in a radial fashion (rather than to one side or the other). The classic tell-tale is a halo highlight in the eyes. If the background is close to the subject, an outline (halo) shadow shows around the entire subject. Photographers sometimes use this shadow as a graphic element in a composition.

Ring flashes are available in different diameters. The most common is the scientific or macro-style flash, in which the flash tubes are very close to the lens. A variation made for

Studio-style flash units, such as this Elinchrom unit, are capable of delivering a lot of light for studio work.

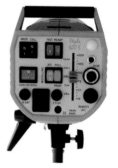

Most studio flash units have a back panel with controls for power output, modeling lights, and synchronization with other flash units, your camera, or your light meter.

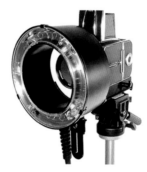

A ring flash attaches to the camera lens, so the flash comes from the same direction as the lens.

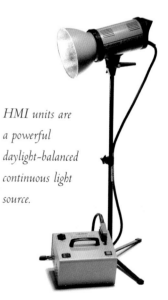

HMI units are a powerful daylight-balanced continuous light source.

One of the interesting aspects of using a ring flash in the studio is the halo shadow created around the subject on the background. The size and intensity of the halo is affected by several factors.

THE SIZE OF THE RING FLASH Some ring flash units are small and encircle the lens closely. These are generally considered scientific or macro-ring flashes, but they work well in fashion. Others are about a foot wide in diameter. The larger the ring, the larger the shadow will be.

DISTANCE TO THE SUBJECT The closer the photographer is to the model, the larger will be the halo behind the subject. In the image on page 122, the photographer moved closer to the model, so the halo became more pronounced.

DISTANCE TO THE BACKGROUND The farther from the background the model is, the larger the halo becomes, assuming there is still enough light hitting the background from the ring flash to make a difference.

Most studio-style flash units must be plugged into a power pack that requires electrical power. These packs come in varying powers and can often serve several flash heads at once. More portable monolights don't use a central power pack but instead have a mini-version built into each head.

photographing people, which has a diameter of about a foot, tends to cast a flatter light with a wider halo.

See the discussion on page 55 for more information on using ring flash, and see several examples of photographs made using this type of flash on pages 54, 110, and 120–123.

ON-CAMERA ACCESSORY FLASH Many SLR and medium-format cameras are designed to accept on-camera accessory flash units. Though these units are not very strong in comparison to the power of studio-style flash units and monolights, they can add fill light in an emergency when you are shooting outdoors.

POTATO-MASHER FLASH Stronger than the average on-camera flash, this accessory flash can be attached to a sidearm bracket on the camera or can be hand-held. These flash units are popular with wedding photographers. View them as a weaker version of a flash monolight.

NATURAL LIGHT The sun is a useful light for some beauty, fashion, and glamour images, but direct sunlight produces hard-edged, deep shadows. To soften or fill it, take advantage of cloud cover and use diffusers and reflectors.

STROBE The (inaccurate) slang term "strobe" is often used to describe any type of flash equipment.

LIGHT MODIFIERS

Whether you're using tungsten hot lights or studio flash, there are several accessories that will help you control and modify the output of a flash. You can put an object in front of the light to block or diffuse it, you can bounce the light with reflectors or flats, and you can block it with gobos or Cinefoil.

SOFTBOX By far the most common light modifier for beauty, fashion, and glamour photography is the softbox—a large cloth box that fits over the flash head. The front of the box is made of a diffusion material through which the light passes. On higher-end units, the diffusion panel can be changed to increase or decrease the diffusion effect.

The sides of a softbox are usually black on the outside and silver or white inside. Softboxes come in many sizes. For shooting in a small studio, 30x40- and 40x60-inch softboxes are commonly used. Chimera, Photoflex, and Westcott are popular brands of softboxes.

Photographers often use softboxes as a soft main light. But they can also be used for fill light or even as a background if you want a window effect.

You'll need a sturdy light stand to hold the flash head and softbox. A boom arm with a counterweight can position your flash apparatus high above the set and out of the way.

UMBRELLA Photographic umbrellas are similar to rain umbrellas in shape, but they are made of photo-specific (and not waterproof) materials. They usually have white or black exteriors and white, silver, or gold interiors. Lighting units are usually reflected into umbrellas with the open inside pointed at the model. If they are made of white, semi-translucent cloth, they can also be set up so that the flash shines through the cloth with the top ("rain" side) of the umbrella pointed at the model.

The hardness or softness of this light can be affected by how close you mount the flash unit to the material of the umbrella. If you place it very close to the umbrella, the effect will be harder than if you allow the light to spread across the entire umbrella.

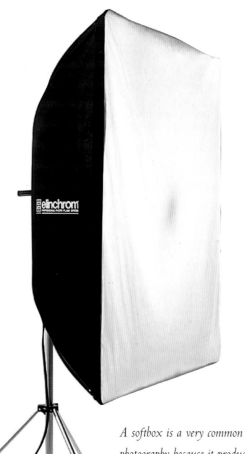

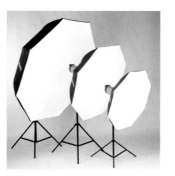

Softboxes come in different shapes, from square to rectangular to polygons. They range from tiny units that fit over an accessory flash unit for an SLR camera to giant units that can mimic light from the sky.

A softbox is a very common light modifier for beauty, fashion, and glamour photography because it produces a very soft light that is good for skin tones.

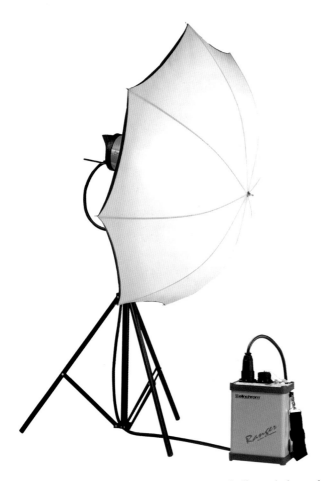

Reflectors come in different sizes (usually measured in terms of the length of the lip, such as 9 inches) or with different angles of coverage, such as the wide-angle reflector shown here.

A flash head or hot light can be reflected into an umbrella, with the inside of the umbrella facing the model, or directed through the umbrella, with the top ("rain") side facing the model.

REFLECTORS FOR FILL White, silver, or gold reflectors are commonly used for fill light, but they can also be used as the main light. They can be hard cards or made from fabric.

Collapsible disc reflectors are very handy. Many times these are two-sided, with white on one side and silver or gold on the other. Matte-white reflectors give softer fill light, while the metallic versions kick back stronger, harder light. Smooth, polished metal surfaces are harder than dimpled metal; the strongest possible reflector fill is an actual mirror. Gold reflectors also add a warm tone to the reflected light.

Large panel reflectors that are held upright with "feet" are commonly called *flats*. Two flats hinged together to create a V-shaped reflector are generally referred to as a *bookend*. Three hinged flats or panels create the *U-bank reflector* described on pages 47 and 48.

Flexfill and PhotoDisc are popular brands of collapsible reflectors. FomeCore and plywood are common materials used to construct flats.

As with umbrellas, if you place the light source close to the reflector (so that it is concentrated in a small circle) the result will be a harder light than if you allow the light to spread out and illuminate more of the reflector.

REFLECTOR HEAD Studio-style flash units generally come with a small reflector head that can be removed or changed. A reflector head helps reduce peripheral light. You can attach larger reflectors to these units.

BARE BULB A flash unit or hot light without any reflectors or light modifiers is described as bare bulb. If used at standard working distances, a bare-bulb light produces a very hard light. Hard lights get their name because of the deep, hard-edged shadows they produce.

BARNDOORS These are small, matte-black doors attached to light heads on two or four sides. You can open or close the individual doors to varying degrees to block the light from certain parts of the set.

BLACKOUT MATERIAL Blackout material is similar to a paper version of velvet. Its flocked surface is extremely light-absorbent, so it records as pure black.

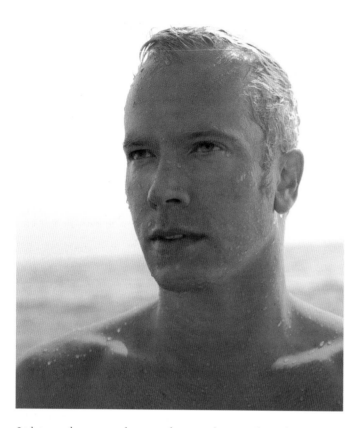

Lighting on location can be as simple as a reflector, used to reduce the strong contrast caused by full sunlight.

DIFFUSERS Any translucent material placed between the light and the subject, a diffuser softens the light. The front panel of a softbox is a diffuser. So are clouds that pass in front of the sun.

FLAG This is a term for a small gobo (see below).

FLAT This slang term describes any large reflector that can be stood upright. Flats are often fitted with legs (so they are freestanding) or clamped to light stands. Most are made of plywood or FomeCore.

FOCUSING SPOT This is a hot light or a flash head equipped with a focusing lens. It allows you to aim the light in a precise direction.

FOMECORE Photographers often use this brand-name product to create large, lightweight reflector flats (see above) in the studio. It is a rigid, foam-like material sandwiched between two pieces of laminated paper to create a hard sheet of varying thickness. White is the most common color, but black and other colors are also available.

FRESNEL LENS This type of lens is used in front of a light to focus it into a spotlight.

GELS A large colored acetate or other material that can be placed over or in front of a light to change its color, a gel can be used over background lights to change the color of a white background. Photographers sometimes use color-conversion gels to cover windows so the daylight matches tungsten room lights (see the section on color temperatures on page 12).

If you are using gels near a light source, make sure they are the heat-resistant type or you may start a fire. Rosco is a popular brand of large sheets of heat-resistant colored gels.

GOBO This light modifier is placed between the light and the subject in order to create shadows, reduce reflections, or shade the camera lens from the potential of flare. Gobos can be made of almost any opaque material; most commonly they're cut from pieces of black cardboard or matte-black metal.

CINEFOIL This brand-name product is almost indispensable in any studio. It looks like super-thick, heat-resistant tinfoil that is matte-black in color. You can wrap it around flash units to create a snoot (see below) in the exact shape and size you want. Cinefoil is worth the (relatively high) price because its matte color controls flare and bouncing light, and its thickness lets you mold it into almost any shape. A version is also available with white on one side and black on the other.

Cinefoil comes in a tinfoil-like roll but costs a comparative fortune (about $50). However, it can replace expensive commercial snoots and is more versatile than they are because it allows you to control the size and shape of the light output.

CUTTERS These are black cards (large ones are called *gobos*; see below) used to block some of the light from hitting the model or background.

Small gobos are often called *flags*; larger gobos are sometimes called *cutters*.

GRID This accessory attaches to the front of a light source and prevents the lateral spread of light, which in turn reduces the amount of flare and fill light caused by the scattering of the rays. The result can be an increase in the saturation of the colors on film. The extent to which a grid does this depends both on its color (black or white) and the degree it is rated at, such as 3, 10, 20, or 40 degrees.

SCRIM When placed between a light and the subject, a black screen called a scrim will reduce the amount of light hitting the subject. A scrim is especially useful for toning down sunlight or a light from a flash unit already set to minimum power. Scrims come in different strengths that correspond to the amount of blockage you want.

SNOOT This attachment goes onto the lighting unit's head to direct the light and concentrate it into a smaller area. When you use a snoot, you can aim a light to hit a certain area with little spillover into other parts of the set. Snoots are available in different lengths and diameters, or they can be created out of Cinefoil.

SPOTLIGHT This is a hot light or flash unit that produces very directional light. Many spotlights have Fresnel or focusing lenses (see above) to help direct the light.

A spotlight delivers a very directional beam of light.

TRIPOD Even in a studio setting, where high shutter speeds can be achieved, a tripod is useful. It allows the photographer to position the camera and leave it set up while tweaking the lights or checking the styling of the model. With a release cord, the photographer can move away from the camera and trigger it remotely—a good trick for more relaxed photos of a shy or inexperienced model.

Tripods can accept different types of heads. A monoball is the most popular because it allows the quick repositioning of the camera with one control. Gear heads allow precise camera movements, even with larger-format cameras. Pan-tilt heads have individual pan (right to left) and tilt (up and down) controls. This makes them great for video panning, but more difficult for studio work.

A *quick-release* system adds speed. Instead of having to turn your camera in a dozen circles to thread it on and off the tripod, you simply mount a quick-release module onto your tripod and install the matching plate on your camera. Then, when you need to change cameras or shoot hand-held, you can release the camera with one turn of a knob or lever.

DOLLY Tripods on wheels, dollies are usually associated with film and video, for which smooth camera movement is necessary. But some photographers appreciate the ease of repositioning that a dolly provides.

MONOSTAND This heavy-duty studio stand for holding the camera has a large central column rather than the three legs of a tripod.

SET & STUDIO EQUIPMENT

APPLE CRATE This kind of small, wooden box comes in handy as a stepstool, a prop, a low table, or a weight. You can use a stepstool to get more height for yourself or your model.

AUTOPOLE This is an adjustable pole with lever action that secures it between the ceiling and the set. A pair of autopoles fitted with J-hooks and a crossbar can be used to hold a roll of seamless background paper. A single autopole and clamp can hold up a FomeCore flat.

CANNED FOG Products such as Fantasy FX provide harmless, scentless, easy-to-dispense smoke in an aerosol-type canister. When you need only a touch of "fog" they are easier and cheaper than a fog machine. Fog from a machine or a can is preferable to a fog filter, because you can minutely control where the fog will appear (say, in front of or behind the subject). With a filter, the "fog" affects the entire image.

CLAMPS Studio photographers need a variety of clamps. A-clamps are great for clipping seamless paper to prevent it from unraveling. C-clamps secure flats to autopoles or light stands. Specialized clamps are available for hanging seamless paper, attaching reflector cards at odd angles, and dangling props over the set.

COUNTERWEIGHTS It's a good idea to have available a variety of counterweights, sometimes called *set weights*. They can be draped over the legs or feet of tripods, light stands, or flats to help prevent tipping. Fancy versions can be purchased, but you can also use sandbags, refillable water bags, or fabric-covered bricks as counterweights.

DULLING SPRAY Also called matte spray, this product is useful for removing the shine from reflective objects. In fashion photography it is commonly used to take the shine off metallic earrings and other accessories. For the photograph on page 82, dulling spray reduced the reflectivity and flare from a mirror. The easiest-to-use dulling sprays are the water-soluble variety, which clean up readily. Artist's matte spray (for charcoal and pastel drawings) and hair spray can be used in a pinch, but they are much harder to clean up.

FABRIC TAPE Two-sided tape is great for temporarily securing clothing to skin.

FOG MACHINE Theatrical fog machines are useful if you want to bring down the flare on backlit subjects. The machines can produce an enormous amount of harmless smoke (clear or colored, scentless or fragranced). For small fog jobs, consider a product such as Fantasy FX (see Canned Fog, above).

GAFFER'S TAPE Don't confuse gaffer's tape with duct tape or masking tape—and at $30 or more a roll, you probably won't! This cloth tape comes in matte-black, white, and gray. You can use it to secure and connect just about anything, and it cleans up quickly and easily.

WORKING WITH BOOMS

Whenever you use a boom arm on the set, you must be extremely careful to secure it well. As the day wears on and the lights heat up, they can suddenly fall. Heavy lights can hurtle down and injure models and other people working on the set.

Always counterweight both the arm and the light stand with heavy sandbags. Double-check and retighten the stand controls several times during the day, as they can loosen with changing temperatures, vibrations, and movement.

LIGHT STANDS You'll need quality light stands to hold your flash heads or hot lights. They also come in handy for supporting reflector cards and other set accessories. For the greatest stability, hang or place sandbags or set weights near the base of a stand to prevent it from accidentally tipping over. A *high boy* is a light stand with extra-tall reach. A *boom arm* is a long arm that attaches to a light stand. Photographers often use boom arms to hold lights, scrims, and other light modifiers at a high angle, or to dangle lighting equipment over the set out of the view of the camera.

PC REPAIRER The delicate PC (pin-cylinder) connections on your flash units, cameras, and meters are easily damaged. This handy tool allows you to repair crushed PC terminals.

SEAMLESS PAPER This heavy paper, commonly used as a background in the studio, comes in large rolls. It is sometimes called a *sweep* because it is pulled down from a high hanging position and "swept" across the floor to create a seamless background and floor. The paper comes in dozens of colors and several widths, including 9 and 12 feet. Super White, Thunder Gray, and Black are the most common colors used in this book. The amount of light hitting them (compared to the main light) can make white seamless look black and vice versa. Color can also be added by gelling background lights.

SLAVES (IR OR RADIO) These small units attach to flash heads, causing them to fire when they "see" another flash go off or when they receive a radio signal from your camera or another transmitter.

SYNC CORD Also called a *PC cord*, the sync cord runs from your camera (or your light meter) to the lead flash unit and synchronizes the shutter with the flash. Additional flash units can then be linked using slaves. Sync cords can go bad, so always have a spare or two on hand.

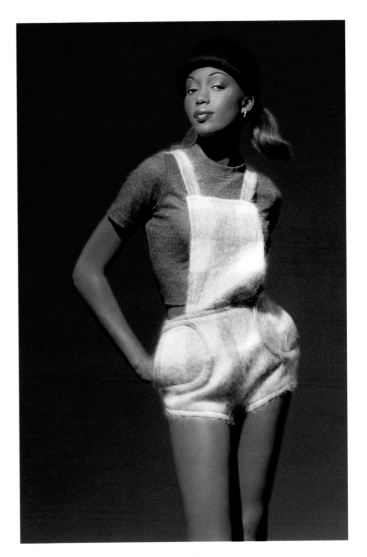

A boom arm can be used to hold lights at a high point for long shadows under the model's chin.

TUNNEL TAPE This tape is designed specifically to tape wires and cords to the floor. A nonstick tunnel runs through the middle of the tape, so cords stay down and don't pick up a gummy residue.

WIND MACHINE Photographers often use this highly directional, extremely powerful fan for dramatic effects.

OTHER USEFUL ITEMS

CLOTHESPINS Quality clothespins are helpful for "instant tailoring"—pulling or holding back clothing (out of the view of the camera).

CLOTHING It's always a good idea to stock a few tube tops or sleeveless shirts that can be pulled down at the shoulder. This allows the model to have a bare-shouldered look while still maintaining a degree of modesty.

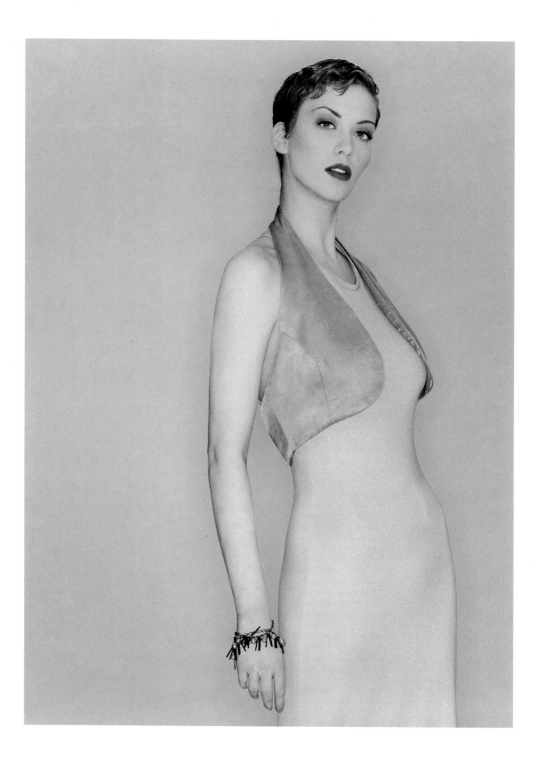

This dress was carefully pinned in the back (out of camera view) to create a flawless silhouette.

EYELASH GLUE The glue that is used to attach fake eyelashes to eyelids can also secure glitter, sequins, or rhinestones to a model's skin. (See the photos on pages 76 and 100.)

MAKEUP Stock a few basic makeup supplies if you're working without a makeup artist or with inexperienced models. The most important item is translucent matte facial powder, for reducing oily shine. Also purchase mascara, eyeliner, a set of eye-shadow colors, and lipstick in several shades. You can use cheap supplies from the drugstore—don't worry about long-lasting quality products, because models will wear them only in a controlled setting and for a short time.

MODEL RELEASE This signed form—a legal necessity in this day and age—gives you permission to sell photographs in which the model appears. There are many different types of model releases, depending on the usage planned for the image and other factors. If you have professional aspirations, you *must* learn about model releases, because without them you may not have the right to sell the pictures you have taken that include people.

For an example of a model release (as well as other legal forms), refer to Tad Crawford's book *Business and Legal Forms for Photographers* (third edition). Amphoto publishes other books on the business of photography that cover model releases in detail. Visit www.watsonguptill.com for a list of these books; go to the Amphoto main page and type in "model releases" in the search field.

SAFETY PINS Keep a jar of different-sized safety pins on hand. They're great for holding clothes in place. A few straight-edged pins also can be helpful.

SESAME MASSAGE OIL This oil is good for simulating moisture on a model's skin—for, say, a fitness fashion shot (see pages 120–123). It makes the skin look "dewy," as opposed to greasy, shiny, or slick. If lit well, the skin will look moist, rather than have the blown-out white highlights water would produce.

SKIN TAPE You can use medical skin tape to pull eyebrows

USING FOG TO REDUCE CONTRAST

Many fashion and glamour photographers make use of "fog" or "smoke" to reduce contrast or to create a soft effect on the set. You can purchase or rent a theatrical fog or smoke machine that produces large quantities of this harmless, scentless material. Add a special liquid, turn it on, and then hose the fog where you want it.

These machines, designed to be used in large theaters and concert halls, can create a vast amount of fog in a short period, and in a small studio, it can be hard to control the amount that is produced. For most small studios, canned fog effects (such as Fantasy FX) are more than adequate and a lot cheaper than using a machine.

When using fog, be sure to turn off all air conditioners or central heating/cooling, as the fog will move toward the intake vents. Close all windows and avoid opening and closing doors; such openings encourage air currents. When you take these precautions, canned smoke effects can remain in place for an hour or more.

If you accidentally release too much fog, open the windows or fan it out a door. Observe the set closely. Artificial fog tends to clump, and you may need to fan it with cardboard to disperse it more evenly. (See page 132 for an example of clumped fog.)

into an attractive arch (see page 57) or tighten skin. The tape must be out of the live image area or be retouched out later.

TRANSLUCENT MATTE POWDER This powder is one of the most important products to have on hand. It is good for reducing unwanted shine on the skin of both female and male models. Most models bring their own, but it's always wise to have some matte facial powder on hand. It is especially important if you are using hard lights, like bare flash heads or direct sunlight.

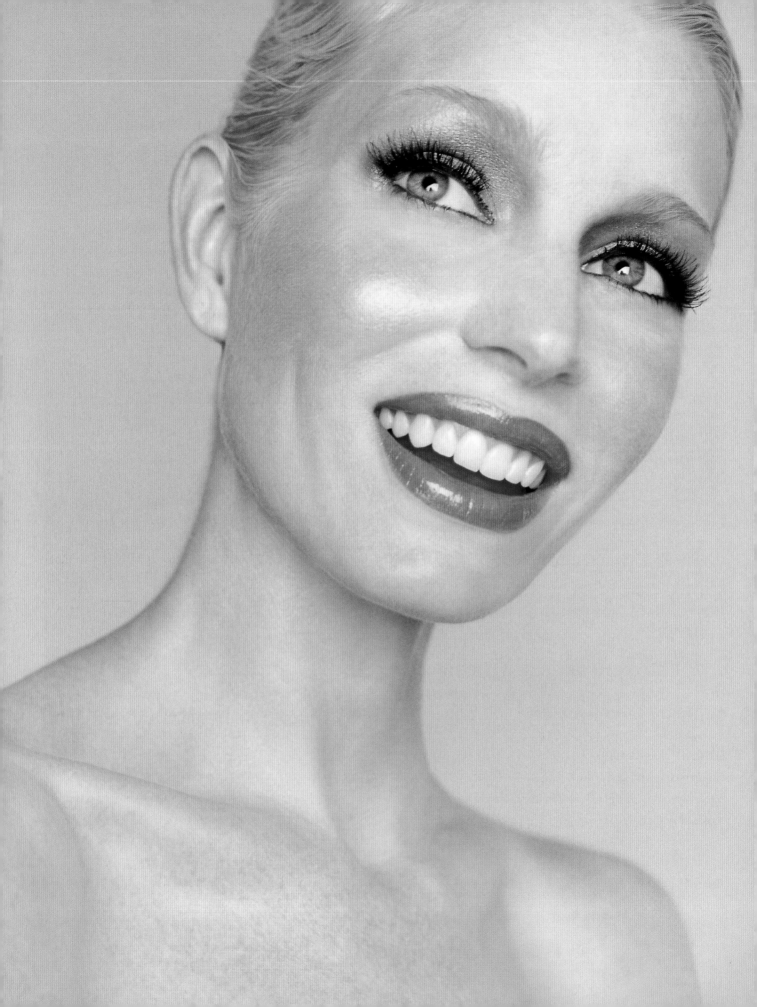

BEAUTY LIGHTING

Lighting to Make the Skin Look Healthy & Beautiful

BEAUTY PHOTOGRAPHY is a specialty that typically emphasizes the face. The model is most often wearing very little jewelry and no boldly colored or styled clothing that would distract from his or her face. Similarly, the hair is usually kept very simple and is often pulled back, away from the face. Most commonly, clients who use beauty photography are make-up and skin-care companies or perfume and cologne manufacturers; occasionally, fashion companies want this kind of shot.

Simple Beauty Lighting is very "forgiving." It works on a broad range of models and poses.

The photographer can create "beauty" photographs a thousand different ways. And though we cannot lay out hard-and-fast rules, we can show you several of the most popular and widely used lighting techniques for this specialty. The setups described in this chapter will produce the lighting that most clients are envisioning when they ask for a beauty shot.

Beauty lighting shows off the smooth gradation of tones and the soft contours of the face.

Once you learn the basics, you can make alterations that put your own artistic stamp on the photograph. However, you should always keep in mind the client's goal of clean skin tones and an emphasis on the face.

Because beauty photography is a specialty that emphasizes skin tones, the lighting for simple beauty has one overriding goal: to make the skin look beautiful but still have definition. For fashion and glamour images, photographers may blow out the highlights or design the light in such a way that the skin has high contrast or is perfectly flat. However, for images emphasizing beauty, the goal today is for the skin to have texture and definition—in other words, it should look like skin. And the overall image should show tone and contours. Even the whites of the eyes should have tone. The only pure white in the whole image might be the highlight in the eye.

That said, later in this chapter we show you two techniques that leave the skin shadowless and two-dimensional (pages 52–53 and 54–55). Despite the current vogue for texture and definition, this "flat" look is still considered valid for many beauty images.

POSING FOR BEAUTY

Most beauty photographs include just the face or the face and shoulders. When inexperienced models pose for this type of closely cropped image, it is easy for them to overdo their facial expressions.

Subtlety usually works best. Big, toothy smiles rarely work for beauty shots. Instead, ask models to try for a pleasant

look. A useful suggestion is to have them smile as if they see something pleasant in the corner of the room.

When working with newer models, watch out for a wide-eyed, deer-in-the-headlights look. Even with a moderate telephoto lens, you'll be working fairly close to the model, which can be a little intimidating. As a natural reflex, the model may open her eyes a bit too wide, which, while barely noticeable on the set, will be apparent in the final image.

Dim studio lighting can dilate the pupils of a model's eyes. If you are using studio-style flash units equipped with modeling lights, be sure to turn them on. They will help keep the pupils at a more normal dilation.

Collarbones can also be an issue. Most models are on the small side, and they are usually very thin. In relation to the rest of the body, their collarbones tend to protrude more than you'd see with the average person. Be aware of this when you initiate poses. And if you are choosing models for necklaces, consider their shoulder physiques in addition to their faces (see pages 48–49 for more on jewelry photography).

Tube tops are a good choice for bare-shoulder shots. Keep one or two in the studio in case the model does not bring one. Tube tops allow a certain degree of modesty for the model. You can tape the top in place if you need to position it lower than normal for the shot.

Posture is very important, even when the image will show only the face and neck. For this reason, when you are selecting models you should evaluate a candidate's posture. People simply look better and more natural—in whatever pose you put them in—if they have excellent posture and grace of movement.

The neck can be an important feature in feminine beauty. Because long, thin necks are considered graceful, you may want to consider posing a female model so that her neck appears elongated.

Avoid "passport posing" in which the model stands squarely in front of the camera. Instead, break up the angles, by turning or tilting the model's shoulders, hips, or head in relation to the camera angle. In beauty photography, these shifts will be more subtle than in fashion or glamour photography.

These poses may not feel natural to the model—but not much about beauty photography is natural. She's in a studio, with a bright light a few feet from her face, and wearing make-up or clothes that are not her own. Posing is just one more unnatural element. You can assure the model that proven photographic techniques will produce a natural-looking photo.

In the same way that fashion styles change from year to year, so do photographic posing preferences. Keep abreast of current trends by observing what the top photographers are doing in the hottest magazines and advertising campaigns.

SIMPLE BEAUTY LIGHTING

A good place to start the beauty lighting process is with what we call Simple Beauty Lighting. This approach to lighting has

METERING FOR BEAUTY

In beauty photography, metering is critical because skin tones rule. As a photographer, you must scrutinize the lighting and observe the skin tones. Both digital imaging and film have more contrast than what we see with the human eye, so even slight variations in skin tone will be obvious in the final image.

For this reason, you must become used to meticulously metering the scene. The easiest method is to use an incident-light or ambient-light meter (see pages 22–23) and point the dome either at the camera or halfway between the camera and the light. Meter and compare the main light to the fill light.

Many beauty photographs are composed with a very tight face crop, so you'll need to check the middle, sides, top, and bottom of the face. Digital meters are preferable, because they can report 1/10-stop variations.

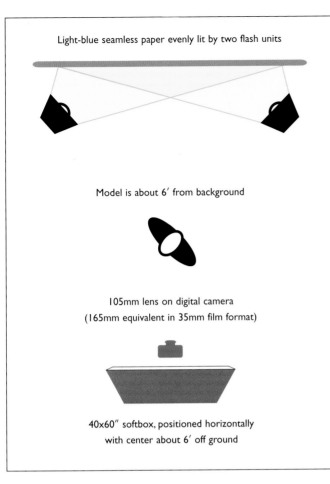

Light-blue seamless paper evenly lit by two flash units

Model is about 6′ from background

105mm lens on digital camera
(165mm equivalent in 35mm film format)

40x60″ softbox, positioned horizontally
with center about 6′ off ground

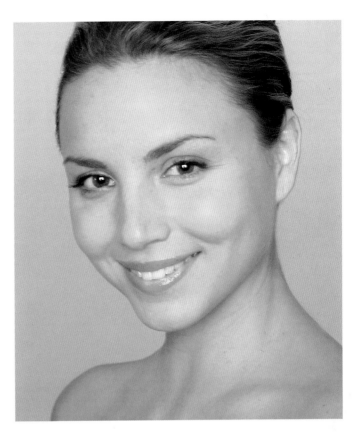

*Simple Beauty Lighting is extremely popular because it works well for a
wide range of models with differing ethnicities, skin tones, and facial features.*

been the mainstay of beauty photography for more than twenty years. Not only does it work on a wide variety of models, it also works for many different poses. And it works equally well for women and for men when a softer look is required (see page 108). Simple Beauty is what photographers call "a very forgiving" lighting, because it does not require great precision in the model's pose.

Begin by setting up a 40x60-inch softbox and placing it high behind the photographer. It should be turned horizontally (so that it's 40 inches tall) and angled downward so it points directly at the model's face. The center of the softbox should be about 6 feet off the ground for a standing model, and angled toward the model.

If you were the model, looking at the camera (which would be at your eye level), the photographer's head would appear about a third to half the way up the length of the softbox. Depending on your height, this would be 4.5 to 6 feet off

the ground. The result is a fairly even band of light on the left side, the right side, and the top.

The high angle of the light casts slight shadows under the cheekbones and the chin, but its diffuse nature makes them soft and subtle. The light gives basic shape and contouring to the eyes, lips, and cheeks.

*Subtle expressions
speak very loudly in beauty
photography.*

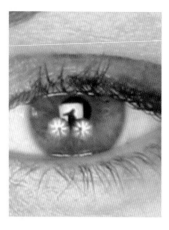

MODIFIED BEAUTY LIGHTING

A modified version of Simple Beauty Lighting can be created with two additional lights. Start with the large softbox used as described for Simple Beauty Lighting, but add two flash units bounced into umbrellas. Place the flash units and the umbrellas in front of the photographer and below the camera, but as close to the camera as possible without being in the photo, and direct them on an angle toward the model's face (see photo at left).

We are used to seeing the world around us lit by the sun, so a single light source from above seems familiar and natural. Lighting from below is unnatural; think of the traditional "horror" lighting of Hollywood movies. The photo on the upper right on page 39 shows the effects of this low-angle lighting used alone, without the main light.

A closeup of just the eye reveals the two umbrellas, the softbox, and the photographer clearly visible in the reflection.

This is the lighting setup for Modified Beauty, as seen from the model's perspective. Modified Beauty Lighting adds umbrellas to the Simple Beauty softbox setup.

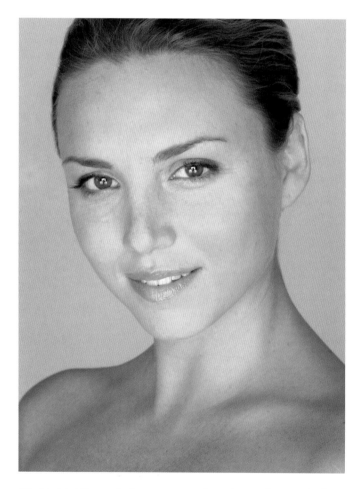

The Modified Beauty Lighting setup uses the softbox with two umbrellas (see the lighting setup diagrammed at right).

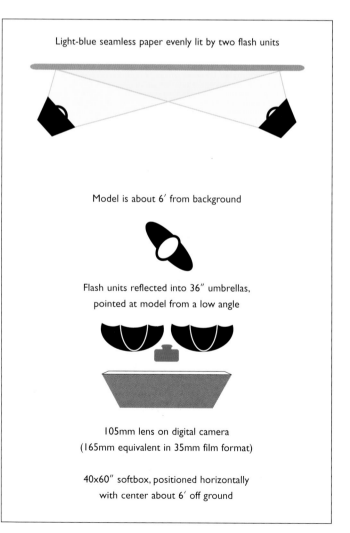

Light-blue seamless paper evenly lit by two flash units

Model is about 6' from background

Flash units reflected into 36" umbrellas, pointed at model from a low angle

105mm lens on digital camera
(165mm equivalent in 35mm film format)

40x60" softbox, positioned horizontally with center about 6' off ground

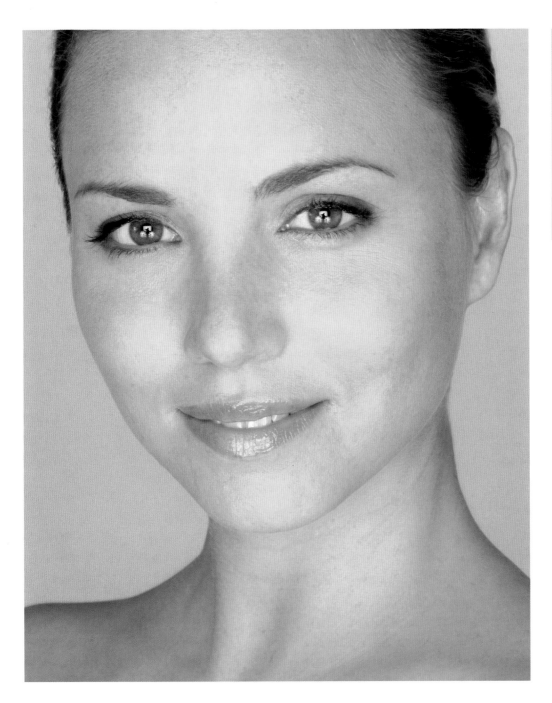

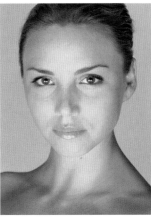

This is the lighting from the two umbrellas without the main soft-box. This low-angle lighting is the traditional "horror" lighting used in the early days of cinema.

Minor retouching with Adobe Photoshop software finishes the image shot with the Modified Beauty Lighting setup.

It is important to note that, in Modified Beauty Lighting, the light from the umbrellas is not fill light; it is metered to be equal (or almost equal) in strength to the main softbox. You are using the umbrellas as a dual main light with the softbox.

The photo above shows the softbox and umbrellas combined. This Modified Beauty Lighting has stronger highlights and more depth than Simple Beauty Lighting alone. Note that Modified Beauty Lighting provides more shadow and shading than Simple Beauty Lighting, even though the model is wearing light, semi-matte foundation makeup and neutral eye shadow.

Both final images made with Simple Beauty and Modified Beauty Lighting setups look good. The model has excellent bone structure, and particularly gorgeous and distinct cheekbones. A model with flatter, less distinct features would benefit more from the Modified setup; its more contoured lighting would give her face better shape than the Simple setup.

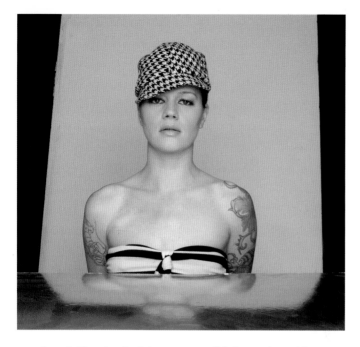

A reflector held at chest level throws strong fill light into the model's face, helping to minimize the shadows under her chin and hat.

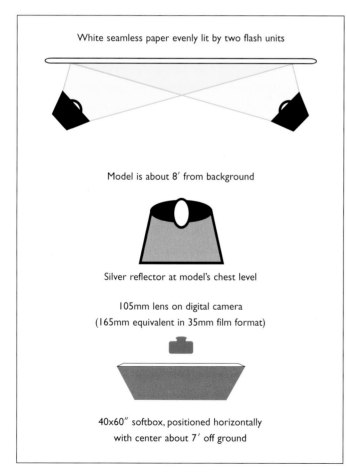

White seamless paper evenly lit by two flash units

Model is about 8′ from background

Silver reflector at model's chest level

105mm lens on digital camera
(165mm equivalent in 35mm film format)

40x60″ softbox, positioned horizontally
with center about 7′ off ground

VARIATIONS WITH REFLECTORS

Beauty photography is a far more subtle art form than fashion and glamour photography, so it should come as no surprise that seemingly minor changes in the lighting for it can make a big difference. The trick is to study your model carefully; then factor in your camera angle, the model's clothing and makeup, and, most important, your creative intent.

In the image shown at right, the intent was a "mod," retro, 1960s look. The work began with the stylist, who chose a hound's-tooth patterned hat from the period. The eye make-up was done with the heavy mascara of the era, and pale lip-stick helped emphasize the eyes. A slight tilt of the hat's brim had the dual effect of emphasizing the eyes and adding a curving line to the composition.

When you are working outdoors, a reflector can fill harsh shadows from sunlight.

The main light was the large softbox, positioned high and angled toward the model (see Simple Beauty Lighting, pages 36–37). Two lights were pointed at the backdrop from 45-degree angles to create an even-light background.

A low camera angle (usually considered a more masculine angle) had the effect of giving the model a strong, confident look. Because this low angle showed more of the shadow under her chin and because shadows were also cast by the brim of the hat, we added a silver reflector, placed parallel to the floor but at the model's chest level (see photo at upper left). This setup reflected very bright fill light back up at her face.

The image was originally shot in color and later converted to black and white.

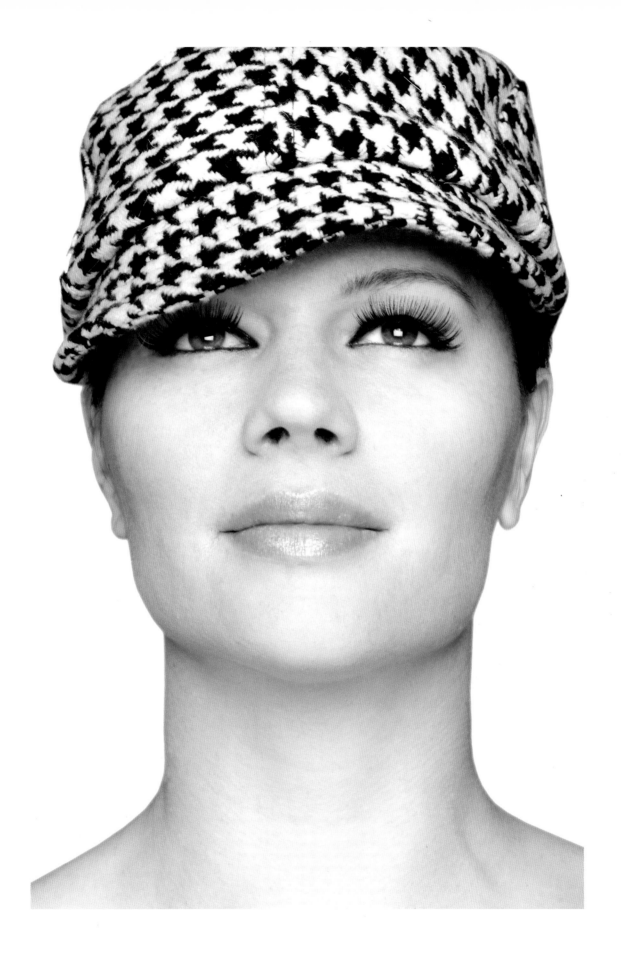

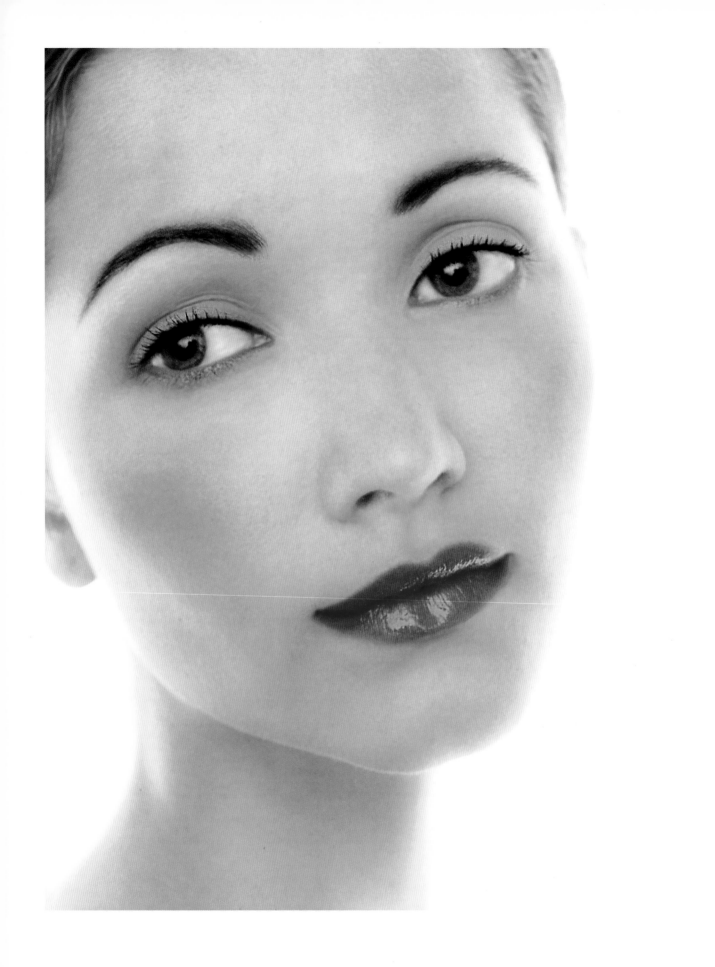

ON-LOCATION BEAUTY

You can achieve a glowing variation on Simple Beauty Lighting by altering the background. It's a simple matter of departing from the simple, evenly lit seamless paper background seen in the images offered as examples up to this point. Instead, you create a background light source.

In the image shown at left, the model stood in front of a north-facing window covered by a sheer, neutral-colored curtain. This created a soft, ambient backlight. Overexposing this backlight in comparison to the main flash illumination (see below) created a bright flare on the rim of the model's face.

The overexposure of the window light was achieved through shutter-speed selection. The main flash recorded instantly on film, while a long shutter speed (approximately 1/15 second) allowed the rimming light to record at +0.5 EV to +1.0 EV overexposed.

The main light was a 40x60-inch softbox, positioned vertically and centered at about the photographer's head level and pointed straight at the model. It produced a soft shadow under the model's chin, nose, and lips, and allowed the lower lip to be slightly brighter than the upper lip for greater three-dimensionality. The overall exposure was +0.5 EV, with the rim of the face and neck even more overexposed.

After the shoot, we did work in Adobe Photoshop to increase the saturation of the color of the lips to make them pop. We also did slight retouching to even out the skin tones on the face and the neck.

If a window with soft light (such as a north-facing window or any window on an overcast day) is not available, you can achieve a similar effect by substituting a giant softbox for the window and curtain.

Create a glowing background by placing the model in front of a window or a softbox.

For a glowing effect, the background, such as a window or a softbox, can be a light source.

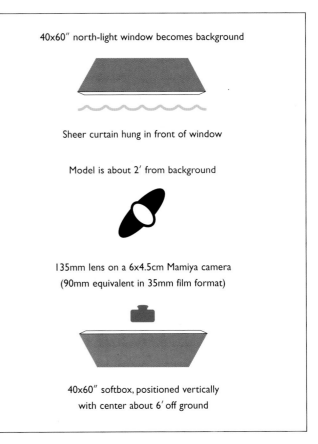

40x60″ north-light window becomes background

Sheer curtain hung in front of window

Model is about 2′ from background

135mm lens on a 6x4.5cm Mamiya camera
(90mm equivalent in 35mm film format)

40x60″ softbox, positioned vertically
with center about 6′ off ground

BEAUTY ON THE ROAD

When shooting an Avon catalog on the road, we needed to modify the Simple Beauty Lighting setup. The goal of the photo was to sell a new, tropical-scented skin-care product—but without a tropical location. However, all we needed was the sunshine, a garden hose with a water supply, a potted plant, and a large reflector. In fact, we took this shot in the outdoor lobby of a hotel. We had to shoot quickly (in less than 20 minutes) because the sun was about to fall below the roof line of the surrounding buildings. Despite the necessity for speed, every aspect of the image was precisely controlled.

Direct sunlight is rarely a good main beauty light because it is so harsh. Instead, we positioned the model so that just a kiss of sunlight hit her shoulder and arm from behind. We rolled a palm plant in a wheeled pot into the distant background, where it was dappled with sunlight.

We positioned a large Flexfill metallic silver reflector in front of the model to the left of the camera, no more than 3 feet away. We angled the reflector at her face, which was in shadow from the sunlight. Direct sunlight hit the reflector, creating the main light for the picture.

Far more difficult to position and set up was the water. In order for running water to show up well, it needs to be backlit. This wasn't a problem because of the direct sunlight, and the fact that the water source was a simple garden hose that an assistant held in place. The finesse was in positioning it so it hit only the model's arm, yet looked like she was entirely under the shower. Had it been positioned to fall on her head, her makeup would quickly have been ruined, her hair would have been drenched and lifeless, and the towel would have become soaked. Instead, an assistant dampened her hair and face separately with a spray bottle.

Exotic location photography does not always have to be shot in an exotic location!

The water also needed to be about 1/2 to 2 stops over-exposed (+0.5 to +2.0 EV) compared to the main light (the reflector). An exposure of 1/15-second with a 135mm lens on a 6x4.5cm medium-format camera (approximately 80mm equivalent in 35mm film format) was slow enough to create a pleasantly blurred image of the water. If the exposure had been any faster, the main stream of water would have been too "frozen" in stop-action to look real. If it been any slower, the individual droplets falling off the model's arm would have been less distinguishable.

On the first try, this lighting looked great on the skin, but then we noticed that the white towel was too bright. Simply switching to a tan towel solved the problem.

The towel itself posed a design question. Who wears a towel when they shower? However, it probably didn't strike you as strange until you read this, because we automatically associate towels with showers—just not in the shower!

The sun, a reflector, a garden hose, and a potted plant were used to create an exotic tropical setting for an Avon catalog shot.

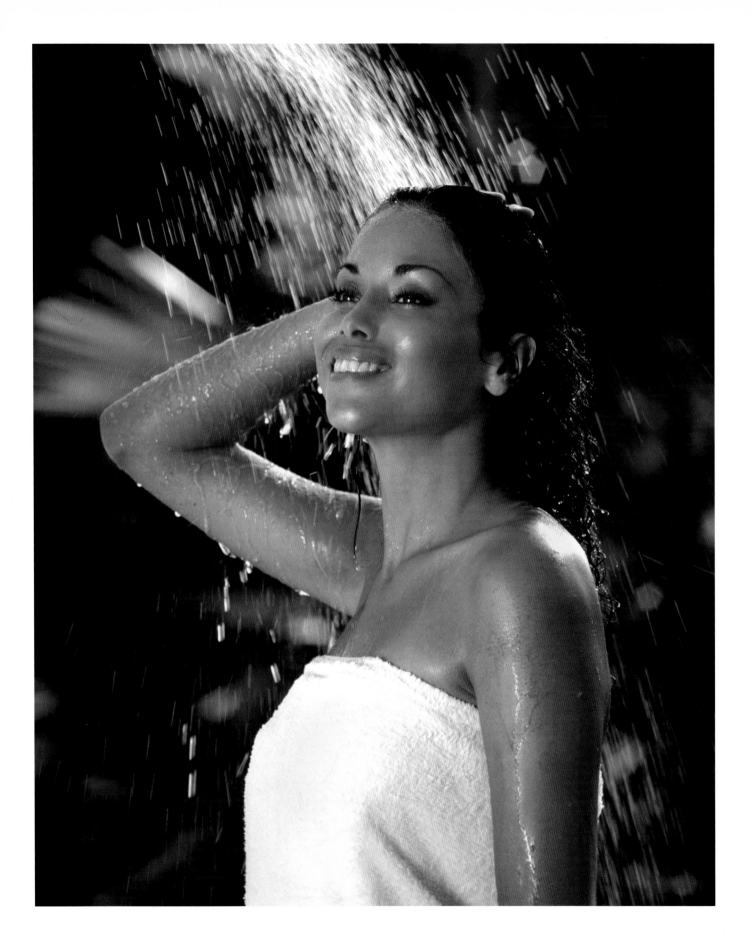

The beach is a difficult place to shoot beauty photographs because direct sunlight produces high contrast. While this dramatic lighting might work for glamour and even fashion images, it makes it hard to achieve the soft gradations of tone required for beauty images.

Even on a heavily overcast day, sunlight creates a very heavy top light. The image shown here was shot on such a day, and this high, diffuse light source (sunlight through heavy cloud cover) produced deep shadows under the model's eyes and chin.

To combat these shadows, an assistant held a large silver reflector as close to the model as possible, without having it show up in the viewfinder. The goal was to reduce the shadows to a half-stop (−0.5 EV) or less than the natural light. You'll need to meter carefully to achieve this goal.

We selected T-Max 400 high-speed black-and-white film, even though finer-grained, low-speed film could have been used. We chose this film for the aesthetic qualities of its graininess. When we did extreme cropping of the image before enlarging it, the grain became even more predominant.

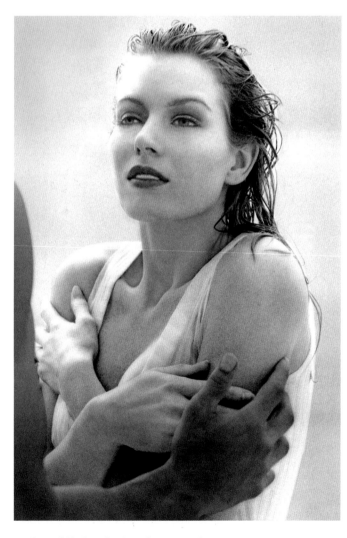

High-speed black-and-white film was used to create a grainy image.

Even heavily overcast sunlight creates contrast, so we added strong fill light to create beauty lighting.

Another popular beauty lighting setup is the U-bank. The photographer creates a bay window (U) shape using three 4x8-foot white panels and then, standing in front or inside the U-bank while shooting, fires two flash units into them. The light reflects off the banks and onto the model. This setup produces a very smooth, almost shadowless lighting, with soft gradations in the skin tones.

You can purchase fancy U-banks made of sturdy materials and equipped with hinges for positioning the sides to create a variety of angles. However, you can also easily make one from large sheets of FomeCore or other sturdy material and "hinge" the unit with gaffer's tape. Don't tape the edges too close to each other; leaving a little extra tape between them allows room for the boards to pivot and bend.

A more permanent homemade version can be made with plywood and metal hinges. A quick coat of white paint or taped-on metallic materials (tinfoil, fabric, or posterboard) can alter the lighting effect. Matte-white paint yields a softer effect; crumpled or dimpled metallic surfaces will be a bit harder; and shiny metal provides the hardest lighting effect.

Whatever the material you choose, you'll need it in large sections. The images here were lit by a U-bank with three 4x8-foot FomeCore panels.

For this image, the model was styled with very little makeup. The hair is deceptively casual; the single ringlet was carefully placed to emphasize her eye.

The model's pose was orchestrated to create diagonal lines, which gave the overall composition a dynamic, fluid feel. Neither the head, the shoulders, the arms, nor the spine is at a straight vertical or horizontal line in relation to the framing of the picture. Had the model been "standing at attention" with her shoulders straight and her head and eyes pointed directly at the camera, the result would have been static and boring.

The pose was enhanced in Adobe Photoshop by tinting the picture with an overall blue tone. The background was neutral gray in the original picture. The added blue color paled the model's lips and enhanced her eyes. It also made the picture more monotone, emphasizing the graphics of the pose.

To add fluidity to a composition, set all the major body parts to diagonal lines.

A blue color adjustment in Adobe Photoshop made the lips and skin tone paler, emphasizing the graphic nature of the pose.

JEWELRY ADDS COMPLICATIONS

Jewelry is a common accessory in beauty photography. However, certain types of jewelry are difficult to photograph. Gems can look dark and dead unless lit with an angled hard light. Glass beads are at their best when light is allowed to shine through them, revealing their true color. Mirror-like beads can appear white with highlights. Natural shells and stones can look flat with-they don't have a polished surface. A big, broad light can cause too much of a reflection in the jewelry. It is not surprising that it can be difficult to light jewelry made of several different materials.

Jewelry photographers working with mannequins or still-life photographers using inanimate props have fewer complications. They can set up the jewelry for a perfect shot. For a necklace that mixes different materials, for example, they can use one or more small lights and miniature reflectors to bring out individual aspects of the jewelry.

Jewelry adds an extra measure of difficulty because of its reflectivity.

Digital jewelry photographers have an additional advantage. If the jewelry does not move and the camera is locked down on a tripod, the photographer can shoot several versions of the scene with the only variation being the lighting. Then she can merge them together in Adobe Photoshop, keeping the portions from each lighting setup that look best and "erasing" the rest.

Once you put that same necklace on a model, every time she moves the jewelry will change in relationship to the lights. Even the rising of her chest when she breathes can alter a highlight on the jewelry. The task of the model wearing jewelry is to "strike her pose" while always keeping the jewelry at

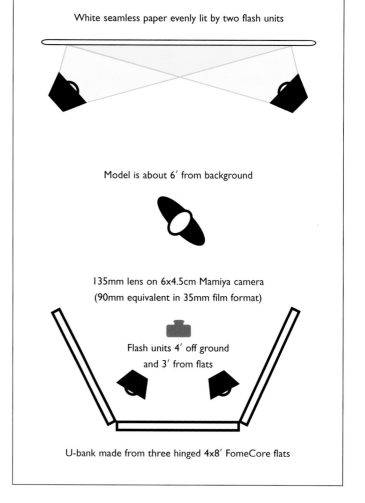

White seamless paper evenly lit by two flash units

Model is about 6' from background

135mm lens on 6x4.5cm Mamiya camera
(90mm equivalent in 35mm film format)

Flash units 4' off ground
and 3' from flats

U-bank made from three hinged 4x8' FomeCore flats

a certain angle to the lights. This difficult task requires a model who is very aware of her posture and posing.

In the image shown here, the photographer looked at the jewelry and noted its intricate design, which included some beautiful beadwork that could have dazzled with a hard light. However, the complicated overall design looked too busy with hard lighting, because there were a lot of little specular highlights. The photographer decided that soft lighting would show the piece off best by emphasizing the patterns and tones.

The photographer lit the model and the jewelry with the classic U-bank described on page 47. However, this time

Soft lighting brings out the intricate patterns of the necklace without adding jarring highlights that would distract from the model's face.

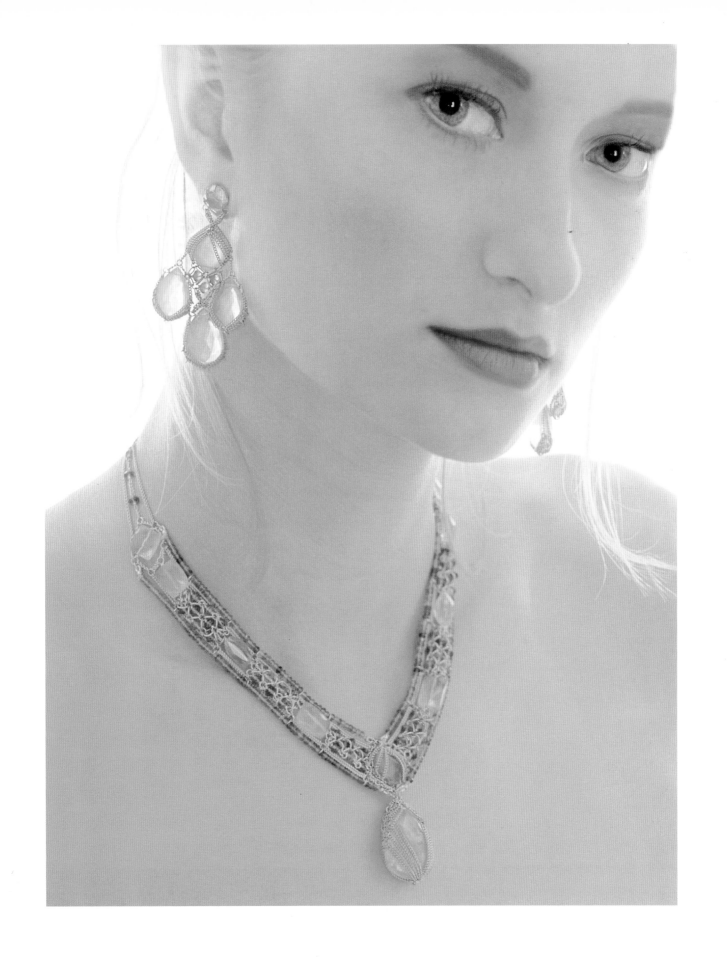

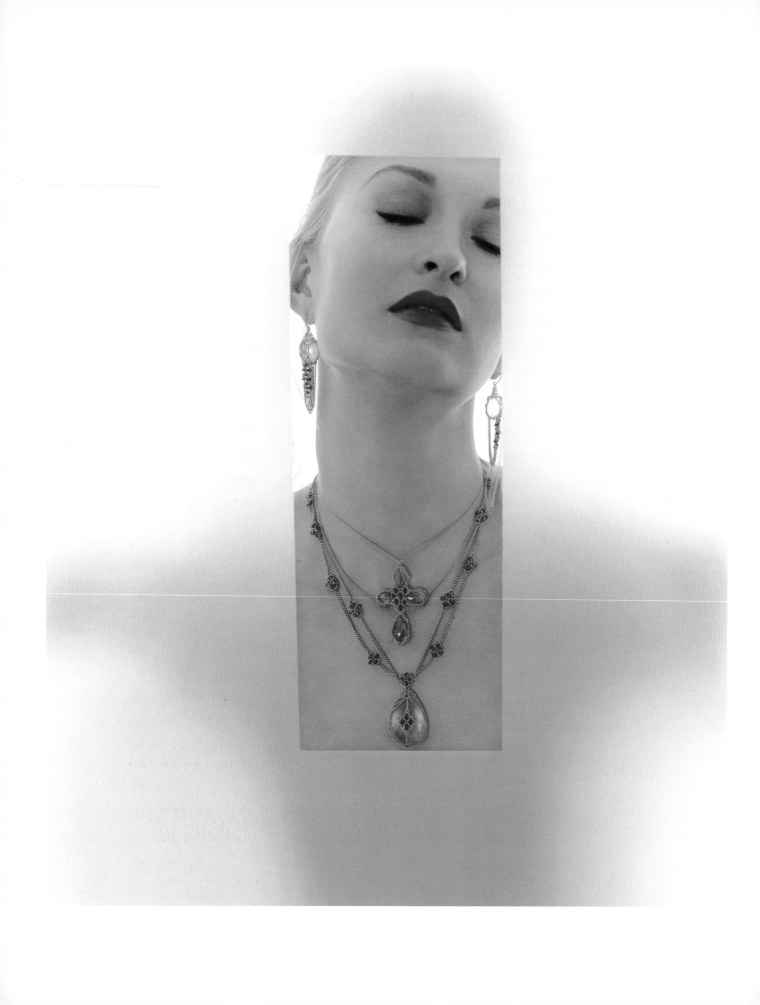

he overlit the background so that it would produce a slight glowing feeling. Experimentation with the power of the background lights yielded different results. The version shown here has the background about +0.25 to +0.5 EV overexposed, in comparison to the main light. Overexposure of +1.0 EV or more resulted in a complete blowout of the hair.

Matte makeup applied to the model's face, shoulders, and chest, along with the flat light of the U-bank, helped create the incredibly smooth skin tones.

VELLUM VARIATION

The beautiful and unusual frame within the photograph shown at left was not an Adobe Photoshop creation. In fact, it was part of the main light source!

This lighting setup began as a creative experiment with several large pieces of 30x40-inch translucent vellum. First, we used a razor blade to cut a large window out of the center of the vellum. For the final image, we cut a rectangle. Less-successful variations had included ovals and circles, as well as sheets of vellum with different thicknesses that affected how much detail could be seen through the uncut portion.

The model was lit by a large softbox powered down about 1.5 stops (−1.5 EV) from "normal" exposure to make it more of a fill light. The vellum itself, which was only an inch or two from her face, reflected light from the background at the model.

At the client's request, the lighting for the jewelry was kept on the flat side. He wanted to emphasize the shapes of the pieces rather than the glitter of the mirror-like beads. A small bare-bulb flash was positioned high over the top of the model's head, and powered down to about −1.5 stops under the main exposure. This was just enough to add a touch of sparkle without affecting the overall exposure.

The intent of the pose was to mimic the graphic element of the cross with the model's outstretched arms.

The photographer cut a hole in a large sheet of vellum and placed it close to the model. It served both compositional and lighting purposes.

A vellum frame a few inches from the model's face becomes the main light source.

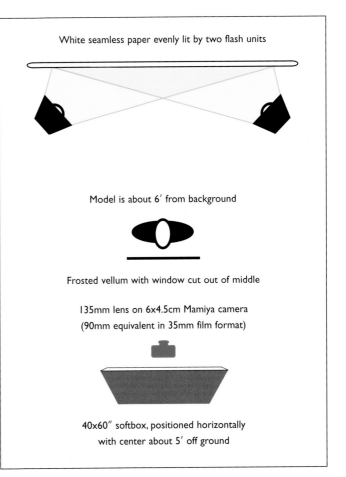

White seamless paper evenly lit by two flash units

Model is about 6' from background

Frosted vellum with window cut out of middle

135mm lens on 6x4.5cm Mamiya camera
(90mm equivalent in 35mm film format)

40x60" softbox, positioned horizontally
with center about 5' off ground

Retro "Hollywood" beauty images can be created with a single hard light and matte pancake makeup.

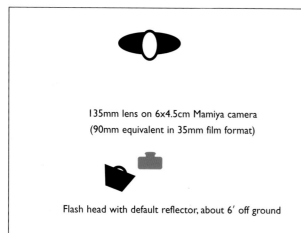

135mm lens on 6x4.5cm Mamiya camera
(90mm equivalent in 35mm film format)

Flash head with default reflector, about 6' off ground

There are times when you want to "break the rules" and use the "wrong" light for beauty. In the image shown at right, the lighting was a single hard light (no softbox, just the standard 10-inch reflector that comes with the flash unit). It was placed next to the camera and angled at the model from an inch or two above camera level. This was just enough to cast a slight shadow under her chin and nose.

Photographers from the 1940s and 1950s, such as Horst and Irving Penn, used a single light source as the key light for many of their beauty photographs. This enabled them to create a highly sculptured and idealized portrait of an actor, actress, or model. The desired result was for the actress or model to have a skin tone that resembled the smooth, marble surface of a sculpture by Michelangelo. This lighting was a direct reflection of the lighting used for the movies of the era, so it was both familiar and glamorous.

To create a 1940s Hollywood effect, we used heavy eye makeup. The hard light made the model's eyes pop. Matte pancake and full lips emphasized the drama of her full lips.

The model's facial features were further emphasized by the fur coat and pose. With her hands wrapped around her head, the coat became a complete circle frame. Black-and-white film emphasized the retro feel.

By wrapping her arms over her head, the model turned a fur coat into a soft circle that framed her face.

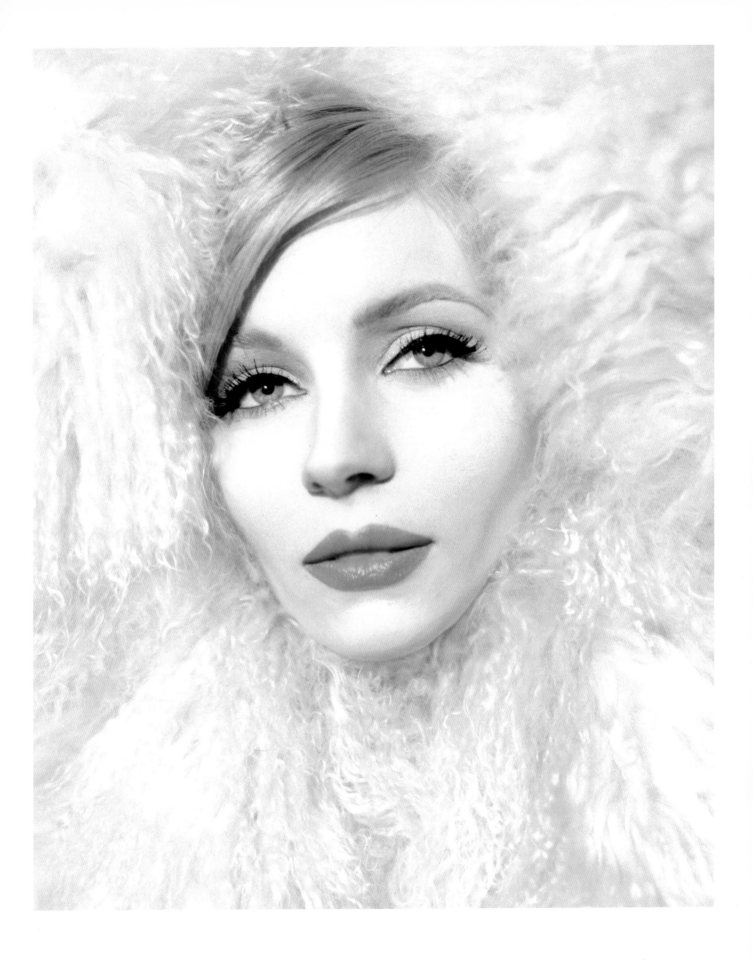

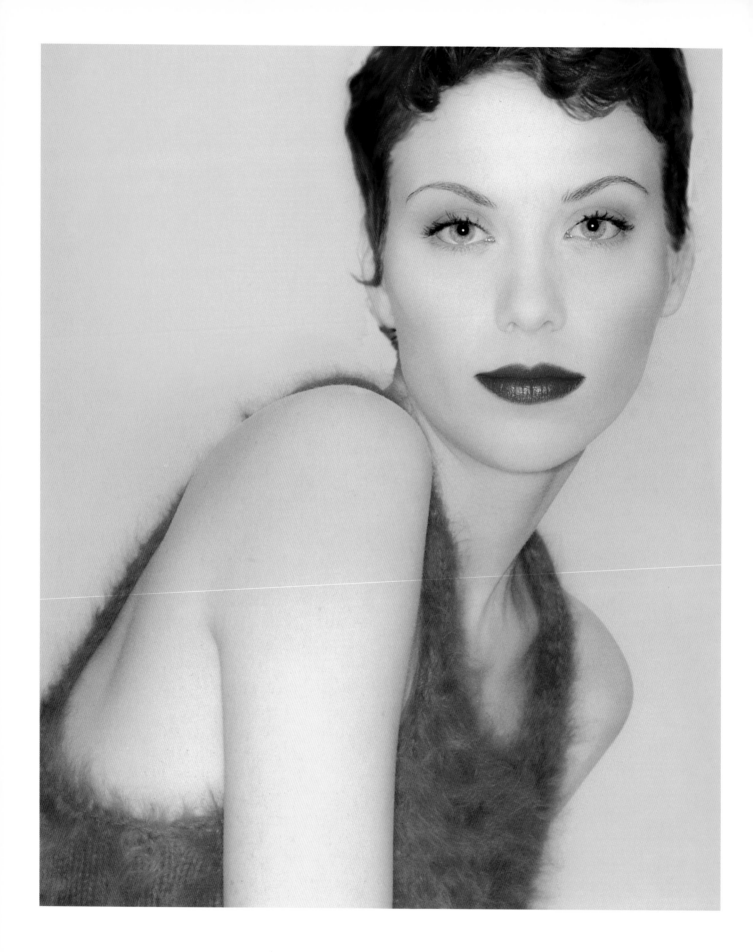

RING FLASH

Most people think of ring flash as either macro lighting for insects and flowers or a very harsh light for fashion. However, if used correctly, it can produce very flat, two-dimensional lighting for an interesting beauty lighting technique. (See pages 24–25 for a basic description of ring flash.)

When used fairly close to the model, ring flash produces shadows on the outer edges of the face. Slight overexposure will open up these shadows and lower the contrast. If you place the model at a distance from the backdrop, you can avoid the tell-tale halo shadow behind her. However, unless the eyes have been retouched, you should be able to see the ring shape in the highlights of the model's eyes.

Ring flash can be an effective beauty light if used fairly close to the model.

In the example shown here, the makeup consisted of a lot of matte makeup—more than is commonly used in beauty photography. It was applied not just to the model's face, but to her shoulder, neck, arms, and all other visible skin. Only her eyes and her lipstick lacked the matte makeup, which had the effect of emphasizing both. This photograph lacks the tell-tale halo shadow commonly seen in ring-flash images, because the yellow background was lit separately with two flash units.

Matte makeup and a ring flash combine to create the illusion of perfect skin.

MAKEUP FOR BEAUTY

For beauty shots makeup is critical. Usually photographers prefer more matte than a woman usually wears, to emphasize the smoothness of the skin, but they do not want to completely hide the skin texture. In the past, all texture was airbrushed away before the photo went to press. Today's digital-savvy consumer is more demanding. Heavily retouched skin looks fake and unnatural. Instead, people want to see the skin's texture.

If the pose shows more than just the face, be sure to apply makeup to all exposed skin. A neck with a startlingly different skin tone will make the whole image look fake.

Try to use a professional makeup artist for beauty photography. A skilled makeup artist can be a huge asset. If you can't afford one or trade services with one (see chapter 6), then you will have to get creative. Perhaps you can recruit a person who works at a makeup counter in a department store or visit a nearby cosmetology school. You may find someone with experience applying makeup who is willing to do test shoots at no charge.

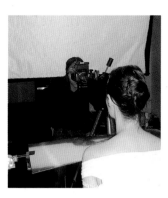

A stretch fabric top allows the model to retain her modesty while doing a sexy, bare-shoulder shot.

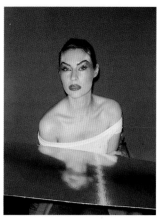

A reflector throws strong fill light onto the model's face. Note the eyebrow tape, which was later retouched out of the final image.

BOLD MAKEUP

Often beauty makeup is clear and concise. But it can also be wild and fantasy-like, such as the image shown at right. Here, the colorful makeup and lighting were planned together. We chose super-gloss lipstick in a very bold color to make the lips jump out of the photo. The pale foundation makeup was offset with colorful eyes and cheeks.

It is important to choose the model carefully when you know the shot will use wild makeup. A model with weaker facial features would not have been able to carry off a photograph like this one. This might seem counterintuitive, since most people think of makeup as a way to improve features. However, without strong facial lines, the model might have appeared to be a cartoon of lips and eyes.

The time-tested technique of taping the eyebrows created an attractive arch. Before the days of easy digital retouching, this tape would have been hidden beneath wigs or bangs. Today only a few moments of work in Adobe Photoshop wiped out all traces of the tape. While the eyebrows could have been "morphed" in photo-editing software to create the arch (see the photo on page 90), it is easier and often more realistic-looking to use the older method of taping.

Lighting for this colorful shot was fairly simple. A softbox was placed behind the photographer, slightly higher than for Simple Beauty Lighting (see pages 36–37). We placed a shiny silver reflector at chest level, just out of the frame of the picture. This kicked back strong fill light onto the shadow side. The result was almost equal lighting strength from the top and bottom. This almost shadowless effect emphasized the pose and the colors for a very graphic end result.

Compare this to another image of the same model (left), taken on the same day. Here, the softbox was raised even higher. The highlight in the model's eye reveals the softbox without the outline of the photographer's head, indicating that the

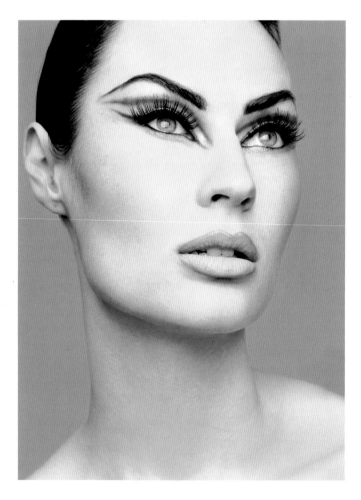

Switching to more neutral makeup (or removing the makeup) and lessening the fill light creates a very different feeling.

Soft lighting and bold colors combine in this dramatic beauty shot. Even though beauty makeup is usually less complex than shown here, this image still falls within the beauty category because it emphasizes the product being sold—the eye-shadow makeup.

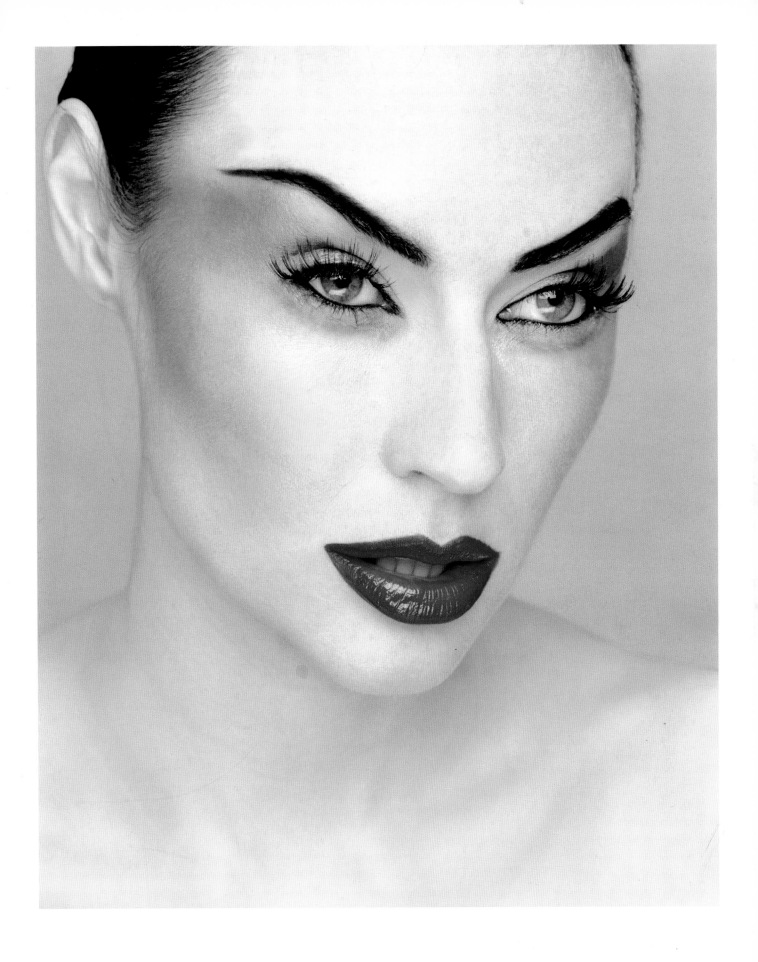

softbox was above the height of the photographer. The amount of fill light was reduced for this image when we changed from a shiny metal to a matte white reflector and moved it farther away, allowing darker, more pronounced shadows to appear on the model's face. She had great natural cheekbones, so we used less makeup (and more shadow) to define them.

The photographer shot from about one foot lower than eye-level height, to emphasize the model's long neck. He was careful not to go so low as to look up her nose.

HEAD SHOTS

Though not beauty photography per se, head shots bear mentioning here. In comparison to a beauty shot, a head shot shows more shadows and contouring. It's not super-soft like beauty lighting, so you can see more of what the person looks like. (For male head shots, see pages 134–135.)

Likewise, head shots are not the same as traditional portraits. Family portraiture studios tend to put more emphasis on backgrounds, propping, posing, color, and dramatic lighting, as well as "gimmicks," such as fancy props like fireplaces, angel wings, or live rabbits.

A head shot should represent what a person really looks like. An actor or actress who submits a head shot to a talent executive working on a television show, film, or stage play may get an audition based on that photo. When the actor walks in for the audition or job, the person in charge of booking will want to see a person who looks very much like the photo.

The same is true of for businesspeople. If they've been "glamorized" so much through makeup, styling, and lighting that you wouldn't recognize them at a conference or job interview, then the pictures don't serve the intended purpose. With this in mind, the subject of a head shot is usually put in light makeup only, with matte foundation.

Head shots of actors, actresses, and businessmen and women are a great way to earn money on the side.

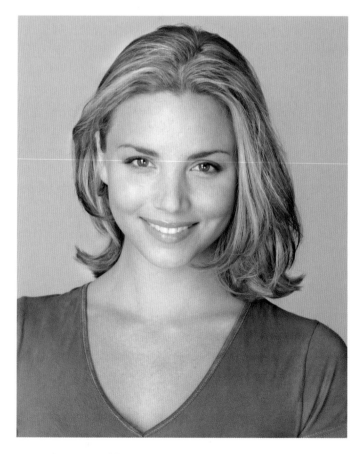

A V-neck T-shirt and loosely tossed hair give a younger, "collegiate" look.

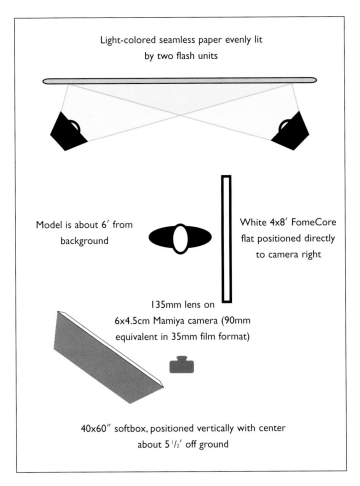

Light-colored seamless paper evenly lit
by two flash units

Model is about 6' from
background

White 4x8' FomeCore
flat positioned directly
to camera right

135mm lens on
6x4.5cm Mamiya camera (90mm
equivalent in 35mm film format)

40x60" softbox, positioned vertically with center
about 5 ½' off ground

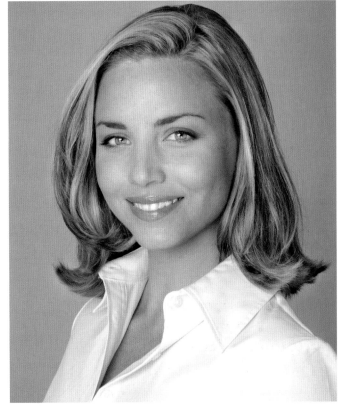

*A button-down shirt and confident smile give the subject the look
of a young professional woman.*

The lighting for these head shots was a 40x60-inch soft-box positioned vertically to the left of the camera. It was straight up and down and pointed straight at the model so that the lighting was even from top to bottom within the live picture area. Because it was placed to the side of the camera, there is a little contouring in terms of visible soft shadows. Fill light was provided by a 4x8-foot white FomeCore flat positioned to the right of the model.

Expressions are crucial in a head shot. You want a comfortable and pleasant look, without any of the tough or edgy expressions often found in glamour photography. If you're working with an inexperienced actor or businessperson, plan on coaxing the right expression from the subject through subtle direction. Also plan on shooting many more images than you would with an experienced actress who is conscious of her facial expressions and comfortable in front of the camera.

In the two versions shown here, the actress wanted different looks based on roles for which she might audition. In the version in which she is wearing the V-neck T-shirt, the goal was to call to mind a college student eighteen to twenty years old. Her hair was basically unstyled; the photographer asked her to just comb it back with her fingers.

In the second version, shown above, the goal was an older, more professional look—a young woman who has perhaps just entered the job market at twenty-two or twenty-three years old. To get this effect, she dressed in a button-down shirt and her hair was more styled.

The only other difference between the two images was the young woman's pose and her distance from the fill light. Because she is looking into the light in the image above, there were fewer shadows on her face, so less fill was needed. The 4x8-foot FomeCore fill card was moved back from 12 inches to about 3 feet.

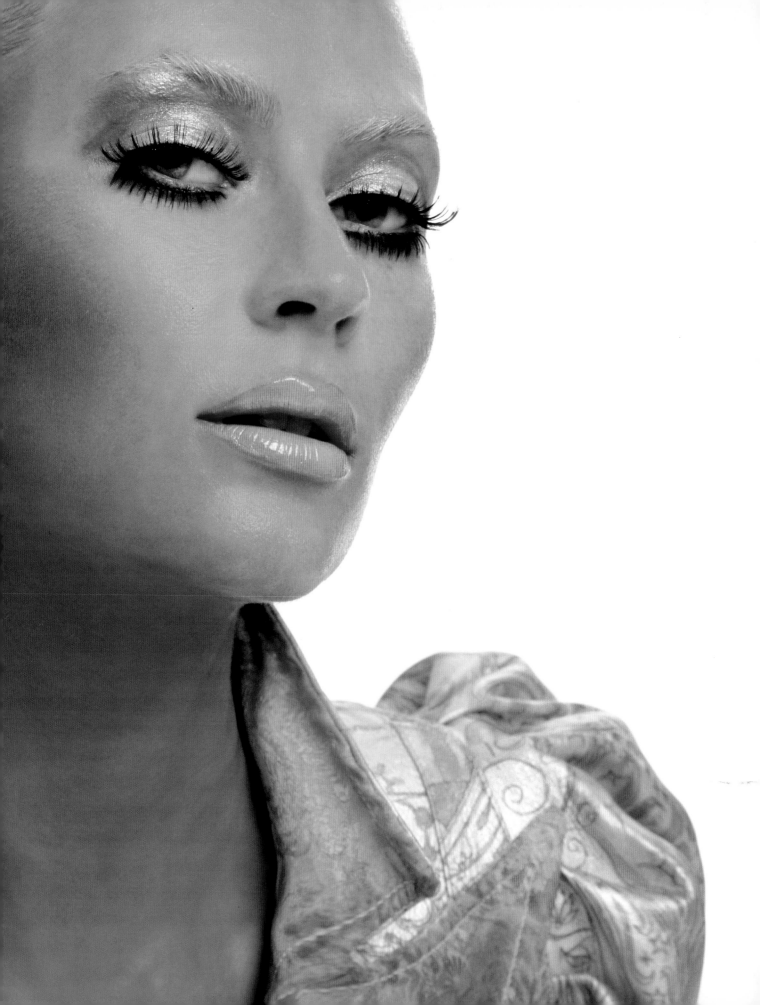

FASHION LIGHTING

Creating Photos That Convey a Style

THE EMPHASIS IN FASHION PHOTOGRAPHY is on trying to create an "image" or "feel" that sells the product. The models should look amazing, but more important, they must make the clothing look great. With beauty images, it's primarily about making the model look stunning, but for fashion the photographer must often make compromises between the clothing and the pose.

THE FASHION SPECIALTY

When compared to beauty photography (see chapter 2), the photographer doing a fashion shoot has a lot more leeway in terms of posing. Fashion poses are selected to allow for the drape and flow of the fabric. For example, an arms-above-the-head pose might show off a stretch lace shirt at its best (see page 79), but it would ruin the silhouette of a suit (see page 111).

In fashion lighting there is a lot more leeway in what is "acceptable," so some photographers get more whimsical or extreme with their lighting. Be forewarned! The more you deviate from the "norm," the more technically skilled you must be in your lighting to end up with a successful photograph.

This specialty is also more prone to changing trends than beauty lighting. For example, today it is not unusual to see a

Compared with straight beauty photography, fashion photographs can have more contrast between highlight and shadow, such as seen in the strong contours of the face. This image was made with about a 1.0 EV (one-stop) difference between the main and the fill lights.

For fashion shoots, the photographer has more options for lighting and poses than with beauty photography.

1.0 to 1.5 EV difference between shadow and highlight, whereas for beauty lighting photographers will usually strive for minimal contrast (with often just a 0.5 EV difference between the main and fill lights).

Art directors jokingly call a fashion shoot a "three-ring circus," because of the number of people who typically are present on the set. It's not a bad analogy: The photographer is the ring master who must keep an eye not just on the model, but also on the hair and makeup artists, the manicurist, the clothing stylists, the photo assistants, the set designers, the art director, the client, and more.

It is your job to interview the client and stylist and find out what is important about the fashion article that is the focus of the shoot. That will determine what you need to emphasize through your use of lighting, poses, makeup, and props. You will need to communicate these ideas to the model, the makeup artist, and the hair stylist.

You also have to make sure that everyone is doing their job. Is the stylist looking at the model from the precise camera angle that will be used, to make sure the dress is draping well? If the stylist is off to the side of the set, he'll see something different than the photographer sees. Does the model's makeup bring out the subtle tones in the fabric's pattern?

As the photographer, it is your job to communicate and enforce the goals of the shoot. You are ultimately responsible for the final image, so you must successfully manage the other people on the set.

FLEXIBLE FASHION LIGHTING

The most flexible fashion lighting allows the model to try different poses without the need for the photographer to readjust the light with every movement. However, the lighting should not be bland or flat. Flexible lighting still needs to have some modeling, to show off the contours of the outfit or garment.

The images on pages 60–65 were part of a fashion shoot for Michael & Hushi that showcased their upscale and extreme summertime version of haute couture.

The position of a flash that is pointed at a flat has a profound effect on the resultant lighting.

The basic set began with a Super White seamless swept out into the studio. We then placed a large piece of opaque white Plexiglas over the seamless on the floor. The shiny Plexiglas worked like a mirror to reflect the background paper, creating a much whiter floor than paper alone. (White seamless on the floor tends to turn gray because of light falloff from high-angle lights.)

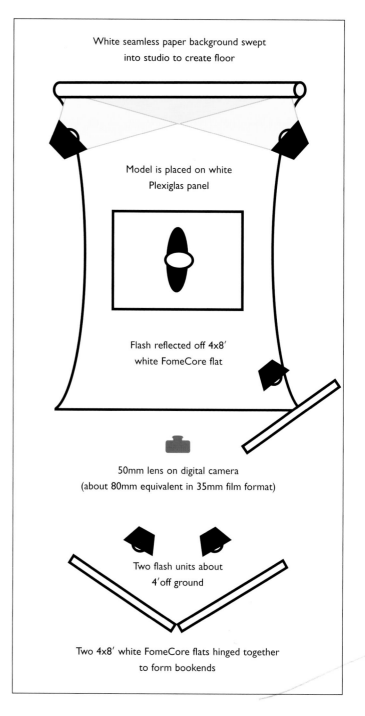

White seamless paper background swept into studio to create floor

Model is placed on white Plexiglas panel

Flash reflected off 4x8′ white FomeCore flat

50mm lens on digital camera (about 80mm equivalent in 35mm film format)

Two flash units about 4′ off ground

Two 4x8′ white FomeCore flats hinged together to form bookends

Plexiglas underneath the model reflects the background for a super-white floor. The earrings are taped in place to remain symmetrical. A sitting pose allowed the long fabric sleeve to drape around the model's hand without obscuring it.

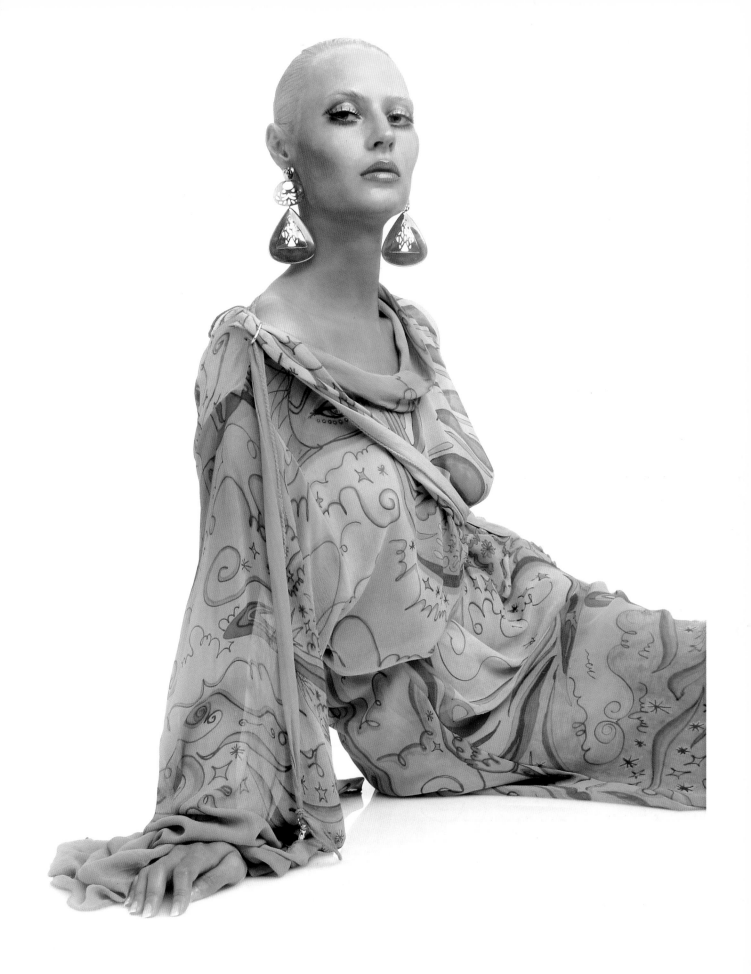

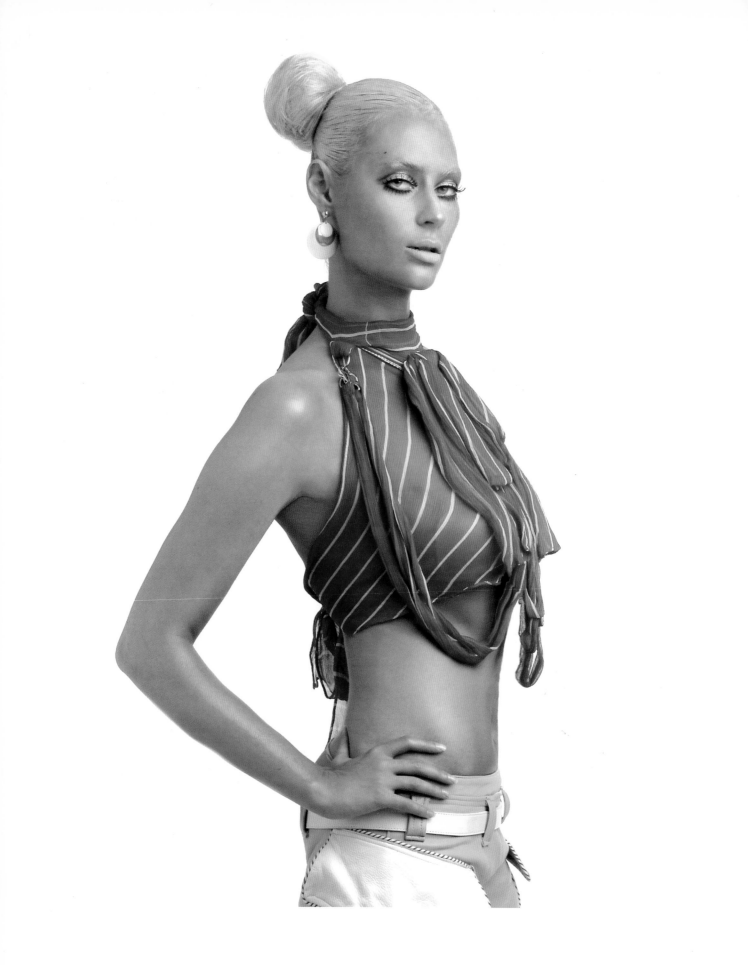

In the old days, the Plexiglas was actually propped up above the floor (like a stage for the model), with a flash unit beneath it to add a "kick" of light from below. Today you can get this extra brightness from beneath in a quick alteration with photo-editing software like Adobe Photoshop; the extra work of raising the Plexiglas is no longer necessary.

We created the fill lighting from two pieces of 4x8-foot FomeCore hinged together to create a bookend, and then propped open these flats into a very wide V-shape. We bounced two flash units into them to create a fairly flat front light.

The background was lit by two flash units at 45-degree angles to the seamless paper. We adjusted their positions until the light metered evenly across the visible background. The exposure for the background (read with an incident-light meter pointed at the camera) was set for +0.5 EV above the main light, which insured that it recorded as white on the film.

The main light came from a third 4x8 FomeCore flat that was positioned to either the left or the right. A flash was pointed at the flat to provide fill light.

The direction a flash is pointed and its distance from the model have a profound effect on the look of the fill light. If the flash is placed close to the flat, it lights only a small circle on the flat, making the light more of a hard-edged spotlight. But if the flash is pulled back, the circle of light spreads out on the flat, making it a much softer, more open light. Higher or lower positioning on the flat changes the angle of the flash in relationship to the model.

The position of the flash on the flat and the change from camera right to camera left are the only variations in the lighting in the four end-result images in this section (pages 60–65).

For the image on page 63, the flat was placed on the right side, with the flash reflected off it from a distance to create a softer effect.

Accessorizing this shot well was critical. Large, bold metallic earrings added to the glamorous look. Earrings usually would be allowed to hang naturally in a fashion shoot, but because the photographer wanted a symmetrical look, the earrings were carefully held in place with skin tape.

The overall goal for the outfit, however, was not symmetry but rather a free, flowing look. The design of this outfit was such that the sleeve would hang longer than the hand. While this looked wonderful on the live, moving model, the hidden hand did not communicate well on film. We solved this problem by having the model sit on the floor, propped up

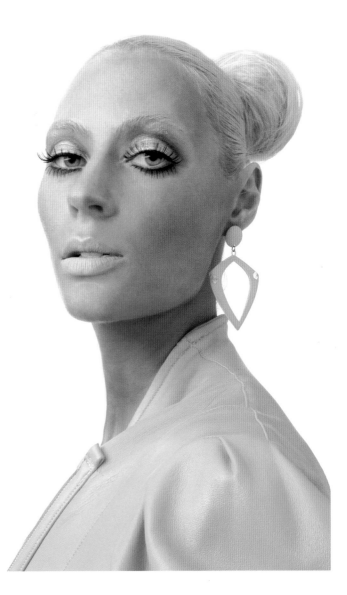

Body makeup (sometimes called body paint) gave the pale model a Palm Beach tan.

The model arrived at the studio without makeup ("clean-faced") and with her hair clean but unstyled.

Large fake eyelashes and black eyeliner added to the fantasy look.

Shimmering cheekbone highlights played off the glittering eye shadow.

Glittery eye shadow gave the model a wild "nightclub" look.

Makeup artist Cyrus used lip liner to help define the lip line and emphasize symmetry.

by her arms, with the fabric carefully placed to cascade around her hand.

The fabric had a busy design, so it was critical that the lighting not have too much contrast. The white background worked well because it did not compete with the colors of the fabric. Bolder bright-pink lipstick was chosen to make sure the face was not overwhelmed by the outfit.

We used the same model for all four of the Michael & Hushi images shown here (pages 60–65). We chose her because she could provide the "resort wear" look the client wanted. Although she was very pale (as most models are), she was given a dark Palm Beach tan through full-body makeup applied to all skin visible to the camera. The pictures at the upper left on page 66 show the model as she looked when she arrived, clean-faced—that is, without any makeup or hair styling.

The model's brown hair was dyed platinum blond and tied back into a fantasy bun. This hair styling gave an added dimension to the fun, extreme outfits.

Blue eye shadow complemented the floral outfit (page 63) and sharply contrasted with the bolder red outfit (page 64). The eye makeup was crowned with large fake eyelashes and severe golden eyebrow lines. The main makeup adjustment was the paling of the lips for the red outfit and the yellow outfit.

Finally, the hair was pulled up into a graphic circular bun and held in place with a myriad of pins and hairspray.

SIMPLE CATALOG LIGHTING

A common and very simple way to shoot catalog photographs in a small studio is to use a large softbox as the background and front-light the model with a hard light source. This lighting setup gives the outline of the model a clean edge and provides great flexibility in poses.

If you are shooting three-quarter-length shots, you can use a 40x60-inch (or larger) softbox and position the model just in front of it. For full-length images, you'll need to use a larger softbox. If you don't have one but do have a large studio, you can substitute a white seamless backdrop illuminated by two flash units at 45-degree angles to the paper.

The front light should be about 2 feet above the camera and pointed at the model. The flash is fitted with a 40-degree grid attachment. Adjust the height of the light so that there is a shadow under the model's chin (but not so high that the nose shadow cuts into the lip). The shadow under the chin gives the model three-dimensionality and shows off the drapes and wrinkles of the outfit. Unlike with beauty images, no fill is necessary, especially if you have a studio with white walls that bounces back some of the light from the softbox and the gridded spot.

A 40x60-inch softbox is just big enough for three-quarter-length fashion catalog shots. If you need full-body shots you may need to use white seamless paper.

A softbox is an excellent background for fashion catalog work.

It is important that the model be made up with extremely matte makeup because the hard light will make any shine on the skin very prominent. Have some translucent matte powder on hand so that several times during a long shoot you can reapply the matte finish on the T-zone (the horizontal area across the forehead and the vertical area down the nose to the chin).

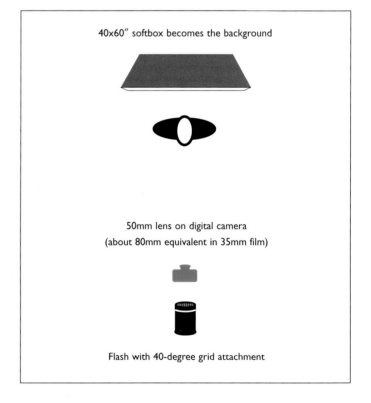

40x60" softbox becomes the background

50mm lens on digital camera
(about 80mm equivalent in 35mm film)

Flash with 40-degree grid attachment

This lighting creates a clean silhouette, with crisp shadows that show how the clothes wrinkle or drape on the body.

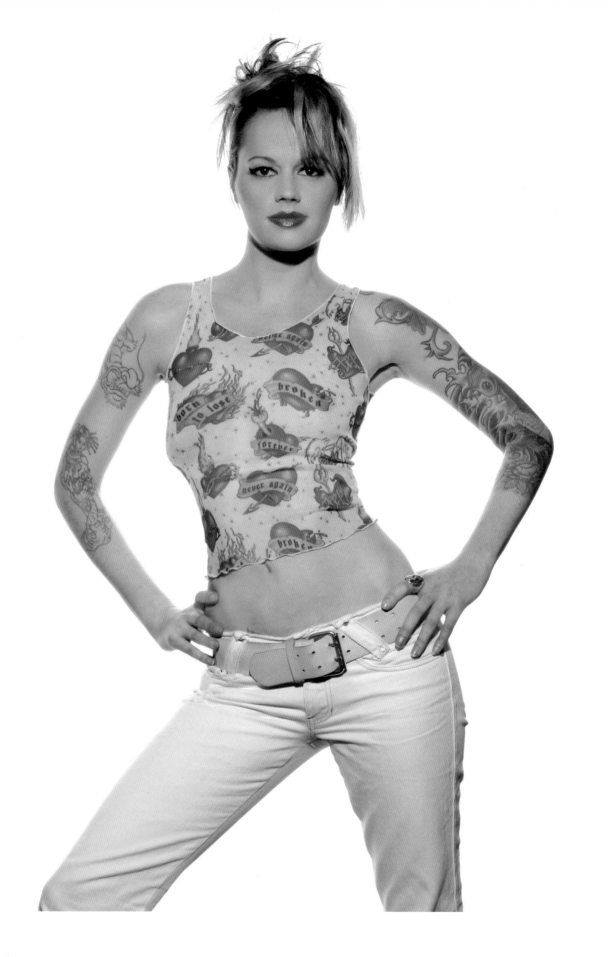

SOFTBOX BACKGROUND VARIATIONS

Flare can be a great creative tool, but it is tricky to control.

The images on this page and the next were photographed in a similar manner to the one on page 69, with a large softbox as the background. However, instead of a hard light in front, we used a flash bounced into an umbrella as a front light.

The front light was set to about −0.5 EV to −1.0 EV under normal exposure. The backlight was set to +2.0 EV. This overexposure, combined with the model's closeness to the softbox, caused the light to flare into the body. Compare this to the photos on pages 42, 69, and 114–115, which all use a softbox as a background.

When working with flare, you can sometimes get unexpected results. Even a Polaroid proof will look different than a final film image. So expect to do post-shooting work with photo-editing software. This image underwent considerable manipulation in Adobe Photoshop following the shoot. Because of the intended flare, the model's makeup was applied darker than usual, in order to hold its color despite the reduced contrast caused by the flare.

After viewing the image, the photographer did a variation (see opposite) in Adobe Photoshop in which he gave it a warmer, more monochromatic overall tone. The overall contrast of the image was reduced. Selectively, the highlights on the side of the model's face were toned down with the burning tool. The color balance of the image was also modified. For an overall warmer feeling, the photographer created a sepia wash by adding a new layer of sepia color over the entire image and then scaling back to an opacity of 17%.

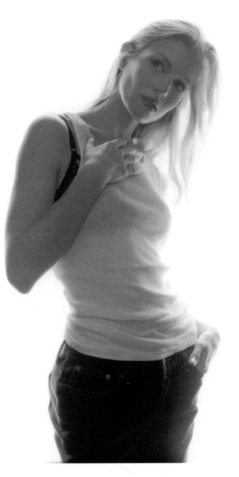

This is the image as it originally looked on film, before it was scanned and doctored with Adobe Photoshop.

Try experimenting with different ratios of foreground to background exposure.

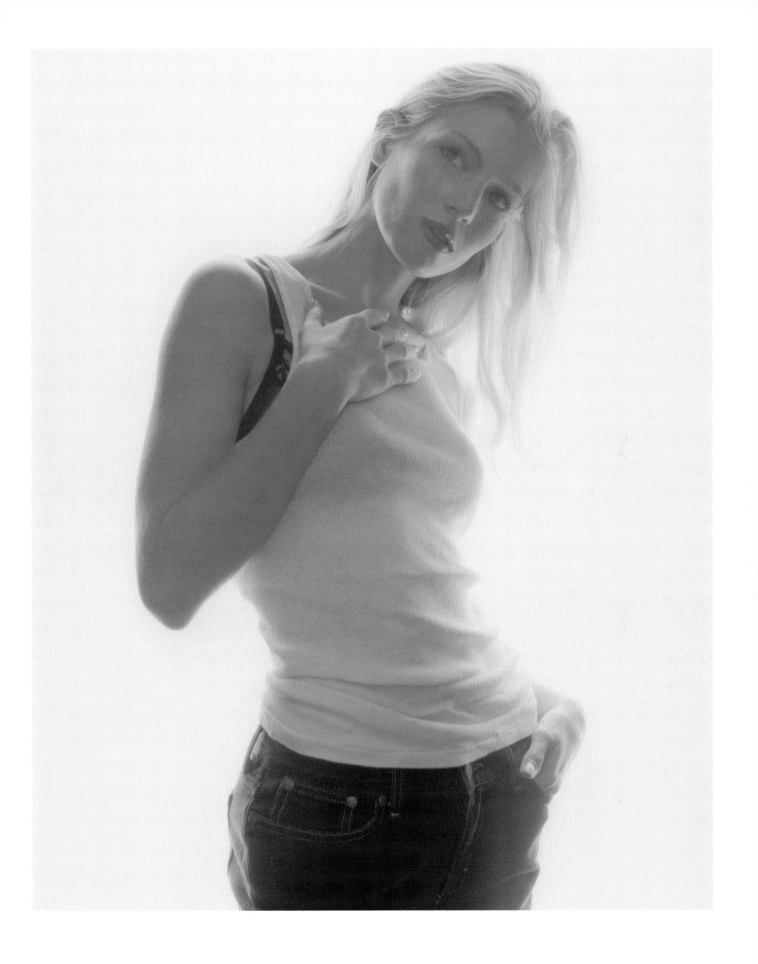

GLAMORIZING A SCARF

When your fashion subject is a $700 scarf, such as this one designed by Maria Pinto (Chicago), you have a particularly difficult challenge. Simply shooting the scarf around the shoulders of a beautiful model will make it look matronly. Instead, you need to show off its upscale feel by creating a dynamic image. This was not your typical scarf, so we could not create the typical catalog photograph.

The photographer knew he needed to keep a fluid set, so the model could move her face and torso into different angles and still look good under the lights. He started with two large, hinged flats, open to the point that they were almost parallel and lit by two flash heads. In front of them was a large softbox. The main light was the softbox, with fill from the flats at −0.5 EV underexposure.

The mottled silver-blue background was created by a set designer. It was a large piece of plasterboard that had been painted with semi-reflective silver paint and then glazed with a hint of blue. The highlights and shadows resulted when the main and the fill lights hit the uneven surfaces.

A powerful wind machine was pointed straight at the model. A wind machine is very uncomfortable for the model and will quickly irritate her eyes, especially if the model wears contacts. Even applying eyedrops (carefully, so as not to damage the makeup) provides relief for only 30 seconds or so. The photographer was aware of this and had the model keep her eyes closed until the moment of exposure. This made it easier for the model to endure the long shooting session and maintain a pleasant gaze without squinting.

Assistants on either side held the scarf a few inches from the model. The wind then swept it against her face, creating an interesting pattern. The assistants stretched the bottom of the scarf tighter to keep the grid pattern symmetrical, while allowing the top to drape and twist into dynamic forms.

Shallow depth of field was an important aspect of the image, so the photographer selected a wide aperture to throw all but the eyes out of focus.

We carefully chose the lipstick to match the dress, and the model's red hair went well with the color theme. Jet-black eye makeup echoed the black lines of the scarf.

This image was a classic example of bringing together composition, graphics, posing, makeup, and props to create an exciting fashion image of a simple product.

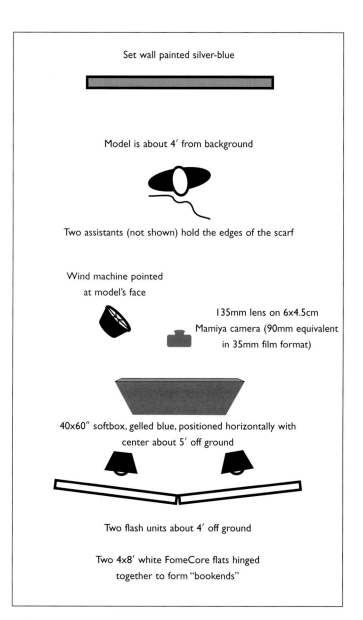

Assistants held the scarf a few inches from the model; another assistant turned on a wind machine that blew the fabric into her face.

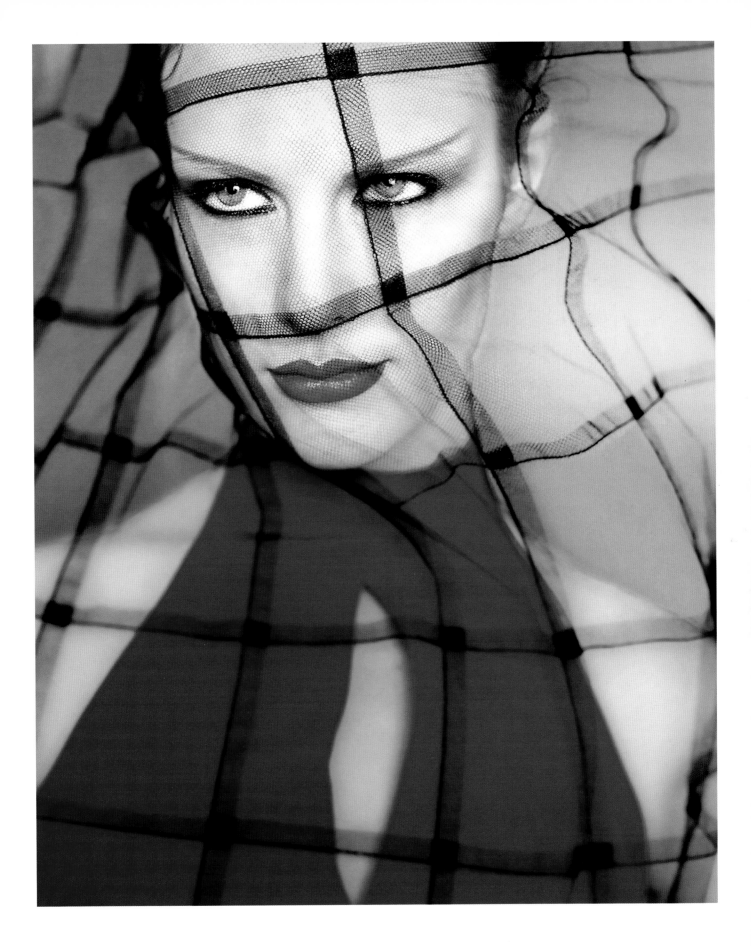

PLAYING WITH SHADOWS

The goal in the images shown on this and the next page was to elegantly use shadows, to create an updated version of the way shadows were often used in *Vogue* magazine in the 1950s. The image on this page was lit with a small softbox (30x40 inches) positioned to the lower right that created an upward shadow on the Thunder Gray seamless paper.

The camera was positioned at a 45-degree angle to the seamless background, causing the shadow from the bottom of the softbox to appear on a diagonal instead of straight across.

We wanted to complement the diagonal lines of the dress with a diagonal shadow in the opposite direction. We spent a great deal of time posing the model, and despite the simple lighting, the shoot went very slowly. Big broad gestures would have made the photo look like a cartoon, so we chose subtle poses that emphasized the hour-glass shape of the dress.

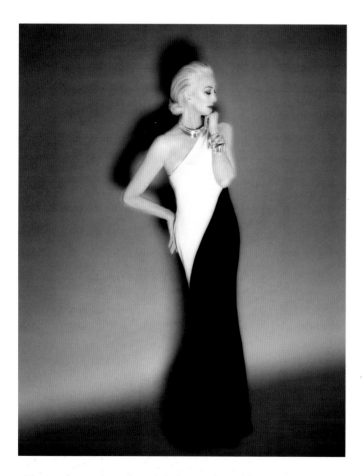

A low softbox casts an upward shadow on the model.

The posing options were limited by the need to have the model's face directed toward the light. By pointing her chin down toward the light (sometimes called "playing to the light"), we avoided shadows on her face. For the same reason, her entire body is also turned slightly toward the softbox.

For the variation in the red dress on page 75, the light was moved higher and closer, causing the shadow to become considerably larger. However, as the dark shadow became quite large, it began to overpower the image. For this reason, we added strong fill light to lighten the shadow.

First we tried using a white card to fill the shadow, but this did not produce a strong enough result. Adding a second softbox behind the camera and powering it to −1.0 EV below the main exposure opened up the shadows for a more balanced composition.

Another variation of this lighting, seen on page vi (opposite the Contents page), was created by pulling the softbox to a more centered position, which cast the shadow straight up behind the model. We used no fill in this case, and the shadow was allowed to go black.

The model was asked to "play to the light" by leaning a little forward in the direction of the softbox to keep hard shadows off her face. Low-angle light can cast an unpleasant shadow on a model with a large nose, and in fact we chose this model partly because of her small nose. She was posed with one knee crossed over in front of the other to suggest much more of an hour-glass figure than she actually had.

The photographer later used Adobe Photoshop to add a more animated quality to the final image. He used the freehand lasso tool to outline the center portion (from forehead to knees) and then selected the inverse of this section with 60-pixel edge feathering. Finally, he applied the Zoom Radial Blur controls on this outer portion. This gave a more sophisticated look than just an overall application of the Zoom Radial Blur filter; it also broke up the hard lines and gave the image a sexy softness.

When the shadow was made larger it became too dominant. Fill light was added to open it up for a more balanced composition.

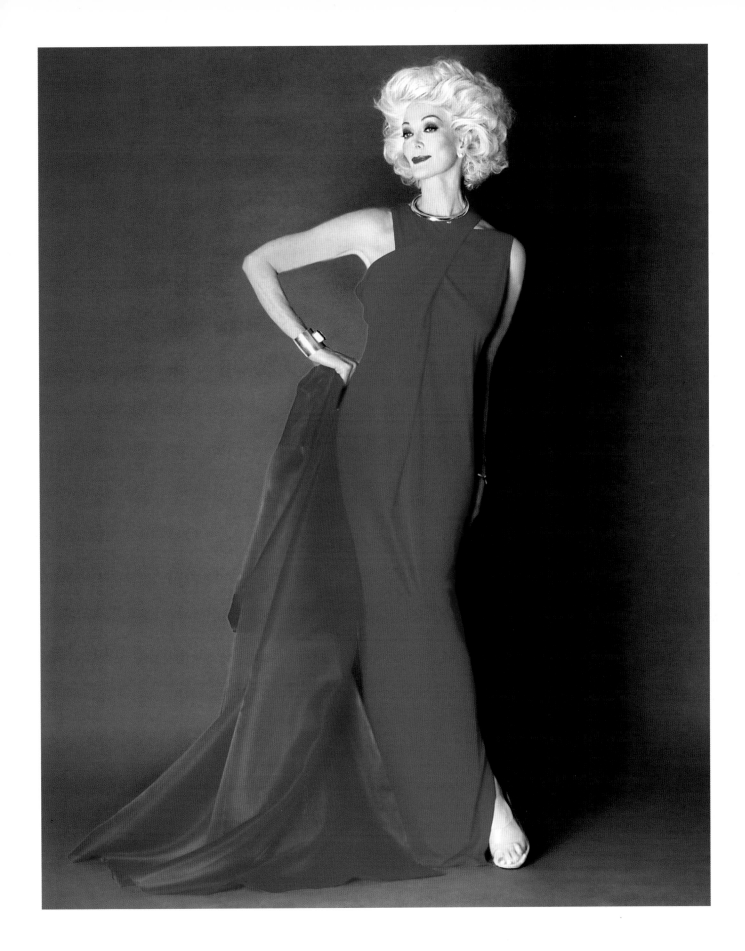

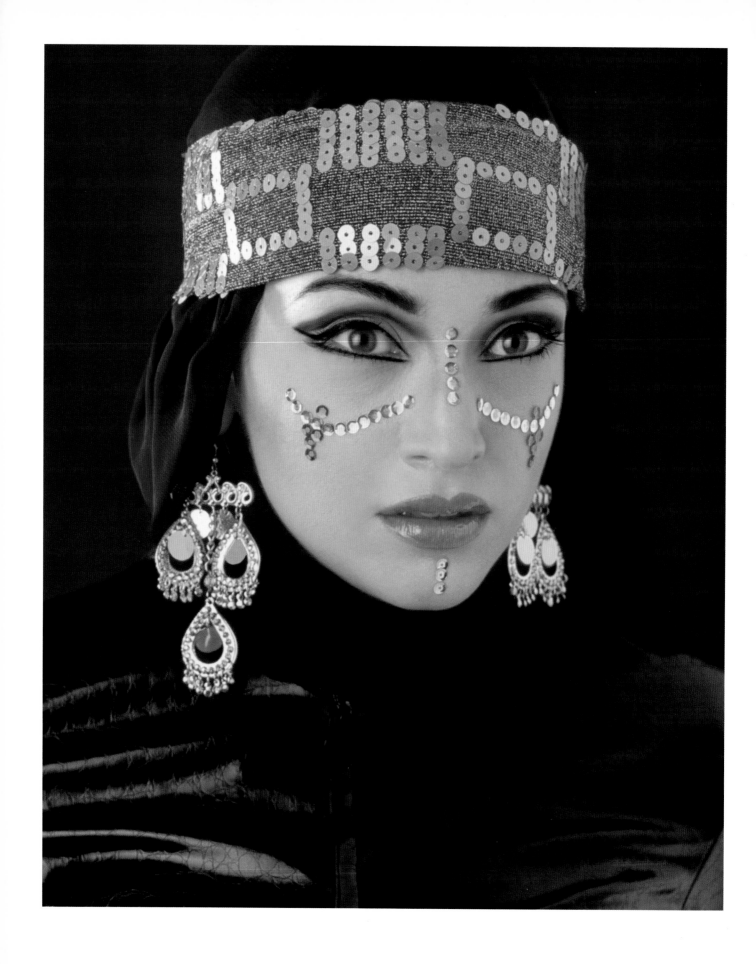

MANAGING DIFFERENT SURFACES

We needed careful lighting for a Persian-influenced fashion shoot because it combined highly reflective jewelry with a black outfit. Sloppy lighting on this type of subject will often result in burned-out highlights on the metallic jewelry and black fabrics that look featureless.

We placed a 40x60-inch softbox to the left of the camera at eye level. (The reflection of this box can clearly be seen in the model's eyes.) A large 4x8-foot FomeCore reflector placed to camera right almost touches her shoulder, just out of camera view. The reflector kicked the light from the softbox back at the model, but at about −1.0 to −2.0 EV less exposure. The effects of the two lights can be seen when you compare the right and left shoulders of the black jacket.

To add a little dimension and sparkle to the whole photo, the photographer used a flash unit reflected into an umbrella as a sidelight. This gave highlights to the model's right earring (camera left) and created a highlight on her temple. It also gave texture to the headwrap. We moved the flash as close to the inside of the umbrella as possible (about 8 inches from the fabric) to create a harder light than is normally associated with reflected umbrellas. This added some brightness and dimensionality to the face, while keeping the lighting on the shiny black outfit as flat as possible (using only the softbox and the reflector).

In this case, we chose the model not just for her obvious beauty, but for her extremely patient temperament. The makeup session was quite long and tedious; the model even had to endure having gold sequins and red rhinestones secured to her face with eyelash glue.

When jewelry or difficult fabrics (such as this shiny black jacket) are involved, the posing and lighting take considerably more time. Some models (even top-tier models) simply don't have a temperament that allows them to sit still—*absolutely still*—for long periods of time. Changes in poses on this type of shoot can be very subtle, sometimes measured in as little as 1/4-inch increments. Therefore, the model needs to be extremely conscious of her movements. A good metaphor is to compare the gestures a theater actor needs (large and blatant for a distant audience) compared to a film actor (small and subtle for the up-close camera lens).

The photographer later made some selective color changes in Adobe Photoshop. He gave the black jacket a slight blue tint (5 to 6 points) to create a hot/cold juxtaposition between it and the warm-colored jewelry.

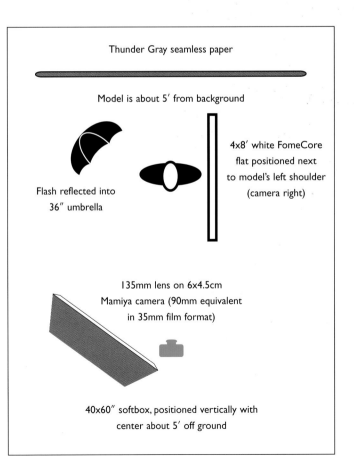

Thunder Gray seamless paper

Model is about 5′ from background

4x8′ white FomeCore flat positioned next to model's left shoulder (camera right)

Flash reflected into 36″ umbrella

135mm lens on 6x4.5cm Mamiya camera (90mm equivalent in 35mm film format)

40x60″ softbox, positioned vertically with center about 5′ off ground

Soft light successfully illuminates the shiny black fabric, while a hard light adds drama to the face and jewelry.

WARM & COOL COMBINATION

A lace top with feather cuffs can be seen as a fantasy outfit, so the photographer decided to use unusual lighting. The look began with fantastic makeup, complete with gold glitter on the eyes and lips. Strong makeup lines on the eyes were designed to mimic the lines of the lace top.

The concept of the outfit was feathers and lace—which are opposites in terms of texture and patterns. For this reason the photographer decided to create contrasts in lighting as well. The subject was washed with blue (cool) fill light, while a yellow (warm) main light balanced it. The red (warm) tones in the makeup also emphasized this contrast.

The background was Thunder Gray seamless paper. The model was positioned close to it, approximately 3 feet away. We positioned a 40x60-inch softbox, gelled blue, just above and behind the photographer. It illuminated the front of her body and cast a shadow to her left on the nearby seamless paper. Because the softbox was fairly close to the photographer, the light fell off quickly, so the model's waist is darker than her upper body.

The main light was an incandescent (quartz-halogen) spotlight gelled orange-red, positioned to the camera's lower right. A homemade Cinefoil snoot directs the light onto the model's face and prevents the light from hitting the rest of her body or the background. The blue light was set at about –1.5 EV less than the spot. The spotlight made the glitter on both the eyes and the lips dazzle with highlights—something the more diffuse light from the softbox couldn't do.

The blue and orange lights combine to create a fairly neutral light on the model's face. (Small variations in color cast on the face were later corrected in Adobe Photoshop.) However, the parts of the image not lit by the orange spot went very blue. And an orange rimming can be seen in the parts not lit by the blue softbox.

The model and the photographer played with a lot of different poses before the final image was taken. Fashion photography often requires exaggerated poses to bring out the right feeling for the outfit.

When shooting an extreme outfit against a simple background, you often have to push the model beyond the standard "stock" poses.

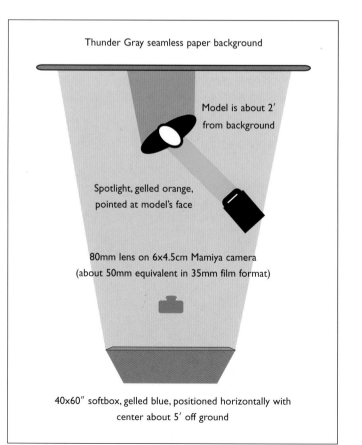

Thunder Gray seamless paper background

Model is about 2′ from background

Spotlight, gelled orange, pointed at model's face

80mm lens on 6x4.5cm Mamiya camera (about 50mm equivalent in 35mm film format)

40x60″ softbox, gelled blue, positioned horizontally with center about 5′ off ground

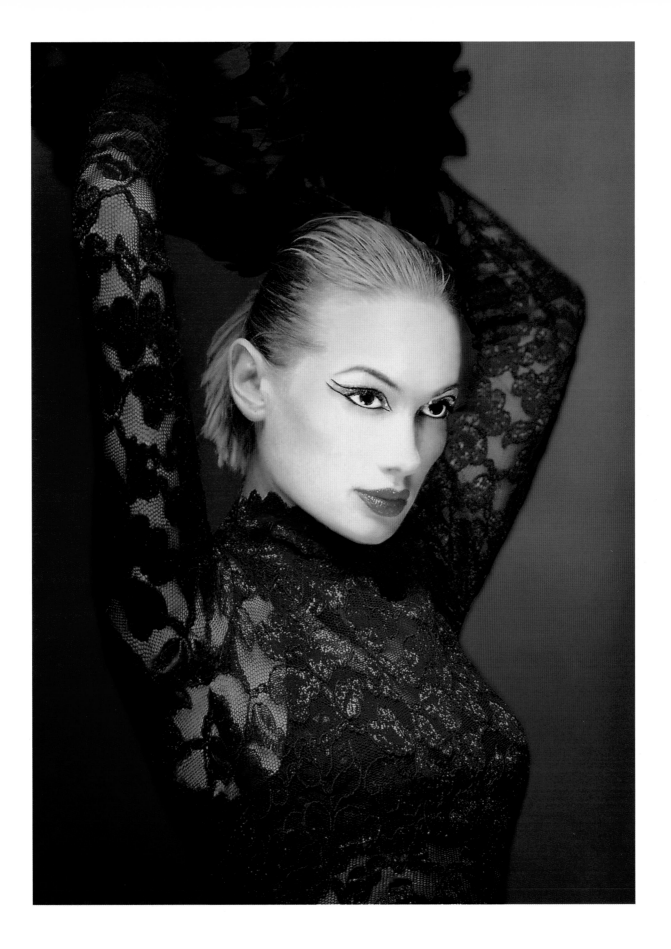

After shooting the feather outfit, the photographer and the makeup artist decided to create a more beauty-like image of the model's face. This second image, shown at left, was all about the face and makeup. The same lighting was used, except that the power of the softbox and the spot were made more equal. Instead of the spot being +1.5 EV brighter (as in the first image), it was changed to less than 1/2-stop (+0.5 EV) brighter. This created a highlight-to-shadow ratio that was closer to what is used in traditional beauty photography (see chapter 2).

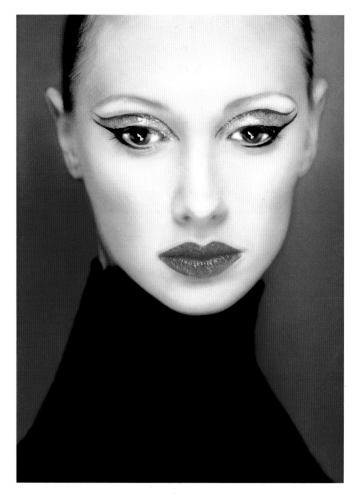

Warm and cool lights combine to create a neutral face with blue and orange shadows. A long exposure caused a slight blur of the yellow spotlight (as seen in the highlight in the eye), while the flash portion of the image (the blue softbox fill) recorded sharply.

> *To create a "beauty" version of the makeup, we strengthened the fill light to within 0.5 EV (1/2-stop) of the main light.*

A close look at the model's eyes reveals a blurred highlight. The photographer noticed a slight blur at 1/60-second, caused by hand-holding the camera during a long incandescent exposure (with light from the spotlight). He decided to emphasize this wiggle and create a slight ghosting of the image by selecting an even slower shutter speed. The final image was shot hand-held at 1/15-second. The softbox flash portion (which occurs instantaneously) was sharp, while the spot-lit portions (non-flash) were slightly blurred.

The photographer felt the lace turtleneck was too distracting. Instead of switching blouses and taking the risk of marring the makeup, he chose to later "blacken it out" with Adobe Photoshop to create a solid neckline.

DIFFICULT FABRICS

When you are presented with a difficult fabric for a fashion shoot, you'll usually have to plan the entire lighting setup around it. Velvets "eat" light and can come across on the film as a featureless block of color. Shiny fabrics can take on harsh, unwanted highlights. Especially light or dark fabrics tend to appear as a block of color and hide the shape of the outfit.

In the example shown here, the outfit was made up of a felt hat and a black dress with different textures. The model stood in front of a Thunder Gray background at a distance of about 6 feet. We put a flash unit with a default reflector on a 10-foot light stand and pointed it at the model from a high position about 2 feet to the left of the camera.

The model held her head a bit high and pointed toward the light to reduce the length of the shadows it created. We asked her to strike a stoic, mannequin-like pose. To avoid squinting under the very bright single light source, she kept her eyes closed until the moment of exposure.

Her very bold makeup—designed to create heavy eyebrows and very red lips—was necessary to help balance the dark, chunky outfit. The hard light brought out a slight shine on the top of the hat, as well as a stripe of texture in the coat.

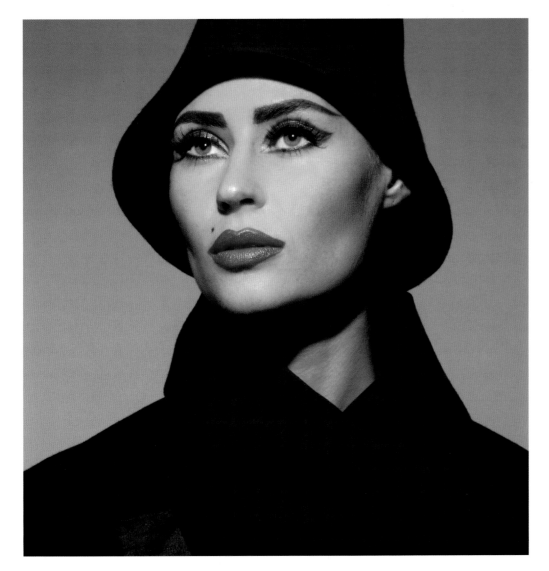

We needed to use a hard light to create a shine on the felt hat and the banner on the coat. These highlights kept the outfit from becoming a single block of black color.

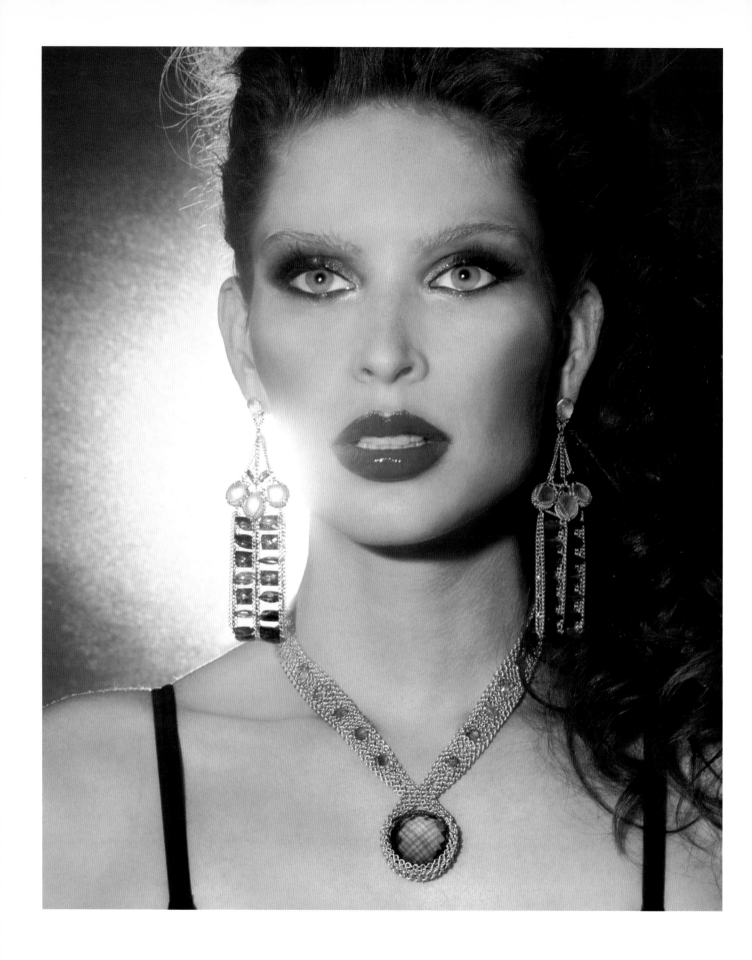

In fashion photography, marketing considerations drive the selection of the model and decisions on makeup and styling. This jewelry image is a classic example of knowing your market. The photographer took the time to discuss the targeted demographic with the designer. The earrings and necklaces shown here were not aimed at the *Town & Country* market, but more for the younger, trendier Louis Vuitton buyer. Both are affluent markets, but the styles are very different.

The unusual construction of the earrings in the image at the left was designed for the younger, hipper Louis Vuitton type of market. The gold and gems in this large, bold design did not fall into the more subdued image typically desired by the "country club" market.

When the fashion product is jewelry, the lighting becomes even more crucial.

We chose a fashionable model with extreme, funky hair and posed her in a simple, plum-colored bra in front of a very large mirror. The entire image was lit with one spotlight that was positioned to shine over the photographer's left shoulder.

An unusual aspect of the set design is that the seamless "backdrop" was actually placed behind the light, so it was reflected in the mirror (the actual backdrop). The mirror shows the seamless paper and the light, but the model blocks the reflection of the photographer.

When we first set up the lighting, the flare in the mirror from the spotlight was too harsh and intense. To tone it down, we needed to interfere with the reflectivity of the mirror. We

Backlighting brings dazzle to gems and glass jewelry. Compare the earring at camera left to the one at camera right, where the model's hair blocks the light.

did this with a very light coat of matte dulling spray. (In a pinch, aerosol hair spray can also work.)

Because of the harsh lighting from the spotlight, we made the model's makeup extremely matte, and she was heavily powdered. The makeup was applied to all visible skin. The hair stylist worked to make the hair look slick but not too perfect, allowing a few "fly-aways" to be rim-lit by the reflected spot.

The primary earring (camera left) has both front spot lighting to make the gold dazzle and backlighting (from the reflection) to bring out the color of the gem. Compare this to the earring at camera right, which has no backlighting (because the dark hair blocks it). The necklace is partway between the two, because the model's light skin allows some of the main light to reflect back through the necklace.

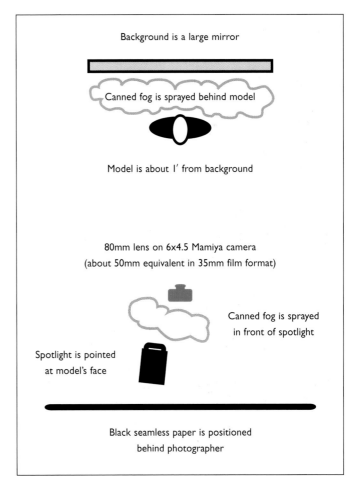

Background is a large mirror

Canned fog is sprayed behind model

Model is about 1' from background

80mm lens on 6x4.5 Mamiya camera
(about 50mm equivalent in 35mm film format)

Canned fog is sprayed
in front of spotlight

Spotlight is pointed
at model's face

Black seamless paper is positioned
behind photographer

EXAGGERATED SET

The goal of this image was an exaggerated sense of perspective to complement the dramatic fit and flare of the designer dress. The first exaggeration was easy—simply switch to an 80mm lens on a 6x4.5cm format camera (approximately 50mm in 35mm film format), for a much wider view of the subject than is normally used.

A professional set designer created two 8x8-foot drywall walls. He found silver paint with a semi-reflective sheen and then added steel-blue pigment. He was intentionally rough in applying it, to create some irregularity in the tones. (This is the same background used on the picture on page 73.)

The two walls were then placed together to create a "corner." However, instead of positioning them at a right angle, the

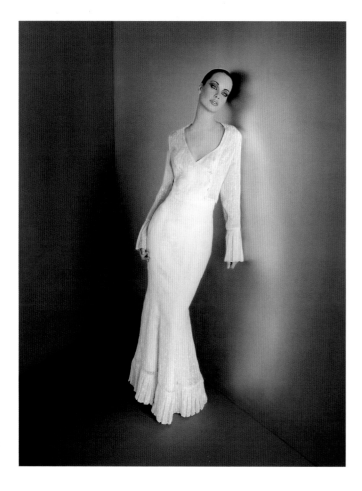

designer angled them inward to about 70 degrees. This created an off-kilter, Alice-in-Wonderland feel to the "room."

The main light was a 40x60-inch softbox placed about 5 feet off the ground and centered behind the photographer. Fill light was added from the left in the form of an umbrella positioned about 4 feet off the ground and 8 feet from the model, with the flash reflected into it.

This photograph was carefully preplanned. The 8-foot set walls had to be made and painted in advance. And until the model was actually in the dress and on the set, the nuances that make this picture successful couldn't be finalized. For example, the angle of the wall (60, 70, or 80 degrees) changed the feeling of the shot, so we experimented with it until it looked right.

Likewise, the model was originally placed in the corner of the set, but this produced a white reflection on either side of her that looked like a big white blob engulfing her. Moving her forward and against one wall placed the reflection on only one side. To increase the exaggerated feel, the photographer shot from a height of about 6 feet, while standing on an apple crate. This higher-than-normal vantage point added to the exaggerated feel of the "room."

The model turned her body slightly upward so she was playing toward the camera and the light. This pose was somewhat awkward for the model, but it kept her face in the light and prevented long shadows. It also reduced the distortion on her face caused by the high shooting angle and the wide-angle lens.

After the shoot, the photographer used Adobe Photoshop to alter the floor (which was gray) to more closely match the wall color.

An exaggerated set and perspective distortion combined to produce a slightly off-kilter feel to the photograph, which emphasizes the strong shape of the dress.

WHITE ON WHITE

Shooting a white or a light outfit against a white or a light background is one of the most difficult challenges for the fashion photographer. The trick is to make all the whites look clean and bright, without blowing out the details. You must also be alert to create separation between the model and the background.

The set for the image shown here began with a white seamless swept out into the studio. Two 4x8-foot black FomeCore flats were positioned with autopoles to create a hallway-like setting.

A snooted hard light was positioned about a foot above the camera and centered on the model's face. The snoot caused the light to fall off to about one stop darker at the edges.

Originally, the photographer had used a softbox in this position, but it was too flat, causing the shiny satin material of the dress to look formless. The hard light of the spotlight brought out the sheen on the material, delivering both highlights and shadows that showed off more of the contours of the outfit. This contouring also helped to separate the model from the background.

The background was lit by two flash units at 45-degree angles to the backdrop, positioned to create even lighting across the seamless backdrop. The flash units were set to a power that delivered about a half stop higher exposure (+0.5 EV) than the main light. Anything brighter might have burned out the hair and the edge of the outfit.

The entire image was slightly underexposed to create a darker-than-normal subject, which also helped to separate the subject from the background.

Legendary model Carmen, who got her start in the 1940s as a model with *Vogue*, worked with the photographer to create elegant poses that would show off the outfit well. She was limited by the set, because the outer edges of the flats end just out of camera range, and they were not real, solid walls. In the final image, she is gingerly touching the "walls" with her fingers.

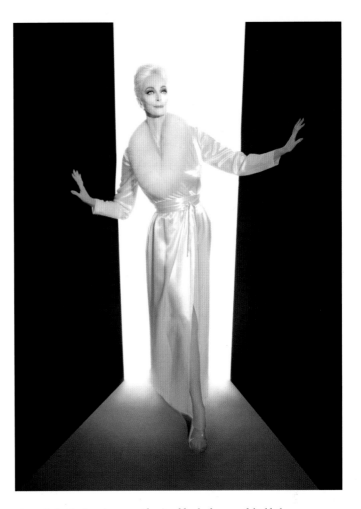

A spotlight (rather than a softbox) adds shadows and highlights to the satin material, helping to bring out its contours and form.

Shooting white on white is difficult because you have to keep the subject from blending in with the background.

PAYING HOMAGE

Often photographers want to recreate the feel of a bygone era; one way to do that is to copy the lighting style of the period. For the image shown here the goal was an Art Deco graphical feel, but nothing too literal. The designer and photographer wanted to pay homage to the era but still look contemporary so the dress would not look old-fashioned.

To create a light, bright set, white seamless paper was swept out into the studio. We quickly constructed columns by rolling 4x8-foot sheets of roof-flashing metal into 8-foot tubes, taping them closed, and then standing them upright. These tubes were then sprayed with photographic dulling spray to reduce the mirror-like reflectivity of the metal.

A flash unit with only a default reflector was suspended from a boom arm, placed high above and behind the model, and pointed at the seamless background, creating a hot spot behind her head and shoulders that gradually fell off darker to the sides.

A second light was placed 2 or 3 feet above the photographer, and a long handmade snoot was made for it out of Cinefoil. The Cinefoil was then formed into a downward-pointing triangle shape so that the light hit the model's head and torso but fell off toward the knees. The top of the triangle of light also hit the columns at the level of the model's head.

The white seamless paper and the white ceiling bounced considerable fill light around the set and created very open shadows. (A photograph made in a black studio would have looked considerably different.)

The photo was conceived and shot in black and white, because it was more important to emphasize the shapes and textures of the dress than the color (light purple).

We rolled metal roof-flashing material to make the columns for the set.

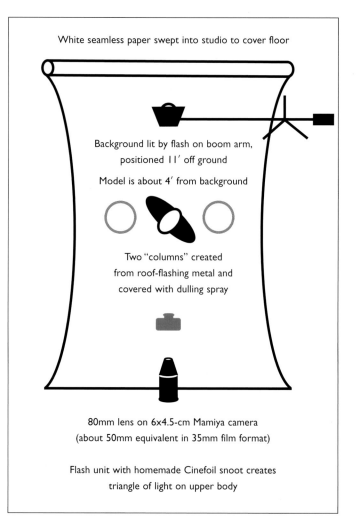

White seamless paper swept into studio to cover floor

Background lit by flash on boom arm, positioned 11′ off ground

Model is about 4′ from background

Two "columns" created from roof-flashing metal and covered with dulling spray

80mm lens on 6x4.5-cm Mamiya camera (about 50mm equivalent in 35mm film format)

Flash unit with homemade Cinefoil snoot creates triangle of light on upper body

Fashion photographers often look to bygone eras for creative inspiration. This photo pays homage to the Art Deco style of the 1930s.

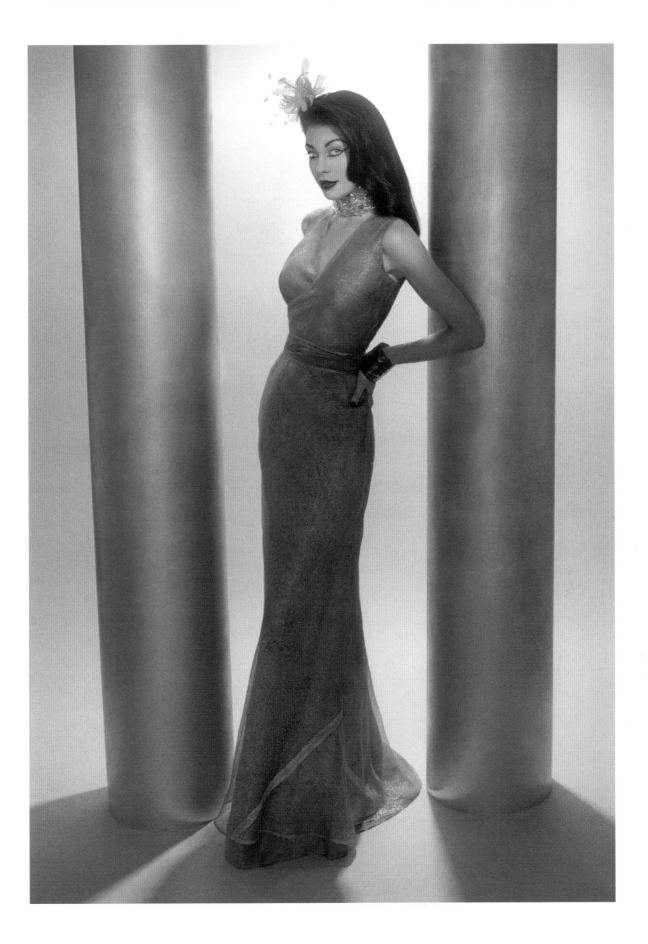

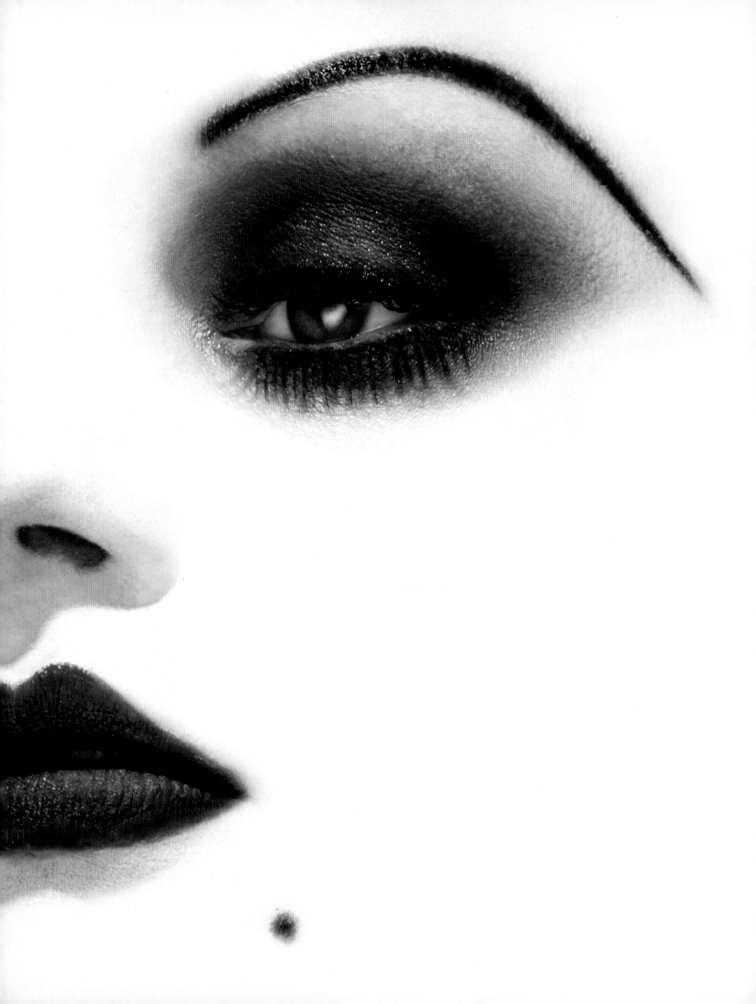

GLAMOUR LIGHTING

Creating the "Image" Photograph

Glamour photography can be harder to classify than beauty and fashion photography, mainly because it is a combination of the two. To the professional photographer, the term "glamour" refers to an "image" photograph. It is not a picture that screams "product"; instead, it creates an image that conveys the feeling of a product. It creates an image of a style.

Beauty photography—by definition, a head and shoulders or face shot—celebrates the beauty of the model. It shows the model's hair, eyes, and healthy skin. Fashion photography places more emphasis on clothing but coincides with glamour in showcasing an overall feel or look. However, it also usually gives a good representation of the drape and fit of an outfit.

Glamour tends to be edgier, and it emphasizes fantasy. Unfortunately, some amateur photographers and photography magazines have associated the term "glamour" with cheesecake and "T&A" photographs. In the fashion industry (and in this book) it refers to a more fantastic version of the fashion image.

HARLOW HOMAGE

If glamour photographs are about fantasy and style, then a good place to start this chapter is with two images designed in homage to film actress Jean Harlow. The stylist and photographer

The photographer took a closeup of the model's face and altered it in Adobe Photoshop for a graphic result.

The model, shown clean-faced as she arrived at the studio, was chosen because her full face was reminiscent of Jean Harlow's. The makeup artist used tweezers to minimize the model's natural eyebrows and then drew on a higher line with a more pronounced arc (see pages 90-91).

Harlow's heart-shaped lips were re-created by painting with lipstick color to emphasize the upward arcs of the upper lip and by using foundation to "subtract" a dramatic cleft. The makeup stylist finalized the look with a fake mole and teased blond hair.

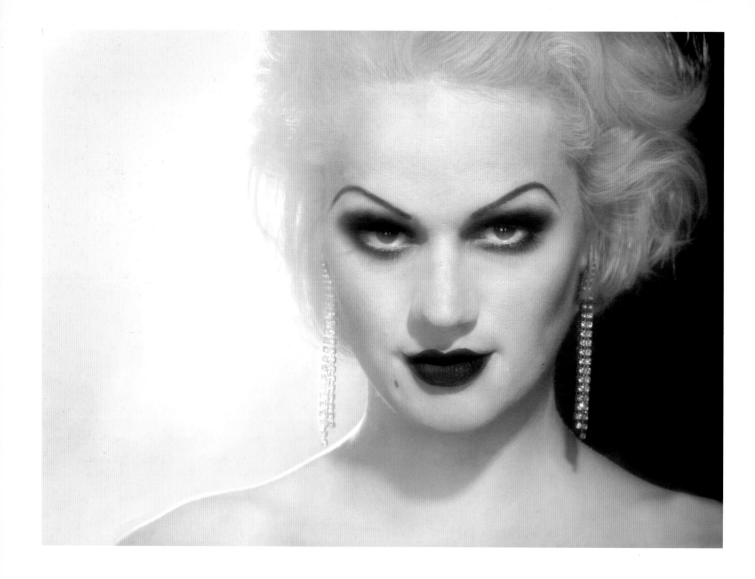

studied photographs of the famous star of the 1920s and 1930s, noting her full face, heart-shaped lips, and somewhat droopy eyelids. Next they went in search of a model who had at least some of these features.

To begin, the model's platinum blond hair was styled into a vintage look. Her eyebrows were erased with tweezing and makeup and then painted to become higher and more arced. Her natural lip line was altered with makeup to emulate the Harlow heart shape—especially the top lip. Alabaster foundation was applied to her upper body to give her skin a porcelain veneer. The makeup artist did not make the skin clown white but gave it a good tonal range. Because the photographer planned to use hard lighting for the shoot, the makeup was kept very, very matte.

The makeup artist and the photographer worked closely to create this vintage look. For the lighting setup, see the diagram at right.

For the first image (page 90), white seamless was swept down and across the studio floor to create a light background. The photographer wanted a graphic checkerboard pattern with the lighting and background, so he placed a piece of black FomeCore behind the model on the right side only.

He then pointed a hard light down at her face from a high position slightly (3–4 inches) to camera right. The light was snooted so that just her face was illuminated. The desired effect was a long, sharp shadow that was much longer than would be "allowed" today (though it was common in Harlow's era).

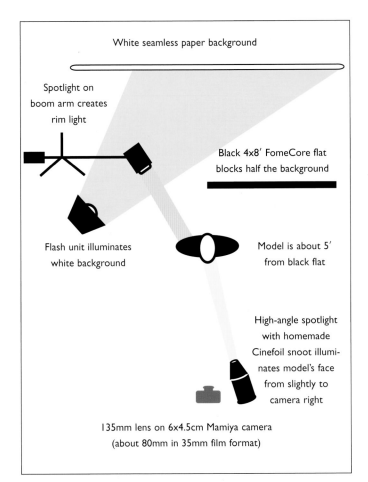

White seamless paper background

Spotlight on
boom arm creates
rim light

Black 4x8′ FomeCore flat
blocks half the background

Flash unit illuminates
white background

Model is about 5′
from black flat

High-angle spotlight
with homemade
Cinefoil snoot illumi-
nates model's face
from slightly to
camera right

135mm lens on 6x4.5cm Mamiya camera
(about 80mm in 35mm film format)

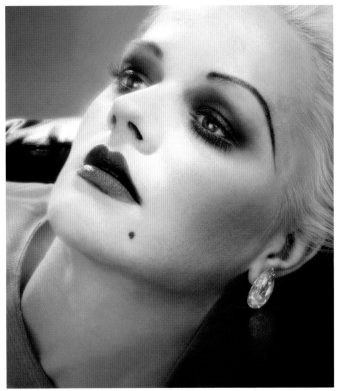

Although the model was propped on a couch in a somewhat awkward and uncomfortable position, the final image as seen through the camera looks natural and relaxed.

Nevertheless, the light was positioned so that the shadow cast by the model's nose did not cut into her lip. Light bouncing up from the white seamless floor filled this shadow so that it was only about −1.0 or −1.5 EV under the main light.

The white seamless was lit from the left by a flash unit that was carefully powered so it did not become too bright and flare out. A third light was placed behind and slightly to the left of the model. This spotlight on a boom arm rimmed both her hair and her shoulder.

As a final touch, canned "fog" created an effect that reduced the overall contrast. The photographer used a lot of "fog" between the background and the model, but only a small amount in front of her.

Later, the photographer used Adobe Photoshop to make several improvements to the image. As part of his original plan to convert the image to black and white, he brought the

The makeup artist and stylist are never far from the set, jumping in when needed to make repairs or alterations. Inexperienced artists and stylists may need the photographer's help in seeing flaws.

black background, which was made grayer by the fog, back to a true black. He completely eliminated the lines of the model's natural eyebrow (just barely visible beneath the makeup), and re-drew perfect lips, especially where foundation had been used to paint out portions of the model's real lips. Finally, he slightly manipulated the highlight levels of the image. The goal was to have no pure whites, just levels of gray.

The second image (page 91) aimed for more of a film noir look, but in color. The model was asked to recline on a leather couch and to lean into a dramatic pose.

The photographer positioned a blue-tinted softbox to the front and left of the model and placed a magenta-gelled spotlight behind her to create a rim light from behind. He hung a third light above the model to cast a nose shadow.

The difficult part of the lighting was trying to balance the spotlights with the softbox, because the diffusion material on the latter cuts down the light output. If you're not careful, this reduction of light from the softbox can allow the spots to overpower the image. The desired ratio was for the softbox and top light to be at about normal exposure and the rim light at +1.0 EV.

For the third shot (page 88), the photographer decided to shoot a variation that pays homage to a famous Vogue cover from January 1950. He moved in closer to emphasize the model's face and the incredible makeup work. He tightened the framing even more to take a closeup of just her face.

Then, using Adobe Photoshop, he erased the chin and jawbone and replaced them with the skin tone to make the final image more graphic. He also toned down the nose shadow so that it wouldn't dominate the image.

A NEW COLOR PALETTE

The Jean Harlow images we've just examined were unquestionably a retro look, especially the ones converted to black and white. For a more unconventional look with roots in the past, the photographer decided to mix 1950s hair and styling with an up-to-date, modern color palette. He did this by contrasting dramatic red hair with skin tones that were paled by cyan and blue lights.

At first glance, one might suspect that the photographer just slapped on a bluish filter to create this image. However, that would have resulted in an overall blue color cast that would have made for a much different final effect. Instead, the image was achieved with multiple lights gelled different colors.

To begin, white seamless paper was lit by two flash units pointed toward it from opposite sides at 45-degree angles to the background. The lights were gelled with cyan filters.

Dual main lights lit the model's face. The first was a flash unit positioned next to the camera and bounced off the studio's 11-foot white ceiling for a broad, even light from above. It was gelled with a blue filter, which is a distinctly different color than cyan (see color swatches, below). A similar effect could have been created with a large gelled softbox about 4 or 5 feet above the model's head.

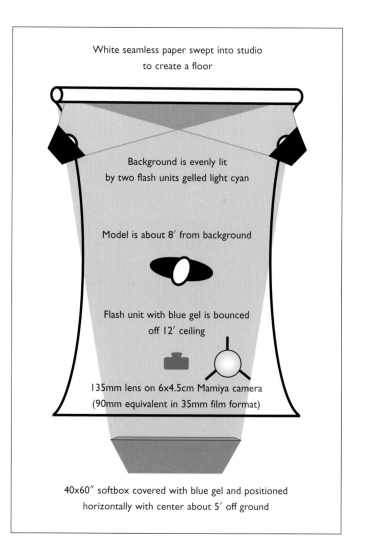

White seamless paper swept into studio to create a floor

Background is evenly lit by two flash units gelled light cyan

Model is about 8′ from background

Flash unit with blue gel is bounced off 12′ ceiling

135mm lens on 6x4.5cm Mamiya camera (90mm equivalent in 35mm film format)

40x60″ softbox covered with blue gel and positioned horizontally with center about 5′ off ground

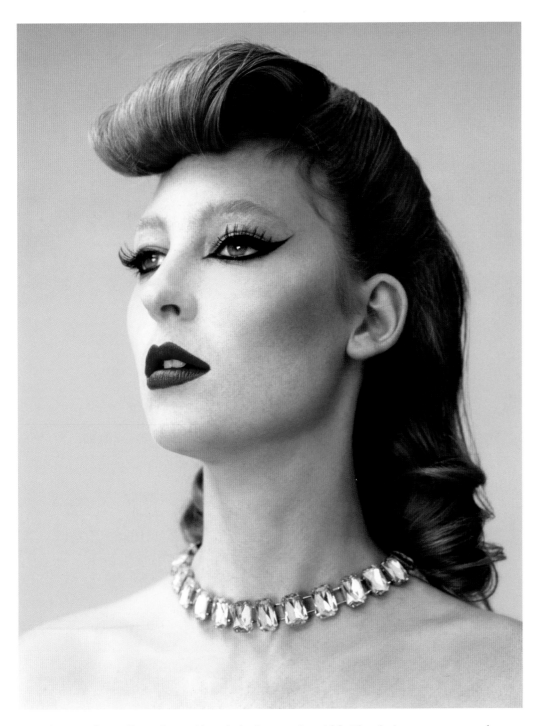

The background lights were gelled with a filter that was approximately this shade.

The light bounced off the ceiling was gelled with a filter that was approximately this shade.

The front softbox was gelled with a filter that was approximately this shade.

Three different colors of blue and cyan (plus a little editing work in Adobe Photoshop) create an image with great depth of color.

The second front light was a softbox behind the camera that filled in the already soft shadows and lit the face nicely. It was gelled with a light-blue filter. The photographer used Adobe Photoshop to retouch the cyan highlights out of the red hair, to give a cleaner look. He used the paint brush in the Color Only mode at an opacity of 15% and then slowly built up to the color level desired. A variation of this image appears on page 136.

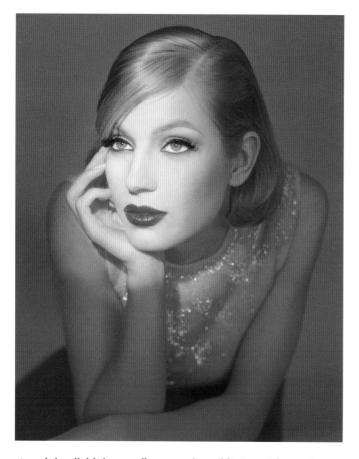

A spotlight gelled light cyan illuminates the model's face, while a pinkish softbox fills the shadows.

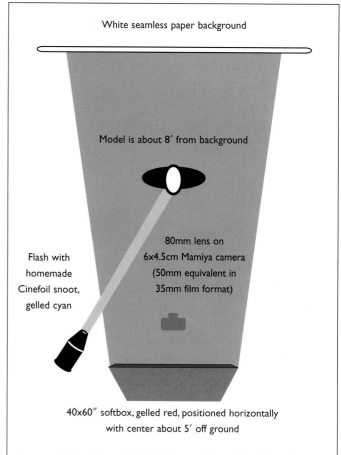

White seamless paper background

Model is about 8' from background

80mm lens on 6x4.5cm Mamiya camera (50mm equivalent in 35mm film format)

Flash with homemade Cinefoil snoot, gelled cyan

40x60" softbox, gelled red, positioned horizontally with center about 5' off ground

USING GELS

If you've ever looked at prints and slides taken forty or fifty years ago, you'll notice they've faded toward pink. The photographer found this tone and monochromism interesting and decided to mimic it in a new photograph.

A snooted spot was placed to the right of the camera and pointed at the model's face from an angle that was a bit higher than her eye level in her leaning pose. The snoot was made with Cinefoil and carefully shaped so that the light missed her ear and cheekbone, thereby avoiding a harsh shadow on the side of her face. The model was also posed with her face angled in the direction of the light, in order to further minimize shadows.

The spot was tinted slightly cyan with a filter and powered to +0.5 EV overexposure. This hard light brought out

the sequins on her sweater and created dazzling highlights in her eyes. Matte makeup kept her skin tones from picking up unwanted highlights and shine.

A 40x60-inch softbox was placed behind the camera to act as fill for the dark portions of the model's face, as well as to light her body and the background. The softbox was gelled with a large light-red filter. The two gelled lights created a relatively neutral light where they met, and light-red shadows and fill where they didn't.

The image was purposely shot at a wide aperture to create shallow depth of field, which helped to emphasize the model's eyes and soften the edges of her frame. The lens was an 80mm on a 6x4.5cm medium-format camera (the equivalent of about a 50mm lens on a 35mm camera). This lens,

combined with a close shooting distance, created some wide-angle distortion.

Canned fog was sprayed on the set to lower the overall contrast of the image.

The cyan and red filters did not yield perfect neutrality, so the color was perfected in Adobe Photoshop. In addition to making the color more neutral, the photographer made the overall tone pinker (more magenta) rather than light red.

Another way to influence the color palette of an image is to introduce tungsten or quartz hot lights but continue to use daylight-balanced films. Tungsten lights have the advantage of allowing the use of slow shutter speeds for slight blurring of an image when the camera is hand-held or the model moves. They also cause interesting yellow-orange color shifts if they

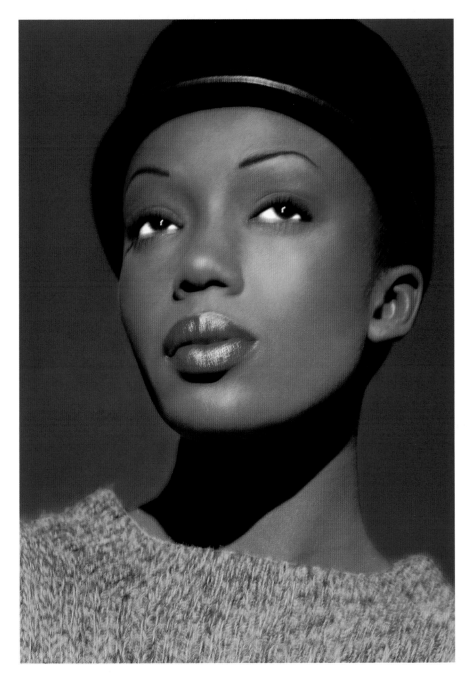

Hard lighting is typically considered unflattering and hard to control, but in the right circumstances it can work beautifully. Here, the hard lighting succeeds by emphasizing the model's perfect bone structure and flawless skin.

are combined with daylight-balanced films. (See the color temperature section on page 12.)

The lighting was simplicity itself. Two quartz-halogen lighting units were pointed at the model and at the blue seamless paper from either side of the camera at a height of about 8 feet. Instead of matte makeup (the usual choice for hard lights), the skin was allowed to appear dewy, which gave nice highlights to the nose and cheeks. These highlights were emphasized by the blur caused by the combination of a slow shutter speed and a hand-held camera.

This shutter speed choice, the color temperature shift, and the simple lighting could have appeared to be mistakes or looked amateurish if they had not been finessed well. Combining "bad" techniques with careful posing, frequent test shots, and well-thought-out aesthetic decisions can yield great glamour images.

The photographer used Adobe Photoshop to brighten up the blue background, which had turned a little muddy from the yellowish tungsten illumination.

See the color temperature section (on page 12) for more information on tungsten lighting, color shifts, and color temperature.

GLAMOROUS NUDES

Although the photo on the facing page is partly a fashion image because the emphasis is on the product—the golden shoe—it is more of a glamour photograph because of the fantastic aspects of the makeup and styling. The image was taken for a worldwide campaign for a major client.

Often, when a big client arrives at the door, a photographer is tempted to bring out all the bells and whistles that can be applied to lighting and shooting. However, experienced photographers know that keeping things simple is often the most "advanced" method. The sophistication here comes though the styling, rather than complicated or harsh lighting.

The key elements of the image—lighting, skin color, makeup, and hair—were carefully planned in advance. This left only the positioning of the $500 shoe to experimentation.

The goal was for the image to have a low contrast, but with some shadowing. The photographer began with a 40x60-inch softbox positioned vertically and to the left of the camera, with the center about 4 feet off the ground. He placed the model about 2 feet from a Thunder Gray seamless paper background. A large 4x8-foot white flat was placed directly to the side of the model at camera right, which softened the shadow from the softbox.

Experienced photographers know that sophisticated photographs don't need complicated lighting.

It took about an hour and a half to cover the model with pale ivory body paint. Bold eye makeup offset the pale body paint and soft lighting. The hair stylist augmented the model's shoulder-length hair with a real-hair pony tail extension, which was clipped on and then tossed and teased to blend in.

The posing was carefully planned to be sexy but not too revealing so as not to distract too much attention from the product.

The model had been chosen carefully. For starters, she needed a patient personality to endure ninety minutes of body painting before even stepping onto the set. The client also wanted a model who was long and lean yet had nice feminine hips and an ample bust, rather than the smaller frame of many fashion models.

The photographer achieved a delicate balance. The pose was graceful without being so revealing that the nudity overpowered the impact of the product— in this case a $500 shoe.

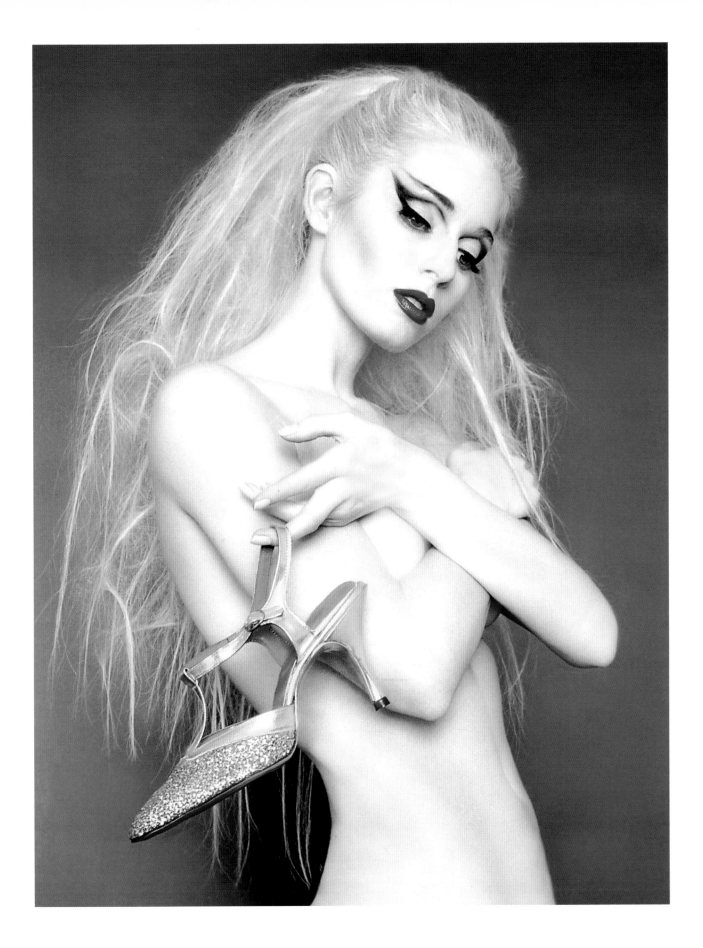

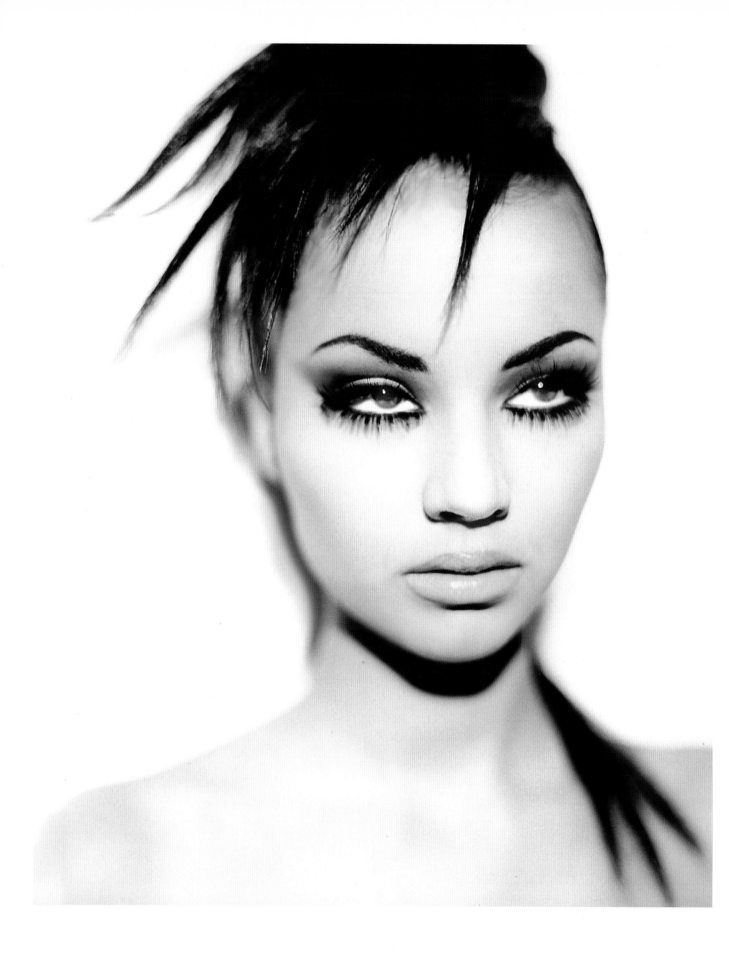

EXPERIMENTING ON THE SET

In comparison to the detailed pre-planning for the nude shot discussed on the previous spread, there are times when you need to just start playing on the set to come up with a successful image. When the makeup artist completed her work for the image at the left and the model saw it, she assumed a role, and her serious look suited the makeup well. Seeing this, the photographer knew the photo was going to be all about attitude, so he immediately got her on the set in front of a white background and started playing with the light.

The model's eyes were incredibly engaging, so the photographer designed the lighting around them. Because a hard light would create a strong highlight in the eyes and make them sparkle, he placed a bare-bulb flash about a foot higher than the camera and to its left. The model then pointed her face toward the light so the shadow was fairly even on either side of her face.

Not only did this light highlight the eyes; it also defined the lips and created strong nose and chin shadows. The contrast was allowed to go high, breaking the image down to the very basic graphic elements of the face.

Although the lighting is very simple, it is incredibly precise. You achieve success in photography not through the number of bells, whistles, and other gimmicks you use in your lighting, but by choosing techniques that are appropriate for achieving your goals and by your precision in using the light to achieve them.

Keep in mind that single-light-source photography feels very familiar to most people. After all, we are used to seeing the world with one light source—the sun.

A good makeup artist is an important part of any glamour photograph. Here the lighting is the same in both images, but the post-makeup result is radically different.

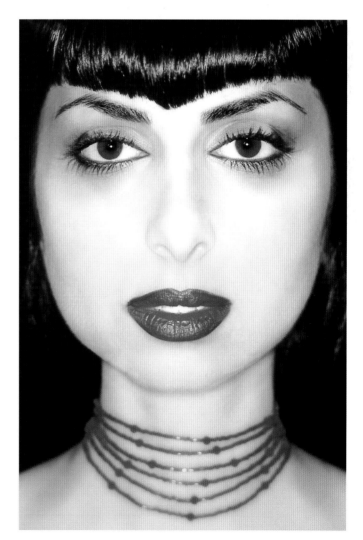

A single hard light adds dazzle to the model's eyes and breaks down the image into strong graphic elements.

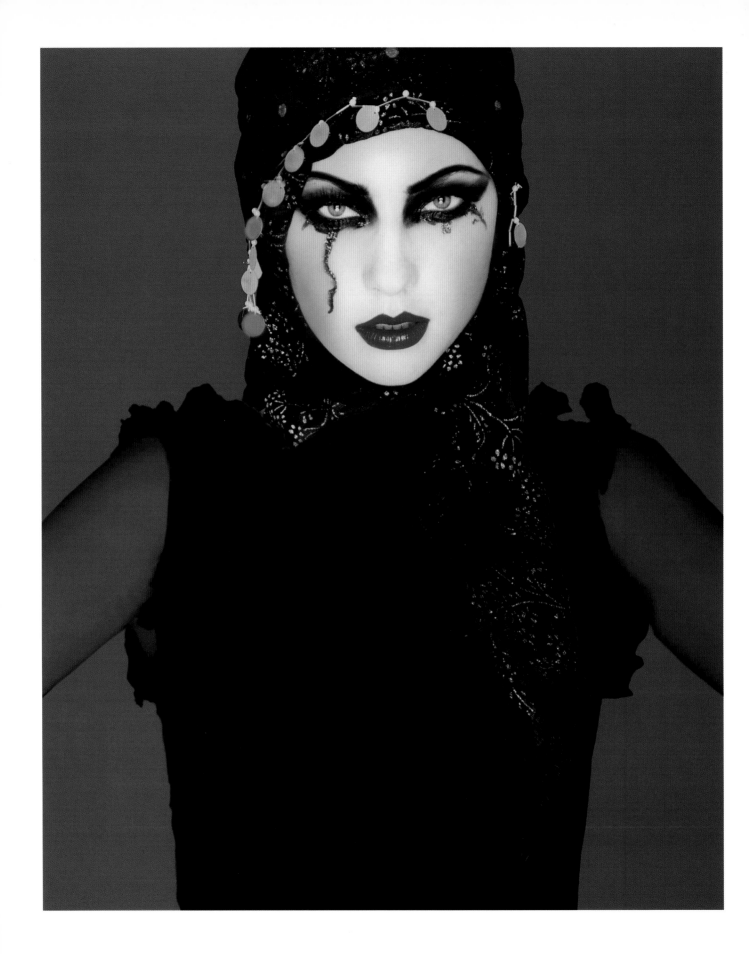

CONCEPTUAL VARIATIONS

A five-minute makeup change and a quick switch of lighting created two glamour images for fashion designers Michael & Hushi. The first image (opposite) was to be used on an invitation to a fashion show by the designers. The goal was to give just a hint of the clothing style, without giving away too much detail. Yet the image needed to communicate enough drama and intrigue that fashion editors would want to attend.

The second image (at right) was for the designers' post-show public relations materials. They needed a brighter, more colorful image that exuded excitement and could run as a full page in a magazine.

The shoot began with the fashion show invitation image. Before stepping onto the set, the model endured more than two and a half hours of makeup and styling. Once the head scarf was chosen, the makeup artist began a very theatrical look with a Persian flare. He used extremely pale, almost white foundation, then added charcoal-black eyes with long fake lashes. The shape of the mouth was redrawn with dramatic red lips.

The eye makeup took the most time and required some experimentation. When originally applied, the tears looked painted on. So the makeup artist added gray glitter with eyelash glue to the tear streaks. Silver or gold metallic glitter would have been too reflective and would have appeared only as white highlights.

The image was lit with a variation of the Modified Beauty Lighting setup (see pages 38–39), but because of the makeup and styling, the photograph falls within the glamour category. For Modified Beauty shots, the top and bottom lighting (softbox and umbrellas) would be at different ratios to give dimensionality to the face. Here, however, the photographer wanted very flat lighting to make the image even more graphic and two-dimensional, so the ratios were equalized.

The lighting began with a large 40x60-inch softbox placed high behind the photographer and turned vertically

The goal of this image, used on a fashion show invitation, was to give a hint of the clothing while creating drama and intrigue.

A more colorful and animated variation on the invitation photo was made for public relations purposes.

(that is, it was 60 inches tall). It was angled downward so it pointed straight at the model's face. Two flash units were bounced into umbrellas placed rather low in front of the photographer and angled straight at the model's face. However, unlike in Modified Beauty Lighting, the softbox and umbrella combo were powered so that the ratio from above was equal to the ratio from below. This flat lighting helped to emphasize all the graphic elements—the shape of the model's face, the makeup, the expression, and the pose.

Compare this to the second image. The photographer tweaked the lighting ratio by increasing the power on the umbrellas slightly—about 1/4-stop (+0.25 EV) to 1/2-stop (+0.5 EV) brighter at most. This created more three-dimensionality; note the shadowing on the model's knuckles.

The makeup was also altered—a change that took less than five minutes. Blue coloring was added over the glittering (it didn't stick to the glitter but did adhere to the surrounding skin), and yellow highlights above the eyes. The dress was changed, but the headscarf remained the same. Finally, a new pose was chosen, with a more theatrical "crying" look.

*An out-of-focus
office building makes a
graphic background.*

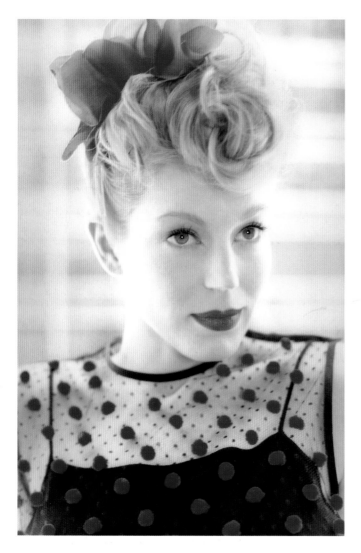

*The natural light is allowed to overexpose (but not burn out) the facial
features for a light and airy feel.*

Shooting on location always requires improvisation—and sharp-eyed photographers can see small things and make them work. Sometimes it is the background or setting that first draws the photographer, such as in the image shown here and the photograph on page 126.

For this image, the photographer needed to make the photograph in the office of the client, a clothing designer. He placed the model in front of a window that looked out at an office building across the street. Creatively employing depth of field, he selected a wide aperture to throw the distant building out of focus. The goal was to turn the scene across the street into an abstract, gridded background.

Next he added a front light in the form of a portable flash unit equipped with just its default reflector. This light was positioned above the camera and powered to supplement the natural light but not overpower it. To make sure this is what happened, the photographer chose a power ratio that set the flash for about −1.5 EV less than the light streaming in from the window—but he still exposed for the face (with the flash). The side lighting was allowed to go very bright but not burn out completely. The photographer wanted the image to look light and airy but still show detail in the skin tones.

ROCK 'N' ROLL GLAMOUR

To create a glamour image with a rock 'n' roll flavor, the photographer selected an edgy-looking model and had her hair teased into a funky, coarse style. Black leather made the model look too hard; the photographer chose a pink leather jacket for a softer look.

A single light lit the scene. A 40x60-inch softbox was suspended above the model with a boom arm. It was positioned 3 or 4 feet above her and pointed straight down, with the long side reaching out toward the photographer.

The high angle of the softbox created deep shadows under the model's hair, nose, and chin, while the forward portion of the box created some fill light. There's a distinct pink

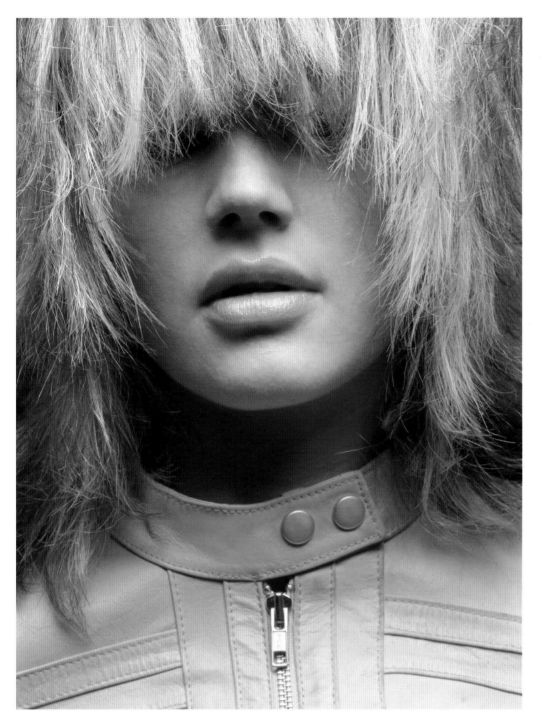

A face that is closely cropped and eyes that are hidden by the model's hair lend a graphic feeling to this top-lit image.

rim under the model's chin, where the shiny leather jacket kicked back fill light. Had the photographer used flatter lighting, the image might have looked too "happy." Instead, the shadows lent the shot more of a serious, edgy feel.

The makeup artist used pale matte makeup, as well as gloss on the pink lips to echo the gloss on the pink leather.

The photographer composed the image tightly, allowing the hair to frame the model's face. The eyes were allowed to fall into darkness beneath her hair.

This is the same model used in the Jean Harlow homage pictures on pages 88–91. The upper-left photo on page 89 shows how she looks without makeup and hair styling.

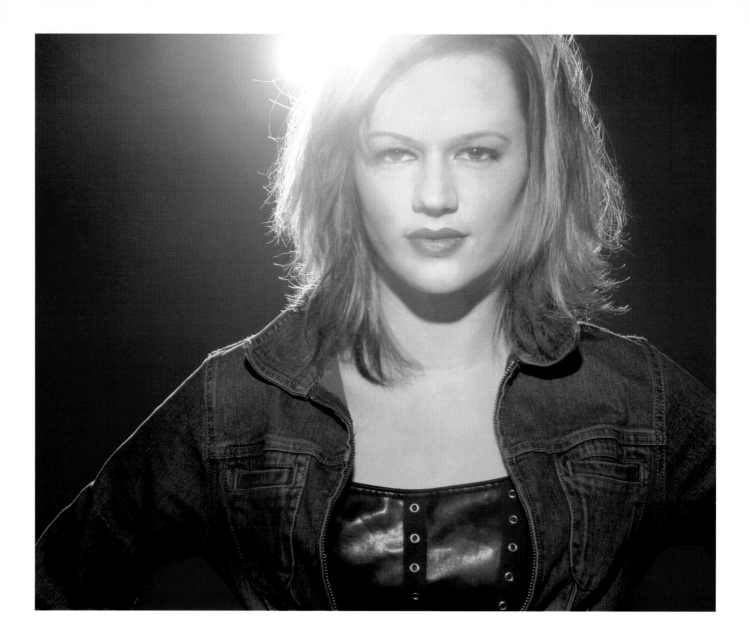

STAGE LIGHT VARIATION

The same model was used for another rock 'n' roll image, but this time the photographer went for a "stage light" look. A hard light with a 30-degree grid was pointed at the model from a high, centered position behind the camera. A gridded spot was then placed behind the model and aimed at her back and shoulders, lighting her shoulders and hair and producing strong flare in the picture.

The model's makeup was done very boldly, with matte foundation and extremely bright lips. The eye makeup was

The eye and lip makeup needed to be bold to hold up against the light flare.

applied a little more boldly than normal to insure that the eyes were still rendered strongly and would not be too faded by the flare.

When a photographer uses this lighting setup, he must take care not to make a model look too hard or extreme. Achieving this depends on using the right model, makeup, and posing. It is often best to ask the model to avoid too bold an expression, and to keep the model's face fairly matte with translucent powder.

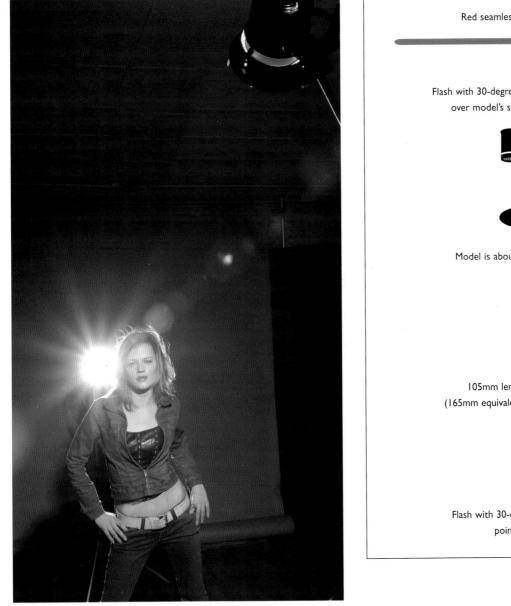

A gridded spotlight behind the model causes intense flare in the final photo.

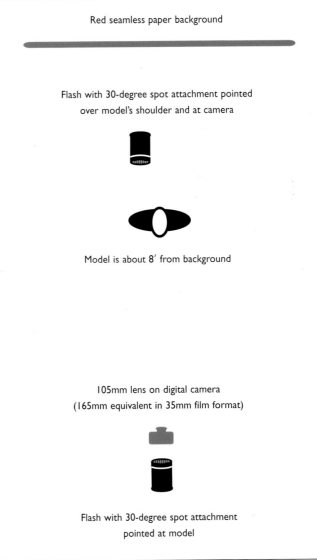

Red seamless paper background

Flash with 30-degree spot attachment pointed over model's shoulder and at camera

Model is about 8' from background

105mm lens on digital camera
(165mm equivalent in 35mm film format)

Flash with 30-degree spot attachment pointed at model

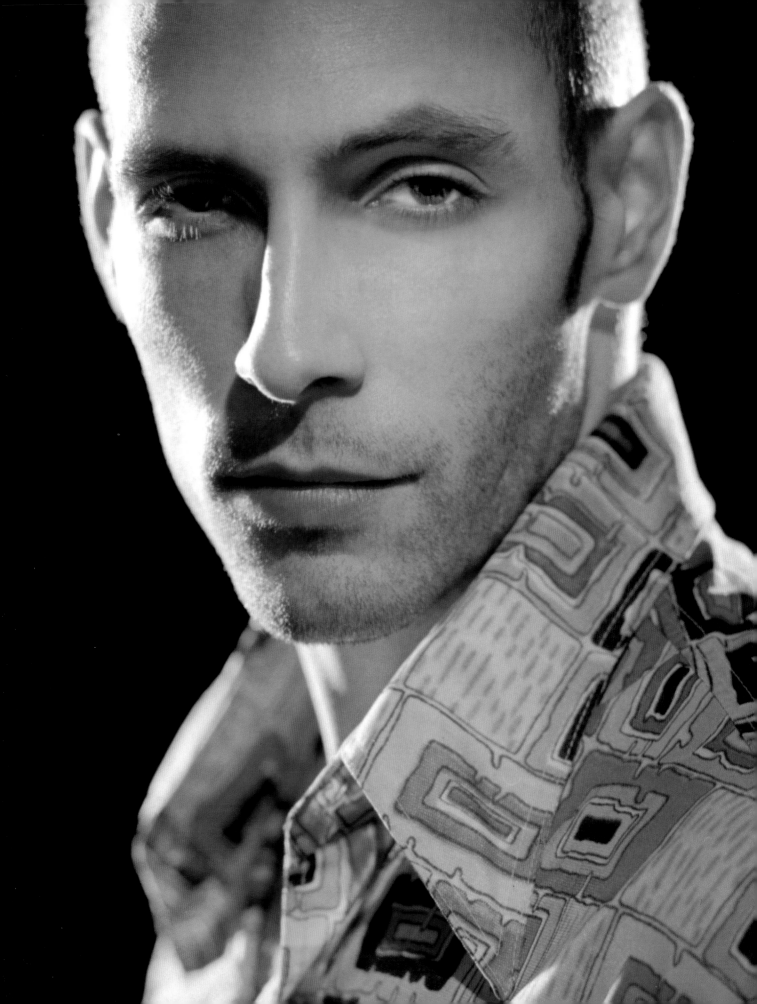

LIGHTING FOR MEN

Use Harder Light & Less Fill for Beauty, Fashion &

Glamour Shots of Men

Because feminine and masculine beauty are so different in concept, most photographers use different lighting techniques when shooting men and women. Common feminine adjectives include *soft, pretty, delicate,* and *graceful,* and photographers typically design lighting to reflect such qualities. On the other hand, because a handsome man might typically be described as *strong, rugged,* or *sharp,* for most beauty, glamour, and fashion shots of men photographers use a harder light and less fill.

MALE "BEAUTY" LIGHTING

"Beauty" lighting for men is generally harder and more angular than it is for women (see chapter 2). In general, chiseled features and character-building wrinkles are considered masculine, so they do not need to be minimized, as is usually done with female models.

In our first example (opposite), the photographer went to an extreme with this idea and chose three hard, snooted lights. The main light—high and above the camera, and slightly to the right—creates the large shadow under the nose. This light was placed as high as it could possibly go without putting both eyes in shadow; at least one eye should be out of shad-

ow to help create a connection with the viewer. The light is angled so the nose shadow will not intersect the lips. The high light also emphasizes a strong mouth line by putting the entire upper lip in shadow and emphasizing the cleft between the lower lip and the chin.

The photographer then placed a snooted light on either side of the model, about 4 feet away and to the side, and

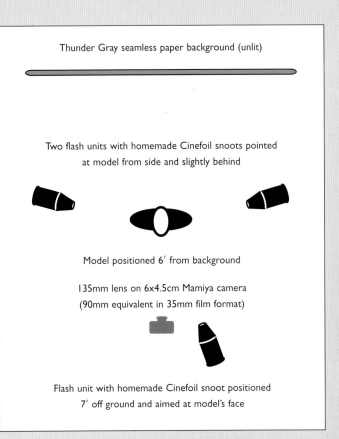

Thunder Gray seamless paper background (unlit)

Two flash units with homemade Cinefoil snoots pointed at model from side and slightly behind

Model positioned 6′ from background

135mm lens on 6x4.5cm Mamiya camera (90mm equivalent in 35mm film format)

Flash unit with homemade Cinefoil snoot positioned 7′ off ground and aimed at model's face

Three snooted hard lights create a light that emphasizes the model's masculine facial features.

metered them to be about 1 1/2 stops (+1.5 EV) over the main exposure, so they would blow out into bright white highlights (see pages 14–15). These highlights create a strong edge line on the model's face, which frames the face and helps focus the viewer's attention on the eyes. A solid black background helps dramatize the edging effect.

Any time the lighting produces deep facial shadows, it is critical that the photographer maintain control over the pose. The model cannot see the shadows, so it is up to the photographer to minutely coach the pose.

BASIC "BEAUTY" LIGHTING FOR MEN

Occasionally, basic beauty lighting as described for women (see pages 36–37) can be used for men, especially if you want to emphasize young, perfect skin. The image on this page uses lighting that is nearly identical to what was used for the image on page 57, except for the slightly different direction of the main light. It starts with a single large softbox behind the photographer and to the right of the camera.

This light is best suited to a man with angular features. It can sometimes look unflattering on men with rounder faces, as it tends to make their features look flat and featureless.

The makeup is different as well. For the woman's version, full-face foundation was used, along with full beauty color. However, for the man's photograph, this model wears only a little bit of cover-up makeup on trouble spots (pimples and under-eye circles). The goal is to let the natural sheen and texture of the skin show through.

THE SUN AS MAIN LIGHT

When you're doing outdoor male beauty shots, the sun often works in your favor. Unless it is diffused by cloud cover, the sun is much harsher than the softbox used in traditional feminine beauty photography. This works well, because for men you generally want to go for harder shadows than with women.

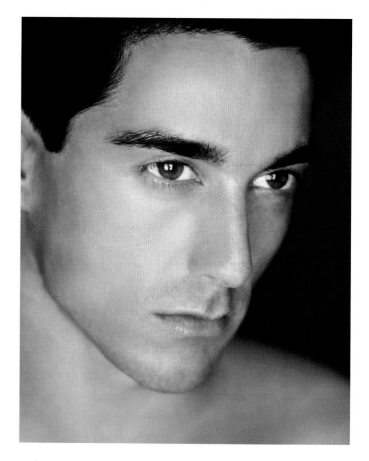

When perfect skin is to be emphasized, the photographer should use softer "beauty" lighting.

The image on the facing page used low, late-afternoon sunlight for the main light. The model was carefully posed at an angle. The photographer took extreme care to keep at least one of the eyes from falling into shadow. Even though the model is squinting, you can still see the highlight in his eye. The wrinkles are clearly visible but not emphasized, and there are shadows under his eyebrows and nose.

The photographer placed a silver reflector slightly behind the model and very close to his face. The goal was to create a bright separation edge, which would add dimension to the photograph. A second silver reflector provided fill from a distance of about 7 feet.

The body positioning was carefully orchestrated. When you're shooting on location, a straight-on stance can look overly posed. You'll get the best results with a more candid look.

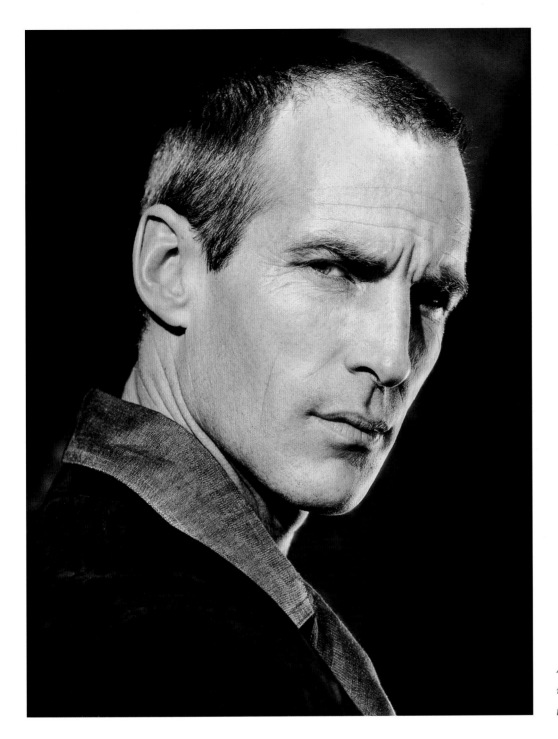

A silver reflector creates a rimming light that helps frame the model's face.

However, the emphasis is on candid *look*, because this was not photojournalism. The model was not photographed walking down the street, which would have required two assistants running alongside to hold the reflectors in place! Instead he was asked to act candidly, to turn toward the camera as if to interact with another person on the street. Imaginary scenarios such as this help the model understand the goals of the photograph.

Because the sun was low in the sky, it had a very red cast that would have altered the mood of the image. For this reason, the photographer used black-and-white film. Rather than being overwhelmed by color, the image instead emphasizes textures and tones.

RING FLASH ON LOCATION

For indoor location sessions, a ring flash can sometimes be a handy piece of equipment. On page 54, we showed a ring flash used in the studio to photograph a female model who was wearing a lot of matte makeup. Here the model is in a grocery store wearing a yellow velvet suit. Because a ring flash surrounds the lens, it produces shadows that spread in an

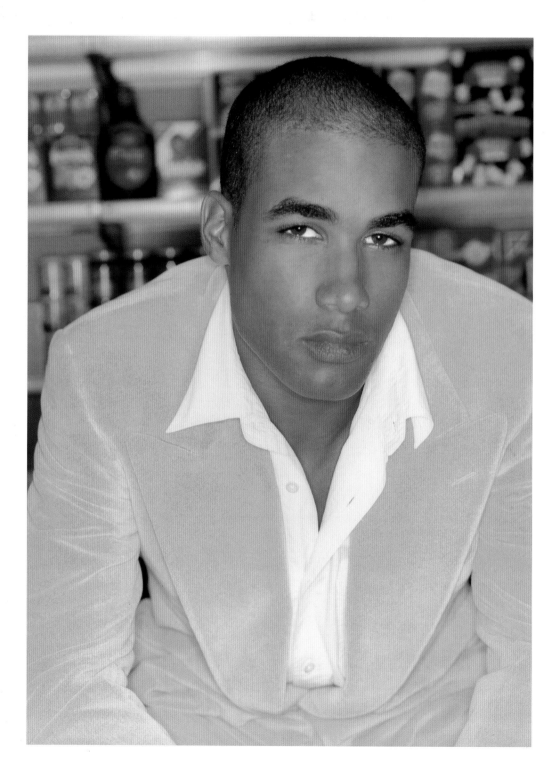

Ring flash can be tricky because it makes some models look great and some look awful. Generally, for a ring flash shot try to find a model with an angular face or good underlying bone structure.

outward direction, toward the outer edges of the model's body. It also creates a sheen on the inner angles of the yellow suit (note the chest and the inside of the arms). The background is about 8 feet away. We chose a wide aperture to blur the background just enough to remove the distraction of readable labels and still create a graphic pattern.

Unexpected results, both good and bad, are common with ring flash. A preview Polaroid or a digital test is almost essential to find out if it works in a given situation. Unless you're shooting with a digital camera, always try to do a Polaroid if you're using ring flash. It can look very harsh and ugly on some models, especially those without good underlying bone structure. Models with somewhat angular faces tend to be the best candidates for ring flash.

MEN'S FASHION

Men's fashion photography is similar to women's fashion photography in that the greater emphasis is on the clothes. The image does not have to be specifically *about* the clothes, but the viewer should have a definite feeling about the clothing after viewing the image.

Every wrinkle and fold of the cloth should be a calculated decision by the photographer.

For the catalog location image shown at right, the pose was chosen to complement the clothes. In fact, the model was put into each pose, and then the clothing stylist went over every detail while the photographer, model, and assistants waited. The stylist perfected the fold of the cloth at the elbow of the leaning arm and tweaked the drape of the suit next to the pocketed hand.

The trick is to find middle ground, where the clothing looks great but natural. If there are too few wrinkles, the result looks like cardboard, but too many wrinkles make the fabric look inferior.

The location for the image here was a scenic lookout covered by a gazebo. The model was mostly shaded by the roof of the shelter. The photographer walked out along the side of the cliff to get a short distance away, so he could shoot with a 135mm lens on a 6x4.5cm format camera (about 80mm equivalent in 35mm film format).

An assistant held a metallic gold reflector disk just outside of camera range and pointed it up at the front of the model from about 3 feet away. The reflector kicked strong fill light back at the subject.

It was a windy day, so the hair stylist chose an accommodating style. Matte powder was the only makeup used.

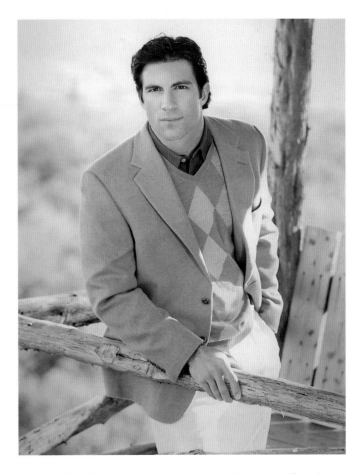

This casual outdoor pose is anything but casual. It was carefully orchestrated by the photographer and the stylist.

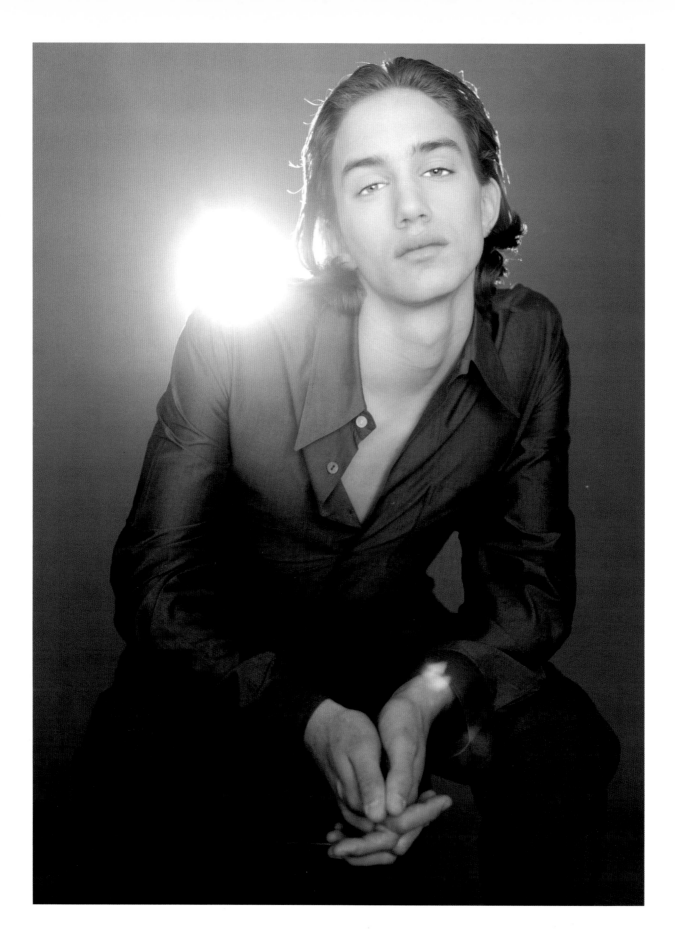

USING FLARE TO ADVANTAGE

This dramatic fashion image of a male model sitting on a chair was shot with only two lights—and one of them was more of a compositional element than a "light." It served the purpose of reducing contrast (see below) but was otherwise simply a design element.

This image was shot in black and white, and was styled for black and white. The main light was a large softbox about 4 1/2 feet off the ground that produced a soft main light. Because the model was sitting (and the light was therefore relatively higher), it cast a somewhat longer than usual shadow under the model's chin.

A flared backlight has more of a compositional function than a lighting function.

The model was positioned on a chair placed about 3 feet in front of a dark-gray seamless paper background. The photographer cut a 2-inch hole in the paper and positioned a bare-bulb flash behind it, pointed at the camera.

Seamless paper is quite thick, but it is not 100% opaque when a bright light is pointed at it from behind. Light from the bare-bulb flash that spills onto the back of the seamless will cause the paper to glow in the photograph. To avoid this, the photographer cut an identical hole in a large piece of thick, opaque black posterboard, lined it up with the paper hole, and propped the board in place with a clamp and a light stand. Any light spillage on the back of the seamless paper was blocked by the board, yet the light traveling through the hole was unaffected.

Using this "keyhole" method of backlight behind the seamless meant that there was no light stand or flash fixture to worry about hiding behind the model—only the light itself showed. In addition to functioning as a compositional element, the backlight produced a nice rim light on the model's hair.

Test shots showed that the flare was a bit too harsh for the photographer's liking. A quick, light spritz of Fantasy FX (a scentless, harmless aerosol smoke) created a light fog—enough to soften the flare effect. The fog and the flare combined to reduce the overall contrast of the image, eliminating the need for fill lights or reflectors.

This reduction of contrast is not unlike that achieved by the "flashing" darkroom techniques of times past. In that technique, the darkroom lights were momentarily turned on during the development of black-and-white film to produce a slight fog or lowering of contrast over the entire image.

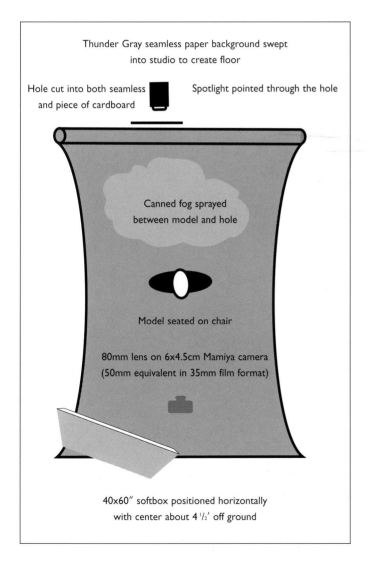

Thunder Gray seamless paper background swept into studio to create floor

Hole cut into both seamless and piece of cardboard

Spotlight pointed through the hole

Canned fog sprayed between model and hole

Model seated on chair

80mm lens on 6x4.5cm Mamiya camera (50mm equivalent in 35mm film format)

40x60" softbox positioned horizontally with center about 4 1/2' off ground

SOFTBOX AS BACKGROUND

Flare can also be utilized in a much different creative manner than that described for the previous images. If the background itself is a softbox, the whole image can be flared. How close the model is to the light and how powerful the light is will affect the total amount of flare in the image.

The set started with a 40x60-inch softbox placed directly behind the model. This light was then set to a power of +2.0 or +3.0 EV. Unseen in the setup shot is a 4x8-foot white flat about 3 feet to camera right and at a 90-degree angle to the camera; the flat produced strong side fill light.

In the first shot (below), the model was about 2 feet from the softbox, which produced the strong rim light on the side

of his face (camera left) and jacket. The softbox also produced controlled flare.

Flare from a background softbox can be altered by changing its distance from the subject, its power in relation to the main exposure, and its angle to the camera. Changes happen quickly, so make them in minute increments.

The amount of rim spillover could have been increased by moving the model closer to the light. Bumping up the power of the light (compared to the exposure) would have given the image even lower contrast and started to burn out the sides of the model's face and given him a thinner, distorted look.

In the second version (at right), the main variation was to move the model to camera right, so that the edge of the softbox was now down the middle of the picture. Behind him, a dark seamless recorded as black. This created a strong checkerboard pattern, with the softbox background (white), the dark side of the face (black), the light side of the face (white), and

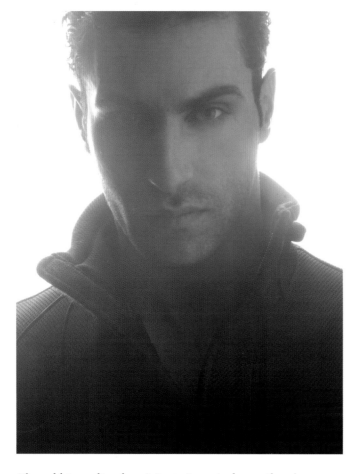

The model is standing about 2 feet in front of a large softbox that is set to about +3.0 EV over the normal exposure.

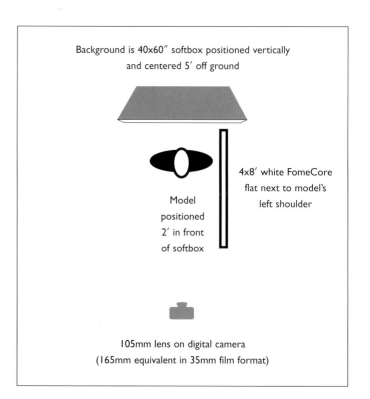

Background is 40x60″ softbox positioned vertically and centered 5′ off ground

Model positioned 2′ in front of softbox

4x8′ white FomeCore flat next to model's left shoulder

105mm lens on digital camera
(165mm equivalent in 35mm film format)

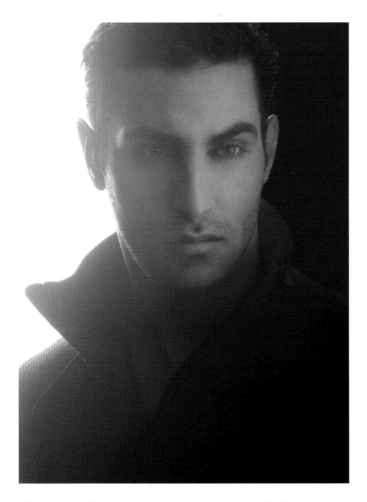

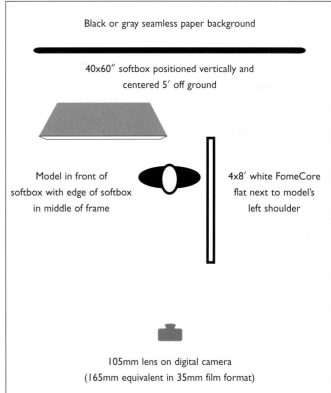

Black or gray seamless paper background

40x60″ softbox positioned vertically and
centered 5′ off ground

Model in front of
softbox with edge of softbox
in middle of frame

4x8′ white FomeCore
flat next to model's
left shoulder

105mm lens on digital camera
(165mm equivalent in 35mm film format)

Placing the model at the edge of the softbox creates a checkerboard pattern.

the dark sweep behind (black). Later, using Adobe Photoshop, the photographer bumped up the contrast a bit to emphasize this white-black-white-black checkerboard patterning.

This type of lighting can also be used when photographing women. In the photo on page 42, we used a bright softbox as a background. However, to make the image more feminine, we added a strong soft fill behind the camera. In a different variation, we might also pull the flat around toward the camera for a less side-lit effect.

Another important comparison is to the fashion catalog lighting on page 69, which uses a softbox as a background. However, in that case the softbox was set to only about +0.5 EV overexposure. The result is no flare, but instead a crisp white background.

A softbox background creates flare that lowers the contrast of the overall image.

MODIFIED "COPY LIGHT"

If you've ever had to copy paintings or prints, you know about copy lighting. You set up two lights pointed at the subject from either side, then tweak the lights until they are even across the entire subject. (This is also the classic background lighting when you want an even tone across an entire backdrop.)

The setup shot below shows this arrangement, but as a *main* light. Two flash units reflected into 36-inch umbrellas were pointed at the subject from a distance of 4 or 5 feet. We positioned the flash units very close to the umbrella material to produce a relatively hard light. The model was about 3 feet from the background.

Starting with this basic setup, the photographer began to tweak the lighting. Moving one light just 12 inches is 20% or 25% of the total distance from the subject. Even this small amount of movement can have a big effect on the power ratio between the two lights.

This technique must be finessed because the lighting creates a lot of shadows, which traditionally are unflattering. However, the careful and specific placement of the lights with a particular model can result in interesting and unusual fashion photographs. Failure to minutely control the lights and shadows can result in an image that looks amateurish.

You must also watch the model's body position very carefully. Slight movements of the model can make a big difference—good or bad. Any time you're working with hard lights, shadowing becomes very prominent. So a 3-inch turn of the model's head can completely alter the image. A small camera movement can do the same.

In the top photo on page 117, the right light was moved slightly higher; the result is the highlighting on the model's face and jacket. However, for the bottom photo on page 117 the right light was pulled back, making the left side of the image comparatively brighter. For the second image, the model also stepped about a foot closer to the camera, putting part of his face into shadow. The creative effects in the two images are very different.

The overall goal of the shoot was spontaneity. The photographer set up the "copy lights" with the foreknowledge that he would tweak them when the model was on the set.

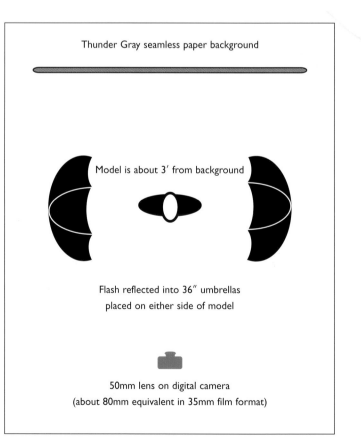

Thunder Gray seamless paper background

Model is about 3' from background

Flash reflected into 36" umbrellas placed on either side of model

50mm lens on digital camera
(about 80mm equivalent in 35mm film format)

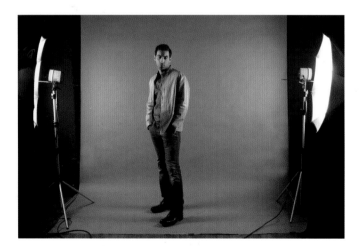

This shoot began with two lights pointed at the model.

Umbrellas can produce hard lighting when the flash is tucked in close to the umbrella.

After the model arrived, the photographer encouraged a relaxed atmosphere; he asked the model to move around and surveyed the scene through the viewfinder. The goal was to find a "happy accident," when model, clothing, poses, and lighting started to come together. Once that happened, the photographer slowed the pace and perfected the pose and the lighting.

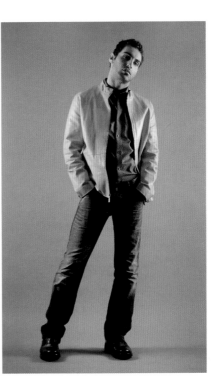

The light at camera right was pulled higher for this image.

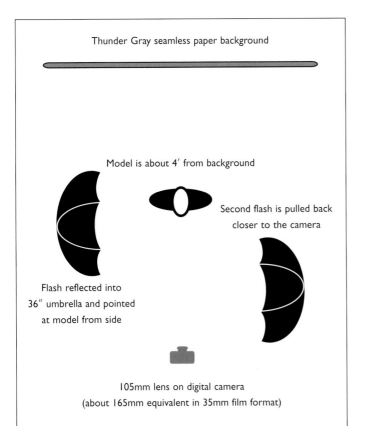

Thunder Gray seamless paper background

Model is about 4′ from background

Second flash is pulled back closer to the camera

Flash reflected into 36″ umbrella and pointed at model from side

105mm lens on digital camera (about 165mm equivalent in 35mm film format)

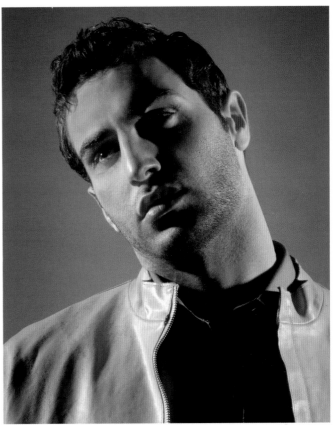

The right light was pulled back and the model stepped forward, which put part of his face in shadow.

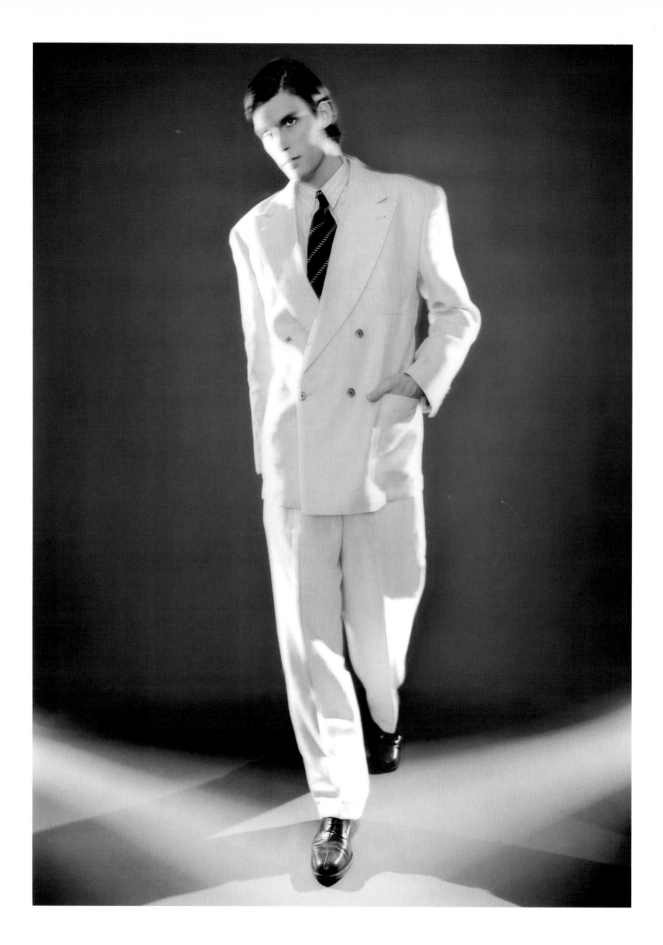

COMPOSITIONAL
LIGHT & SHADOW

When you're trying to create interesting backgrounds for fashion photographs, consider using highlights and shadows as elements in the composition. In the image opposite, the photographer used strong side lighting to add dynamic patterns to a simple fashion shoot. The overall feel of the diagonal lines and rim lighting was meant to echo Art Deco, and it also complemented the tailoring of the suit.

This fashion image began with a dark gray (Thunder Gray) seamless backdrop that was swept down into the studio. Rather than arranging it in a wide, gentle sweep, the photographer dropped it to form a sharp, L-shaped angle. The model was positioned very close to the backdrop in a fake walking

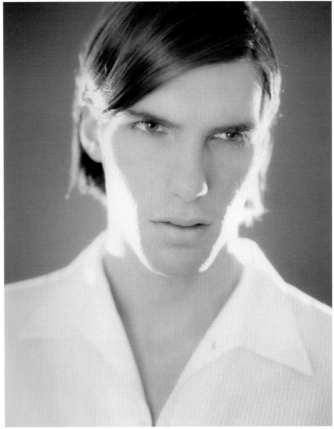

The angular features of the model complement the angles of the shirt collar.

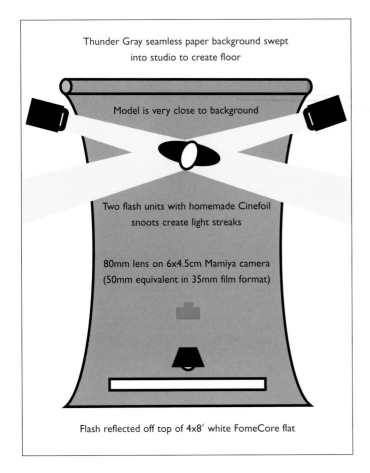

Thunder Gray seamless paper background swept into studio to create floor

Model is very close to background

Two flash units with homemade Cinefoil snoots create light streaks

80mm lens on 6x4.5cm Mamiya camera (50mm equivalent in 35mm film format)

Flash reflected off top of 4x8' white FomeCore flat

A wider than normal lens, exaggerated pose, and strong compositional lighting yield a dynamic image reminiscent of Art Deco.

Side lights create compositional streaks of light, and frame the subject with rim light.

position; in fact, his foot was almost in the angle of the seamless where it hits the ground.

The main light was designed to give flat lighting for subtle modeling of the face, while harsher rim lights created an edge to his figure and a dramatic background.

The main light was a flash unit bouncing off just the top portion of a single large 4x8-foot white FomeCore flat secured to an autopole with clamps.

Two rim lights were placed slightly behind the seamless backdrop, one on each side. They were pointed at the model at mirror angles to one another. To create the wedge-shaped light, two 2-foot strips of stiff, black Cinefoil were taped to either side of the head of each rim light. The large Cinefoil strips produced the hard-edged lines desirable for the Deco look. Had smaller pieces been used, the light would have been able to spread out more, creating a softer edge.

The main light was metered normally, but the two side lights were set for +1.5 to +2.0 EV overexposure, which caused them to burn out the features on the side of the model's face and clothing, creating a white frame around his right and left sides.

For a head shot made during the same shoot (see page 119) the photographer modified the lighting only slightly, pulling the main flash unit slightly farther away from the flat to create a softer main light. The result was an exercise in composition and angles.

FITNESS FASHION

When you want to emphasize male muscle tone and fitness, you can create a strong, dramatic image with two rim lights and a ring flash, which bring out the muscle cut lines on the model. Be careful when using this lighting with a female model—it is very harsh.

In the three fitness images shown here, the lighting setups were relatively the same. Two flash units snooted with Cinefoil created the rim lights. They were placed one on each side from an almost 90-degree angle, at a height of 4 or 5 feet off the ground. The handmade snoots kept the light from spilling

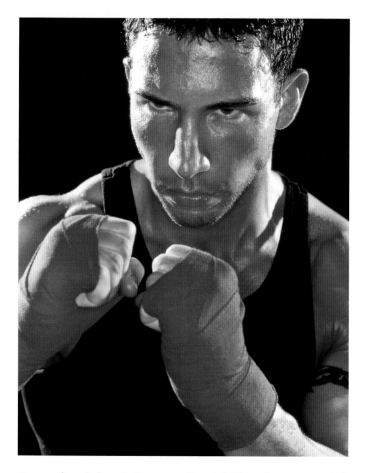

Sesame oil on the boxer's skin gives a dewy feel. The makeup artist applied a light mist of water to the chest and forehead, for an authentic look.

onto the backdrop. The power was set to about +2.0 EV over the main light source, so it would burn out white.

The main light was a ring flash attached to the camera. As is characteristic of ring flashes, it produced shadows toward the outside of the body. The diameter of the flash tube itself helps determine the quality of the light produced.

These images were taken with the smaller scientific or macro type of ring flash rather than the larger 12-inch fashion type. This smaller flash unit is closer to the lens and casts somewhat harsher shadows than the wider fashion variety. For comparison, the image on page 54 was taken with

The pictures in the series feature a red prop (the wraps, gloves, or bottle) as the sole color accent.

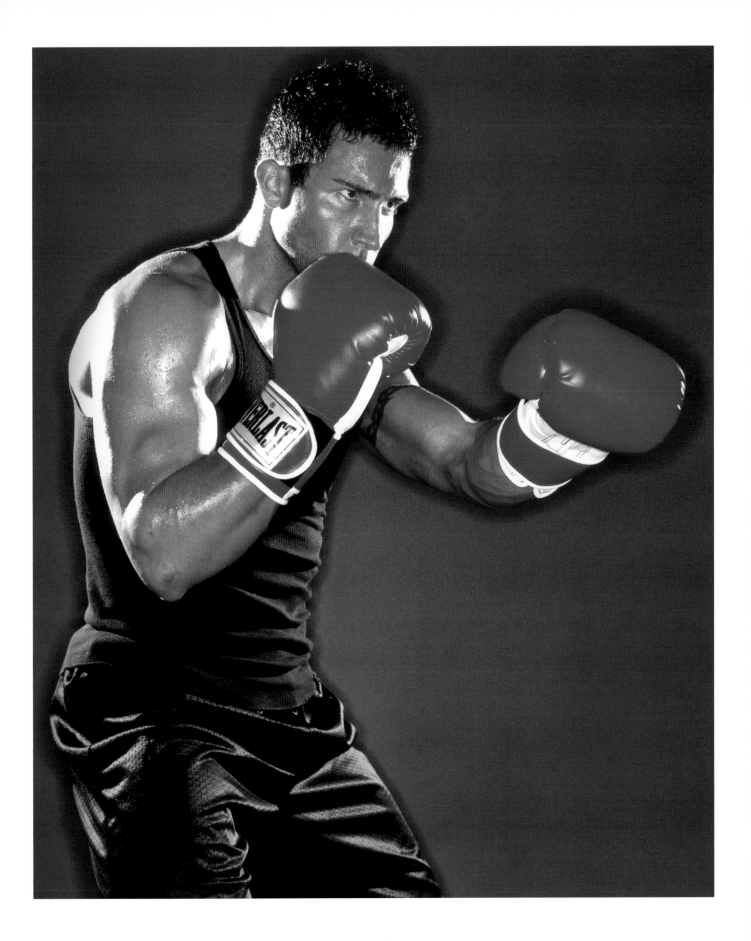

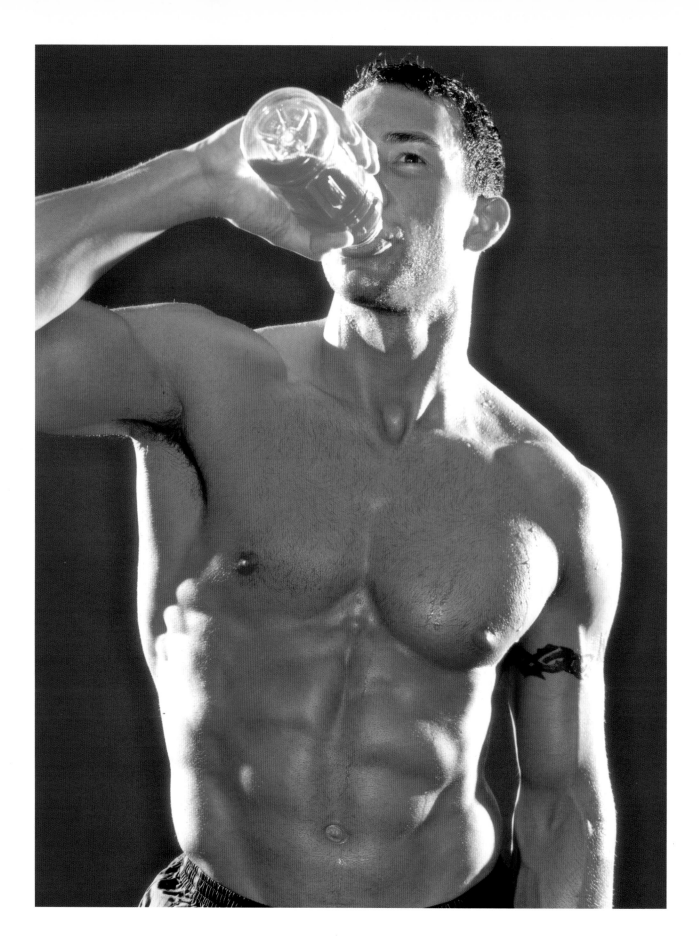

the wider ring flash. See pages 24–25 for more information on ring flash.

The model was placed on a Thunder Gray seamless background paper that was swept out into the studio. For the images on pages 121 and 122 the model was only 2 or 3 feet away from the background. In the photo on page 120 he had moved about 8 or 10 feet from the background. This greater distance caused the same gray background to look black on film, because it received less light from the now more distant ring flash.

The goal of the styling was to make the model look like he had just finished an intense workout.

Sesame massage oil was applied to the model's skin. Sesame oil is a favorite with makeup artists because it gives a "dewy," moist look, rather than a greasy one. To simulate body sweat, the stylist used a spray bottle and added a light mist of water to the model's forehead, shoulders, chest, and forearms. The goal was authenticity, so the stylist took care not to overdo the water but to make it look real by applying it to the places on the body where the most sweat forms during a workout.

These photos were planned for maximum graphic impact. The overexposed highlights were designed to bring out the musculature of the model. The model's skin tone and clothes were kept relatively neutral; the only color accents are the red bottle, the hand wraps, and the gloves. The color in these images was not retouched, and the images were not cross-processed. The boldness of the colors comes from the lighting and the oil-saturated skin.

The main light was a ring flash, which gave a characteristic halo shadow when the photographer moved in close for this image.

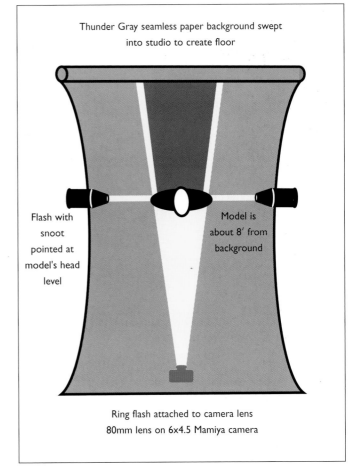

Thunder Gray seamless paper background swept into studio to create floor

Flash with snoot pointed at model's head level

Model is about 8' from background

Ring flash attached to camera lens
80mm lens on 6x4.5 Mamiya camera

FITNESS WITH A HARD LIGHT

Another technique for shooting male fitness models (also called body models) is a single hard light from above. This probably sounds easier to set up than a combination of lights, but it is in fact far more difficult, because of the harsh shadows the overhead light produces.

It is a lighting that can look either stunningly beautiful or astonishingly terrible, depending on the precise positioning of the light and the model. It can beautifully show off perfect muscle tone but can also emphasize the model's weak points or flaws.

The images shown here were lit in a similar fashion. The setup started with a white seamless swept out into the studio.

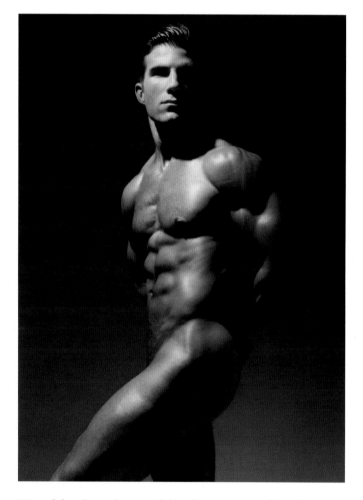

We needed to change the pose in half-inch increments to achieve the perfect balance between the seen and unseen portions of the back arm.

The model stepped onto the paper-covered floor about 10 feet in front of the back portion of the seamless. A single light illuminated the entire set. For the photograph on the opposite page, it was hung on a boom arm about 4 feet above the model and slightly toward the camera. Strong fill light from the white floor produced highlights on the bottom of his legs and arms that helped delineate the cut lines of his muscles.

A tremendous amount of time was needed to tweak the position of the lights and then the pose of the model. Once the photographer decided on a basic pose, it was finessed in sections—the legs, the torso, the arms, the head. The model's left leg was propped up on an apple crate to make it easier for him to hold it in a forward position. The placement of the leg needed to look natural, while still covering his genitals for a nude photograph that did not emphasize *nudity*.

Next the photographer worked on the torso, and then the arms. The final finesse was in the position of the head, which the model had to hold at an uncomfortable angle. This tilted position was necessary to keep his face from falling into shadow under the high angle lighting.

For the image at the left, the photographer kept the light high but moved it about 2 feet to the left. This plunged the opposite side of the model's face into darkness, filled only by the light reflecting off the white floor. (Note that the contrast for this image was later increased using Adobe Photoshop.)

Creating a compositionally balanced photograph was difficult. The absence of model's right arm was disconcerting, but when it was shown more fully, it disrupted the balance of the image. Under the photographer's direction, the model moved his right arm in half-inch increments until the camera caught just a hint of it, which worked well to balance the image.

While sesame oil added a nice dewy sheen to the model's body in the fitness photos on pages 120–123, the hard light used for the images shown here would have produced too much sheen; oiled skin would have produced too much shine and thus white, blown-out highlights. No oil was applied, because the model's own natural skin oil produced better

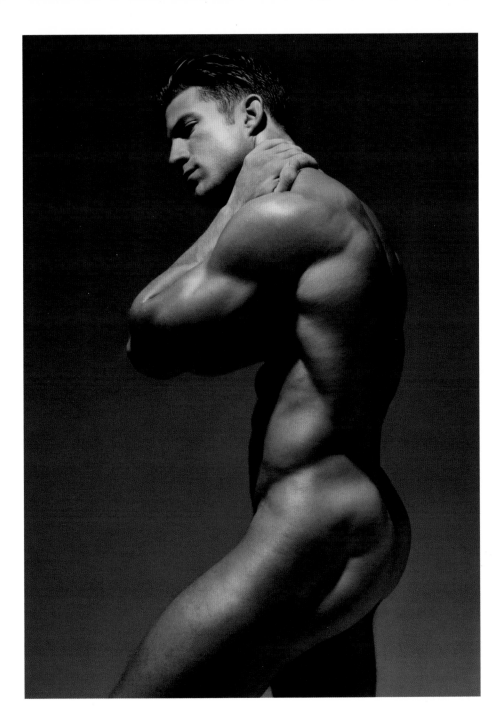

In order for the photo to look "right," the model had to tilt his head in an uncomfortable manner to turn it toward the light.

highlights. The model's face was lightly powdered to prevent too much shine there.

For both final images, the model simultaneously flexed his legs, abs, chest, shoulders, arms, and glutes—and the lighting was able to showcase it all. This level of posing precision requires a model who is extremely cognizant of his body's muscle groups and how to showcase them effectively. One simple example is the body builder's trick of exhaling at the moment of exposure to significantly tighten the abs.

Physical fitness is also a necessity, not just in creating the sculpted muscles in the first place, but for the extreme duration of the poses. Because the pose was perfected in tiny increments, each of these images took more than half an hour to shoot.

GELLED FILL LIGHT

When the photographer was assigned to shoot a sexy, "street-punkish" outfit, he and the stylist searched for a good urban setting for the image. They selected an adult movie theater much more for its graphic design than as an editorial statement, but the setting certainly added to the attitude of the image.

What first caught the photographer's attention was the graphic nature of the yellow and red backlit signs, echoed by the white gridded window. Despite the garishness of the setting, the lights themselves were fairly dim. Because the photograph was made at night, daylight from the street was not available for fill.

Preliminary test shots showed that the side lighting from the signs left the front of the model dark, yet fill from a flash ruined the feel of the existing light. So the photographer chose an unconventional fill light. He taped a purple gel over a powerful flashlight (the police baton type that runs on several D-size batteries). The flashlight could be adjusted for a wide throw, so it was able to illuminate the model's face and torso with a wash of purple light.

The image was allowed to flare out a bit on purpose. Flare, caused when direct light hits the camera lens, is usually considered a mistake. However, it can be used for artistic purposes, such as when you want to create a stage-light feel. Later the photographer used Adobe Photoshop software to add a little more purple tint to the top of the image for artistic effect.

Backlit signs at an adult movie theater created side light, while an ordinary flashlight was gelled purple and used to fill in the model's face and torso.

*An outfit with
an unusual shape
often requires
a simple set
to create a graphic
silhouette.*

*A bold outfit was offset with simple hard lighting
that created a clean outline of the model and a sim-
ple but graphically interesting shadow.*

The exposure was quite long (about 1/4 second), so the model had to be placed in poses that could be held during a long exposure. In the final image, he is lightly bracing his arms against the ceiling.

EMPHASIZING THE SILHOUETTE

Sometimes a fashion outfit is so exaggerated in cut and color that the simplest of backgrounds is almost a necessity. This Versace sailor outfit was one such example. Bold buttons, flared pants legs, and a brazen striped shirt were offset by the only other compositional element in the photo—the model's shadow.

The set began with a white seamless backdrop that was swept into the studio. Instead of giving it a gradual curve where it met the floor, the photographer dropped the seamless into an almost 90-degree angle. The model was then placed within 3 or 4 feet of the background.

The main light was a bare flash head, positioned about 10 feet high to camera left, which caused a hard-edged shadow to fall to the right. The shadow has an abrupt angle where the seamless meets the ground.

Originally, a fold was made in the seamless to give the impression of the wall of a room, but this created an even more abrupt angle to the shadow, and the photographer chose to soften it with a curve instead.

Should you want a folded effect, simply sweep the seamless out into the studio. Unroll some additional material so you have "too much" and it doubles over. Fold this doubled-over portion to create a crease. Then re-roll the seamless back up until the crease falls exactly at floor level.

The photographer added fill light from behind the camera to help fill the harsh shadows caused by the main bare light. This fill was a flash unit shot *through* an umbrella (so the top "rain" side was pointed at the model), set to −1.5 EV under the main exposure. Because the main light was a hard light, it was important to apply matte translucent powder to the model's face to avoid shiny highlights.

In the past when photographers used white seamless paper sweeps, models had to keep their feet clean so they would not leave footprints. The same was true of stylists, assistants, and the photographer—anyone who might step onto the set to make adjustments. Today footprints can be retouched out with ease, so these painstaking measures are no longer necessary.

The photograph on page 127 shows a strong use of the compositional shadow. This section shows two images that also utilize a hard light for a dramatic shadow, but with very different results.

Our photograph of the setup shows a single hard light with a 30-degree grid spot pointed at the model. The grid was added primarily to prevent light from spilling off the flash unit onto the white walls of the studio, because this would have produced accidental and unwanted fill light. A snoot made out of Cinefoil or a large black gobo could have achieved a similar affect.

The light is placed fairly low, about 5 feet off the ground. For the final image, the photographer literally placed his camera above the light. The result (lower left, page 129) is fairly flat lighting on the face (since the camera is at almost the same axis as the light), but with a bold dark shadow above the head and shoulders. The effect is not unlike a ring flash.

A hard light was pointed at the model from a low angle.

Because the model is only about 6 inches away from the cyan-colored seamless paper and the upward angle is not great, the shadow is fairly thin.

This lighting would also be attractive for many women, because there is very little shadow on the face. It is actually not dissimilar to the ring flash image on page 54.

For the second variation (below, right) the light was moved to the right and placed even lower. This caused the shadow to become much larger.

To prevent this larger shadow from becoming too dominant, the photographer opened it up with a fill light. He added as a second light, placed directly behind him, a flash head reflected into a large white umbrella with the inside of the opened umbrella pointed at the model. The power of the fill was set to −1.5 EV under the main light.

The size of the shadow, as well as its lightness (openness) or darkness, can easily be altered.

Because the camera was close to the same angle as the light, the lighting on the model's face is almost shadowless and similar to the lighting from a ring flash.

The light was moved to the right and placed even lower, while fill was added from camera position.

FILM NOIR FASHION

A more complicated lighting setup was used for a fashion shoot that was designed to pay homage to the film noir era. The final result required three lights, smoke effects, and a small amount of Adobe Photoshop contrast control.

The model was posed in front of a Thunder Gray seamless background. Three lights were set up around him. The front light was a 40x60-inch softbox behind the camera, positioned vertically with its center about 5 feet off the ground (see the first photograph on page 132).

In the next photograph, a rim or back light was set up to give a crisp outline to the model's hair and ears and the top of his suit. It was produced by a flash unit with a 30-degree grid spot, held by a boom arm. It was powered up so that the light was approximately +1.5 EV over normal exposure. (See sidebar on using booms on page 30.)

The side light was created with a flash bounced into a white umbrella placed about 4 feet to camera left and slightly behind the model so that no light fell on the background. It was set to +1.5 EV in the image shown at the upper right on page 132, but was later powered down to +1.0 EV for the final image. Doing this created less burnout and allowed some skin texture to be visible.

The image at the lower left on page 132 shows all three lights together. However, in this image, the model is simply standing and waiting for the lights to be set up. In the next image, the photographer begins to perfect the pose, turning the model to a 45-degree angle to the camera.

Test shots showed that the contrast on the picture was quite high, resulting in a harsh look to the image. To reduce the contrast, the photographer sprayed the studio with canned "smoke." (See the sidebar on using canned or "smoke" fog on page 33.) Fog created the desired effect of reduced contrast, but in the first attempt it "clumped," as can be seen in the last photo on page 132. Fanning lightly with a piece of cardboard dispersed the clumps for a more even effect.

In the final image, the model changed from being a "mannequin" placeholder (in other words, just standing there) and went to work finessing his pose and expression. The image was later converted to black and white using Adobe Photoshop. A slight contrast enhancement was made to help differentiate the dark gray shirt from the dark suit coat.

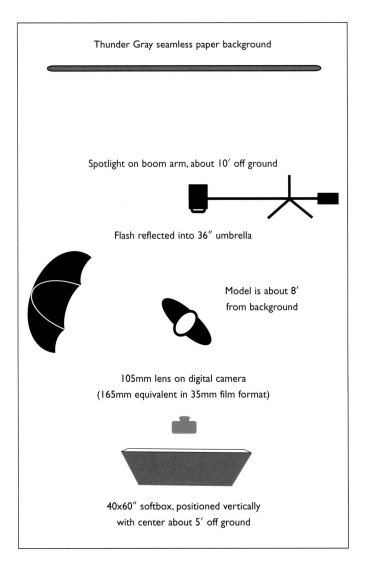

This film noir image was created with three lights.

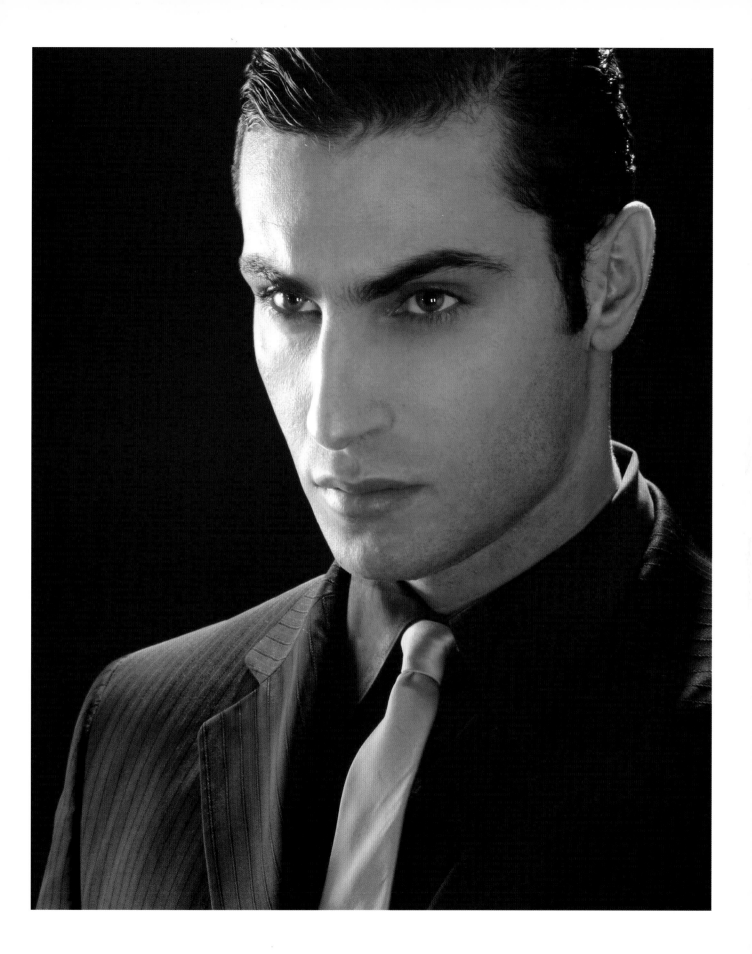

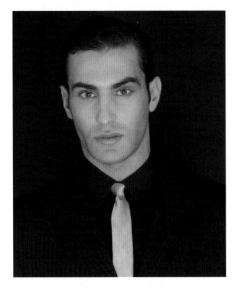

The front light was a large softbox positioned behind the camera.

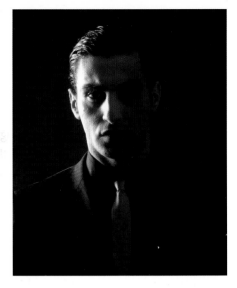

Only the back light (or rim light) is shown here, set to +1.5 EV.

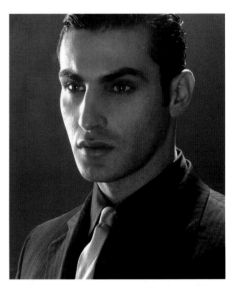

Only the side light is shown here, set to deliver +1.5 EV.

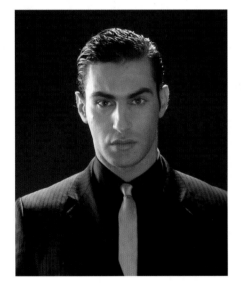

This image shows all three lights together, but before the model began posing. After reviewing the results, the photographer darkened the front light slightly and reduced the side light to +1.0 EV.

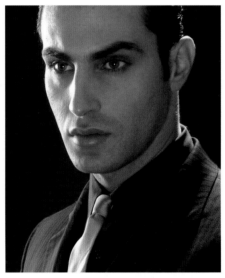

The model was turned away from the camera for a color test shot. The photographer decided the image had too much contrast.

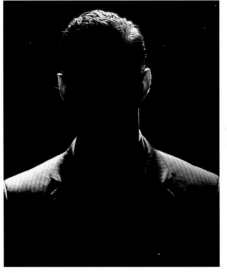

He added canned "smoke" or "fog" to reduce the overall contrast. The smoke appeared "clumpy" and had to be fanned out before the final image (page 131) was made.

HOLLYWOOD VARIATION

The photographer used a variation of the setup for the previous image to create a more glamorous Hollywood style. Because the model had something of a "baby face," the photographer chose a hard, masculine lighting, which he designed to provide a sophisticated but ruggedly handsome look. Compare this image to the male beauty shot of the same model on page 108. The earlier shot was all about skin tones, while this one is about image and style.

The setup began with a 40x60-inch softbox positioned vertically to the right of the camera and about 3 feet from the model. The light was on the low side, with the bottom edge only about 2 feet off the ground, which avoided shadows under the chin.

A classic Hollywood look is created with two lights.

The model has beautiful, dark skin. The tonal difference between his complexion and the white shirt was significant, so to balance the tones the photographer added a strong side light. He positioned a hard light behind the model and to camera left, creating the highlights on the side of model's face and white shirt. This setup also gave more contouring than a rim light would. The light was snooted to prevent it from flaring in the camera lens. Alternately, a gobo could have been placed between the camera and the flash to prevent stray light from hitting the lens.

The camera was positioned about a foot below the model's eye level, a vantage point generally considered to be "masculine," and reminiscent of the Hollywood photography of the 1940s and 1950s. This setup elevated the model higher (literally and visually) and made him look larger and more statuesque.

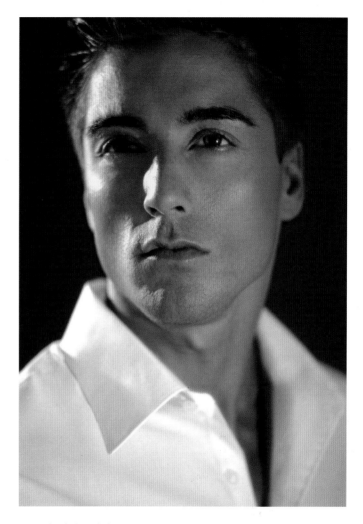

A hard side light balances the white shirt against the model's dark complexion.

MALE HEAD SHOTS

As discussed on page 143, head shots can be a good source of income for a beauty, fashion, and glamour photographer trying to get started. The lighting for head shots of actresses and businesswomen is discussed on pages 58–59. It should come as no surprise that for head shots for men, successful photographers take a somewhat different approach.

To create a successful head shot of a man, you need to avoid lighting that is too soft and thereby feminizes your subject. However, you can still use the 40x60-inch softbox. For men, instead of positioning it immediately to the side of the camera, try swinging it at least 3 or 4 feet to the right or left. This will create a triangle of highlights on the opposite cheek, a common technique in the classical portraiture of bygone eras.

Even though for men you want more shadows and modeling than for a female head shot, the male version must still

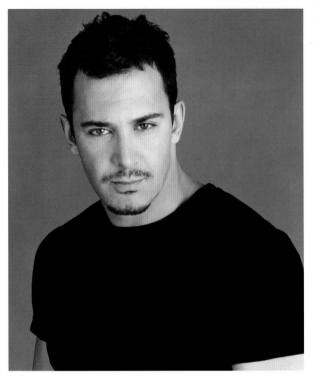

This head shot was taken for a specific audition, for which the actor wanted an edgier look.

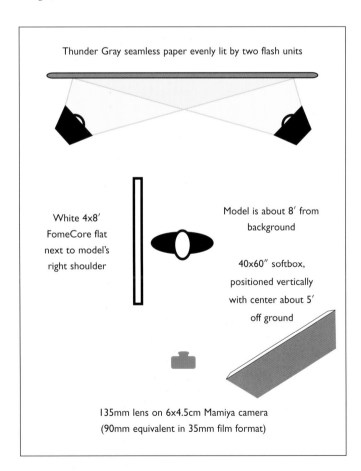

Thunder Gray seamless paper evenly lit by two flash units

White 4x8′ FomeCore flat next to model's right shoulder

Model is about 8′ from background

40x60″ softbox, positioned vertically with center about 5′ off ground

135mm lens on 6x4.5cm Mamiya camera (90mm equivalent in 35mm film format)

For male head shots, move the softbox farther from the camera until a triangle forms on the far cheek.

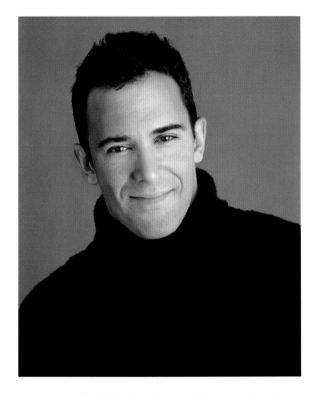

A more typical male head shot shows a pleasant smile and implies a friendly demeanor.

When actors want to show variety in their portfolios, such as full-body images, you can take them outdoors. The photographer took the actor shown in the previous section into a park on a clear day when strong sunlight dappled through the trees. They found a bench near an undappled area where the actor could sit. Had no seating been available where the light was not dappled, the photographer could have blocked it with diffusion or solid material above the actor's head. Even in the shade, a clear sky can create strong top lighting. To counteract this, a silver Flexfill collapsible reflector was placed just out of camera view on the lower left, positioned so that direct sunlight hit it and sent strong fill light back at the model. This created a nice soft overall lighting, even though it was a day with very high contrast.

not be contrasty. A 4x8-foot white flat placed next to the model's shoulder on the opposite side from the softbox will open up the shadows nicely, making the triangle from the main light distinguishable but not prominent.

In the images shown here, the model wanted two different shots. The first was for an audition for which he wanted a tough, streetwise look. He posed for this shot with a goatee, a more intense stare than usual, and a more aggressive pose. He then shaved and changed into a sweater, for a friendlier version taken a few minutes later.

For both images, a little cover-up makeup was used for facial blemishes. Matte translucent powder was applied lightly to avoid any shine on the skin.

A silver reflector bounces sunlight back at the model from a low angle for a soft overall effect.

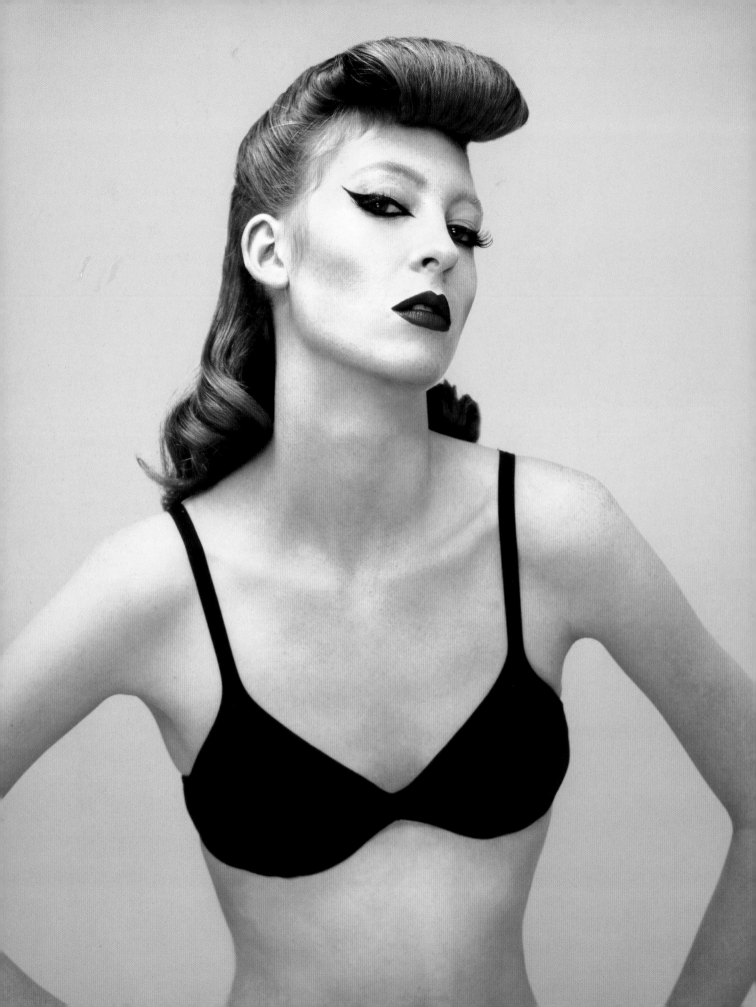

BUILDING YOUR PORTFOLIO

Getting Started in Beauty, Fashion & Glamour Photography

YOU CAN BE THE BEST SALESMAN in the world, but no amount of talk is going to get you a job without a good portfolio. A photographer's portfolio (sometimes called a *book*) is a collection of images they have taken, along with *tear sheets* (pages torn out of magazines, books, or brochures) that show his or her published work. There are dozens of ways to present your work, from stacks of mounted images, to the more common binder with pictures behind protective sleeves.

There are many different strategies to putting together your portfolio. Some photographers have beautiful bound books that look like pieces of artwork in and of themselves. Others prefer to use binders so that they can add the absolute latest images at the last minute or instantly tailor their book to a specific client.

One successful strategy is to show a very narrow selection of images, selected for the potential client who will be looking at the book. For example, if you're interviewing with an advertising agency that has a skin-care client, you may edit out everything but your beauty shots. You may have the world's best fashion, photojournalism, or wildlife images—but if you include them, the client may think of you only as a "generalist" and keep searching for a beauty specialist.

It is also a good idea to edit out all but your very best images within the specialty. Showing ten fantastic photos is a much better presentation than showing twenty that include weaker images.

There are dozens of ways to present your work, from stacks of mounted images, to the more common binder with pictures behind protective sleeves.

Sometimes models will agree to do test shoots in which you both work for free to produce images for your respective portfolios.

TEST! TEST! TEST!

How do you get a great portfolio when you're just starting out? Probably not through jobs, but rather through *test shots*. In photography lingo, practicing your craft is called "testing." A test shoot is a non-paying photography job in which you try out new lighting and styling ideas or try to perfect old ones. Free of the constraints and expectations of clients, you can create images that reflect your own style and the type of work you hope to someday secure.

Unfortunately, for test shoots you pay your own film and equipment expenses. And unless you're independently wealthy, you won't be able to pay the fees that are usually charged by top models. Test shoots are a way around modeling fees, and this can benefit both you and the model.

Basically, you and the model (and perhaps a makeup artist and stylist) all agree to work for free. You get to use the pictures in your portfolio, and they do too. Often the photographer gives the participants one or two copies of the best images, or they can choose images to have copied at cost. It is an economical way for you (and the model, stylist, and makeup artist) to build your portfolios. If the model is willing to sign a model release, you may be able to sell these pictures as stock photography, greeting cards, and more.

When you take photographs as a professional, you must obtain model releases. You can't sell or publish pictures you have taken of people (even friends) without this written authorization. Keep up with professional photography magazines for the latest news on model releases and the law.

Consider joining a professional photography association, such as the Advertising Photographers of America (APA), the American Society of Media Professionals (ASMP), or the Professional Photographers of America (PPA) for their educational materials and other information. For an example of a model release (as well as other legal forms), refer to Tad Crawford's book *Business and Legal Forms for Photographers* (third edition).

One of the hardest tasks for the photographer who is starting out is securing models for test shoots. You can approach an agency with your portfolio and try and convince them that you have such great talent that their models should do test shoots with you. Or you can approach models or potential models individually.

Unfortunately, top models don't need to do test shoots. They already have terrific portfolios. And if they need new pictures, top-name, cutting-edge photographers are willing to do their tests. But there is more than one type of model.

Good makeup artists are especially important for beauty photographs. If you can't find a professional willing to do test shoots, inquire at a cosmetology school or at the makeup counter at an upscale department store.

Test shoots are a great opportunity to experiment with exaggerated makeup, hair, and clothing.

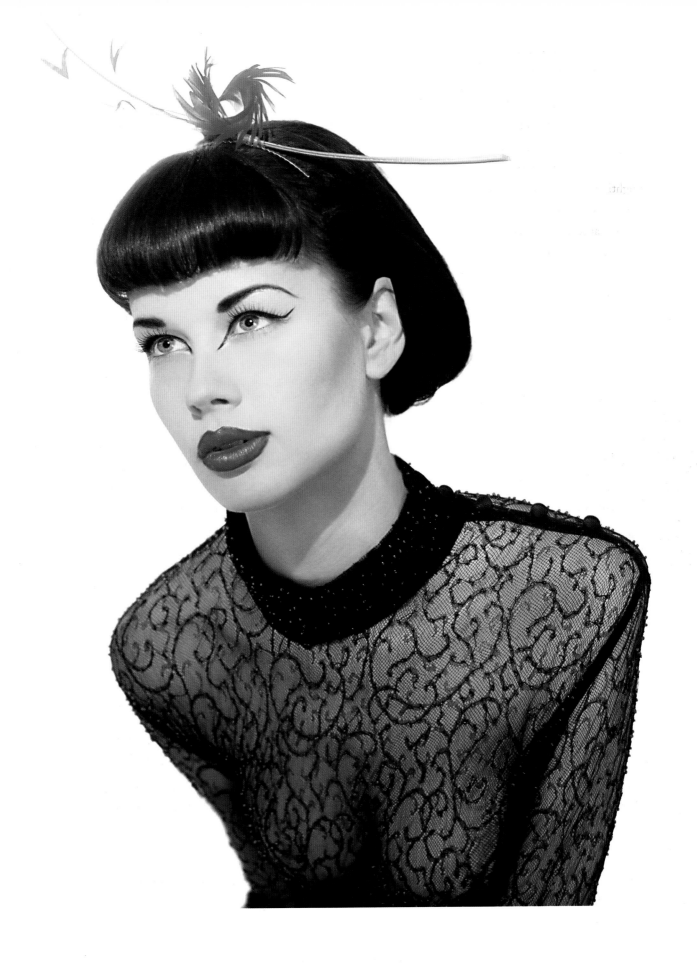

FOUR TYPES OF MODELS

There are basically four types of models: full-time professional models in major markets; full-time models in minor markets; freelance and amateur models; and "real" people.

FULL-TIME PROFESSIONAL MODELS Professional models in New York City, Los Angeles, and Chicago are the top tier of modeling, because the big-money modeling jobs are mostly found in these cities. The top-tier models are typically represented by agencies. Although you may be able to arrange "test shoots" with them (see above), you will be very limited in how you can use these photos. Top-tier models can easily make salaries in the six figures. They won't usually sign full model releases without an agent's approval.

In smaller cities, modeling agencies may be more relaxed about test shoots with models. Even if you must hire the model, the day rates are generally less than those received by models working in major markets.

FREELANCE & AMATEUR MODELS A freelance model is not signed exclusively with one agency. He or she

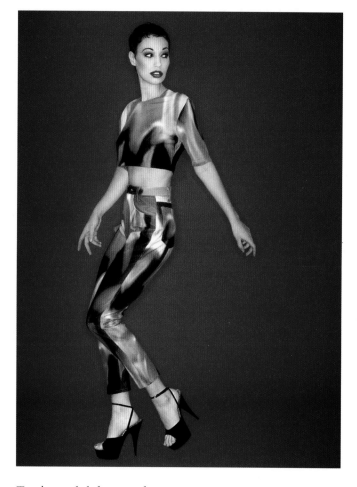

Test shoots, which do not involve artisitc constraints from a client, are a great way to add diversity to your portfolio.

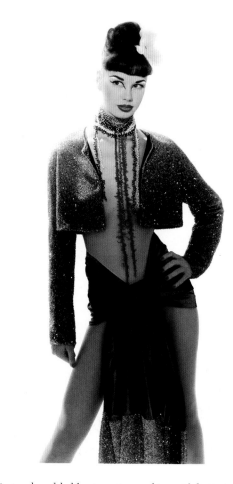

Some professional models likewise enjoy working with beginning photographers in order to add images to their books.

may have several agents, or none at all. An amateur model is doing it for the fun of modeling. Both types of models may be willing to work with aspiring photographers for free, in exchange for images for their portfolios.

Several specialties are dominated by freelance and amateur models. The swimsuit model market, for example, offers only a few reasonably well-paid catalog, calendar, and editorial jobs in the entire country. In addition to competition for these jobs from models who have agents, there are thousands upon thousands of pretty young women and handsome young men who want the job and are willing to pose for free or nearly free.

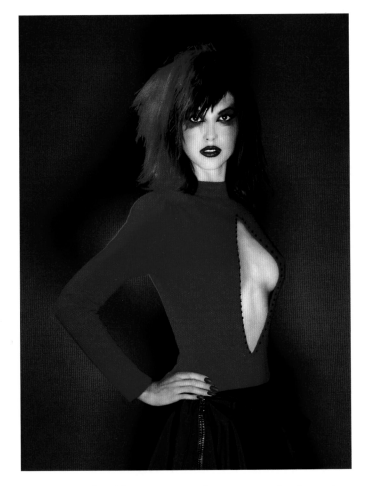

This professional model was not surprised to face two or three hours of hair and makeup preparation before she walked onto the set.

Child and baby models are also usually freelance or amateur. The fact is that *everyone's* baby is adorable, so the few modeling jobs that exist go at surprisingly low rates. So-called "hair" models are also something of a myth. An advertising or editorial client needing a "hair" model will use a full-time professional model from an agency who happens to have the right kind of hair. A hair model who does the modeling as a hobby may get "jobs" modeling for the local salon, but the payment is usually a haircut.

The good news for the photographer is that the type of models mentioned above sometimes need you as much as you need them. They usually can't afford to pay a photographer to shoot their portfolio. And while they might not be the next supermodel, they could be just what you're looking for in a test model.

A number of websites are devoted to freelance and amateur models. Many of these models are in smaller cities. Two top sites include www.onemodelplace.com and www.models.com.

"REAL" PEOPLE Occasionally you'll find very photogenic people in "real life" who will be willing to model for you. They will be thrilled with the attention and will love getting some free pictures of themselves. Or they may view posing for you as an opportunity to break into modeling.

Regardless of the type of model you use, you should treat them all professionally. Check out our book *The Complete Guide for Models: Inside Advice from Industry Pros*, by Eric Bean and Jenni Bidner (Lark Books, 2004), for more information on working with models.

For an example of a model release (as well as other legal forms), refer to Tad Crawford's book *Business and Legal Forms for Photographers* (third edition). Amphoto publishes other books on the business of photography that cover model releases in detail. Visit www.watsonguptill.com for a list of these books; go to the Amphoto main page and type in "model releases" in the search field.

CHECKLIST FOR YOUR MODEL

If you're planning a test shoot with an inexperienced model, it's wise to go over a few things with him or her before the shoot. Even on a professional shoot, don't take anything for granted.

GOALS Explain your goals for the shoot, both creatively and in business terms. Let the model know if it will be a studio shot or a location image.

USAGE, MODEL RELEASES & FEES Discuss how you will use the images. If you're going to have the model sign a release, explain all the clauses in detail. If he or she will be working for free, explain this explicitly. Let the model know whether you will supply him with a certain number of free prints for his portfolio or whether he will have to pay the printing costs.

AGE OF THE MODEL Check the model's age and know the laws in your state. If a model is under eighteen years old, insist that a parent or guardian be present and sign the model release. Don't be afraid to ask for identification to check a model's age. Make a photocopy for your records.

SOBER AND RESTED Ask the model to be well-rested before the shoot. No amount of makeup can hide the sagging skin and fatigued look caused by a hangover or lack of sleep.

MAKEUP & HAIR If you will have a makeup artist at the shoot, ask the model to arrive clean-faced. If there will be a hair stylist, ask the model to wash her hair but leave it unstyled and without gel or mousse. If the model is doing her own hair and makeup, ask her to bring extra supplies, as you may want to change the color of the eye shadow or the shade of the lipstick. You should have clips, bobby pins, and barrettes available to pull hair away from the face when necessary.

Once makeup is applied, keep an eagle eye on the model. Ask her not to touch her face. Coach her on how to eat with her teeth so as not to smear her lipstick, and to drink beverages with a straw (even coffee!). Also watch out for nervous habits. Many people unconsciously rub their eyes or pull at their hair.

NAILS If the model's hands will be in the photo, give him specific instructions about the type of manicure you want.

CLOTHING If the photograph will show bare skin, make sure the model does not wear anything binding for several hours before the shoot. A line from a bra strap or elastic-cuffed sock can take hours to disappear. Stock a few tube tops or other stretchy tops in your studio, so that bare-shouldered photographs can be achieved without the need for actual nudity.

NUDITY You must discuss with the model any nudity (or even just a provocative clothed pose) before the shoot begins. Unfortunately, Hollywood has created the stereotype of the "lecherous" photographer who preys on the hopes and aspirations of young models. While the real-life version of this stereotype is rare, it's always a good idea to have an assistant in the studio (preferably of the same gender as the model) whenever you are taking nude, semi-nude, or risqué photographs. This third party in the studio should help to avoid any misunderstandings and put the model at ease.

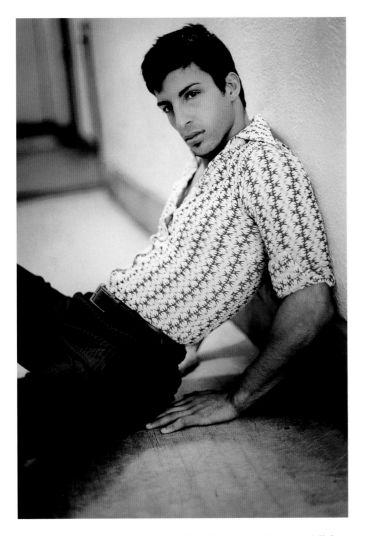

When working on location, professional models such as Dave are skilled at adapting their poses to new situations. You may have to coach amateur or new models on their body language.

MAKEUP ARTISTS

Good makeup is essential for great pictures, especially in the beauty category. If you can't find a professional makeup artist willing to do test shoots, you may be able to find someone experienced in makeup application at a department store makeup counter or at a cosmetology school.

STARTING A HEAD SHOT BUSINESS

A nice way to earn side money while building up your beauty, fashion, or glamour photography business is to shoot head shots. In most cities, the fee for a head shot session ranges from $100 to $400. Most photographers now shoot head shots digitally, so there are no film and processing expenses. Services included in the fee range from delivering one final retouched version, to a CD with all the images, a contact sheet plus one final image, or even printing services for head shot postcards. Some photographers offer to have makeup and hair stylists at the session for an extra $50 or $75.

Begin by photographing a few people for free, to create high-caliber sample images. Then advertise your services. You can do this by advertising in local publications or Internet "classified advertisement" sites that cater to actors. You can also approach acting schools and coaches and ask if you can post or distribute flyers.

A nice aspect of the head shot business is that you can schedule appointments. Some photographers limit appointments to certain days, such as Mondays and Tuesdays, which leaves the rest of the week free for pursuing other work. As seen in the lighting diagrams on pages 59 and 134, the lighting setup is very flexible and can be assembled quickly.

Some photographers worry about being typecast as a "head shot photographer" rather than achieving the status of a beauty, fashion, or glamour photographer. If you're concerned about this, you can always do your head shot work under a separate business name.

See pages 58–59 and 134–135 for more information on head shots.

INDEX

Adobe Photoshop, 21
Ambient-light meter, 22–23
Aperture selection, 16
Apple crate, 30
Autopole, 30

Background, softbox, 70–71, 114–115
Background treatment, 17
Bare bulb, 27
Barndoors, 27
Beach location, 46
Bean, Eric, 5
Beauty
 metering for, 36
 on location, 43–46
 posing for, 35–36
Beauty lighting, 35–59
Bidner, Jenni, 5
Blackout material, 27
Body makeup, 65
Body models, 124–125
Booms, 30–31
Building portfolios, 137–143

Camera supports, 29
Cameras, 18
Canned fog, 30
Catalog lighting, 68–69
Cinefoil, 28
Clamps, 30
Clothespins, 32
Clothing, 32
Color palette, 92–93
Color temperature, 12
Colored flashlight, 126
Compositional light and shadow, 119–120
Cool and warm combination, 78–79
Copy lighting, 116–117
Correct exposure, 15
Counterweights, 30
Cutters, 28

Depth of field, 16
Diffusers, 28
Digital cameras, 18
Dolly, 29
Dulling spray, 30

EV (exposure value), 14
Exposure, correct, 15
Exposure value (EV), 14
Eyelash glue, 33
fstop, 14
Fabric tape, 30

Fabrics, 81
Fashion
 film noir, 130–132
 fitness, 120–125
Fashion lighting, 61–87
Fashion makeup, 80
Female head shots, 58–59
Film format, 18
Film noir fashion, 130–132
Film scanners, 18
Fitness fashion, 120–125
Flags, 28
Flare, 113
Flash photography, 16
Flashlight, colored, 126
Flats, 28
Focusing spot, 28
Fog
 canned, 30
 using, 33
Fog machine, 30
FomeCore, 28
Fresnel lens, 28

Gaffer's tape, 30
Gelled fill light, 126
Gels, 28, 94
Glamorizing a scarf, 72–73
Glamour lighting, 89–105
Gobo, 28
Grids, 29

Hard light, 11
 single, 52, 124
Harlow homage, 89–92
Head shot business, 143
Head shots
 female, 58–59
 male, 134–135
Hollywood look, 133
Homage
 Harlow, 89–92
 paying, 86–87
Hot lights, 24

Incident-light meter, 22–23

Jewelry, 48, 83

Lenses, 18
Light and shadow, compositional, 119–120
Light meters, 22–23
Light modifiers, 26–29
Light stands, 31
Lighting, 9
 beauty, 35–59

catalog, 68–69
copy, 116–117
fashion, 61–87
glamour, 89–105
for men, 107–135
quality of, 11
sunlight as, 108–109
technical considerations, 11–33
tungsten, 95–96
Lighting ratio, 16
Lighting sources, 23–25
Location
 ring flash on, 110
 simplicity on, 102

Makeup, 33
 bold, 56–58
 changes in, 101
 fashion, 80
Makeup artists, 143
Male head shots, 134–135
Male nudes, 124–125
Matte powder, 33
Men, lighting for, 107–135
Men's fashion, 111
Metering for beauty, 36
Model release, 33, 141, 142
Modeling light, 24
Models
 checklist for, 142
 types of, 140–141
Monolights, 24
Monostand, 29

Natural light, 25
Nudes
 female, 96–97
 male, 124–125

On-location beauty, 43–46
Overexposure, 14–15

Paying homage, 86–87
PC (pin-cylinder) repairer, 31
Photo-editing software, 21
Photography, 9
 flash, 16
Pin-cylinder (PC) repairer, 31
Plexiglas, 62
Portfolios, building, 137–143
Potato-masher flash, 25

Reflected-light meter, 22
Reflector head, 27
Reflectors, 27, 40
Ring flash, 24–25, 55
 on location, 110–111

Rock 'n' roll glamour, 102–103

Safety pins, 33
Scanners, 18
Scarf, glamorizing a, 72–73
Scrim, 29
Seamless paper, 31
Sesame oil, 33, 120–123
Set
 exaggerated, 84
 experimenting on, 99
Set equipment, 30–31
Shadows
 compositional light and, 119–120
 playing with, 74
 treatment of, 128–129
Shutter speed, 16
Silhouettes, 127–128
Skin tape, 33
Slaves, 31
Snoot, 29
Soft light, 11
Softbox, 26
Softbox background, 70, 114–115
Software, photo-editing, 21
Spot meter, 23
Spotlight, 29
Stage light variation, 104–105
Strobe, 25
Studio equipment, 30–31
Studio-style power-pack flash, 23–24
Sunlight as lighting, 108–109
Surfaces, managing, 77
Sync cord, 31

Tear sheets, 137
Test shots, 138
Tripod, 29
Tungsten films, 12
Tungsten lighting, 95–96
Tunnel tape, 31

U-bank reflectors, 27, 47, 48
Umbrellas, 26

Vellum frame, 51

Warm and cool combination, 78–79
White-light balance, 12
White on white, 85
Wind machine, 31

QUAIL STARLING

Apple Tree

GOLDEN ORIOLE JAY

SPARROW HAWK

GREAT GREY SHRIKE

GLOSSY IBIS

Home Again

Bird's Nest

ROOK

BLACK WOODPECKER

WHITE-THROATED DIPPER

ROLLER

ROSE-RINGED PARAKEET

Silver and Gold

SISKIN

HOODED CROW

I Wish You Well

Bright Hopes

HOOPOE

ROSEFINCH

Autumn Leaf in Delectable Mountains

BLACK-HEADED GULL

BLACK TERN

COMMON TERN

WHITE-WINGED TERN

Miller's Daughter

The Thorny Thicket

Beacon Lights

The Quiltmaker's Journey

STORY BY Jeff Brumbeau

PICTURES BY

Gail de Marcken

ORCHARD BOOKS · NEW YORK
An Imprint of Scholastic Inc.

Special thanks to Barbara Brackman for her book *Encyclopedia of Pieced Quilt Patterns*,
in which Gail de Marcken found all of the quilt patterns
used in *The Quiltmaker's Journey*.

Text copyright © 2004 by Jeff Brumbeau ▪ Illustrations copyright © 2004 by Gail de Marcken

Library of Congress Cataloging-in-Publication Data
Brumbeau, Jeff; de Marcken, Gail, ill.
The quiltmaker's journey / by Jeff Brumbeau; illustrated by Gail de Marcken. p. cm.
Summary: The quiltmaker grows up wealthy and sheltered, but radically changes her life after she
discovers the poverty and need outside her town.
ISBN 0-439-51219-0
[1. Quiltmakers—Fiction. 2. Generosity—Fiction. 3. Conduct of life—Fiction.]
PZ7.B82837 Qv 2004 [E] 21 2002044989
10 9 8 7 6 5 4 3 2 05 06 07 08 09
Printed in Singapore 46
Reinforced Binding for Library Use
First edition, April 2005
The artwork is rendered in watercolor.

To Marcia, who travels the earth with love as her compass

—Jeff

For Marina and Carl, Natasha and Aaron, and Paya,

all of whom have recognized walls

and chosen to live beyond them

—Gail

You may have once heard the story of a quiltmaker who lived in a wee house on the side of a mountain, her only neighbors the sun and the moon and the stars. Each day she toiled away on the beautiful quilts that all said were the loveliest in the land.

Few had ever seen her, a lost shepherd, a wandering wood-cutter or two. But many knew who she was by her deeds. They said she was the most gifted and giving woman ever known, and that she could have grown immensely rich by selling her wondrous quilts. But she would only give them to those in need. And so, every night by the last of the candle-light, the quiltmaker was remembered in the prayers of many.

But if by luck you should happen upon her, and ask if she had always been such a giving person, the quiltmaker would tell you that she was once quite different indeed. As a young woman, she gave no thought to people in need. It was not that she was selfish, but because she and all the children of the town had lived their lives in a world where poverty was unknown.

A great stone wall, thick and high, had been built around the town. The children had never seen what was outside, but the town Elders warned that there was something terrible out there, something too awful to speak of. They told them to never, ever even think about looking for a way to the other side. And so, for many a night, the young would tremble in their beds, fearful of the creatures they imagined lay waiting just outside the walls.

Because all the people of her town were rich, the girl thought the same was true of everyone in the world. Her parents had died and left her a fantastic fortune, and her life was very much like that of a princess. Everything she needed, she had. Everything she wanted, she was given. So incredibly wealthy was she that one day she simply ran out of things to buy.

The house where she lived was grand and tall—so tall that it cast a shadow on all the others in the town below. Each and every meal was a feast, with delectables piled high on a table so long that waiters needed bicycles to get from one end to the other. She was never cold or ever hungry, and always safe from harm. Yet, she was as unhappy as she was rich.

Often, she would
visit with the
seamstress, who made
her gowns and had taught her how
to make pretty little things with cloth and
thread. One day as they sat together in the
attic sewing room, the older woman could
see that the girl was sad.

"What is it that makes your mouth turn
down so?" she asked her.

"Oh, I just don't know. I have everything
anyone could ever want, friends who love
me, and a wonderful party to go to each
night of the week. Yet, even with so much,
my heart feels empty. It seems as if there
should be something more. I feel that I'm
meant to do something important with my
life. But I just don't know what it is."

"Don't worry," said the seamstress as she
hugged her. "You'll find your way."

"But how?"

"Is it near or far? Is it right there before
you to see? I cannot say for sure. But I do
know you've already begun your journey."

Now, ever since she was quite young, the girl had always been known for her bravery. She'd be the first to dare to climb the tallest tree, dance beneath the wildest rainstorm, or stand up to anyone for what she believed. And so, for some time, she had thought about stealing outside the wall to see just what the horrors were that lurked there. She knew the Elders would be furious, but her friends would love the stories she brought back.

It had always been said by some that far below the town hall there was a secret passageway. And that, if you were bold enough to venture inside, it would lead you to the world beyond the wall. However the stories went, those who had gone in had become lost forever.

Still, one night, the girl decided to see for herself. She slipped by the six snoozing guards outside the town hall. Then she crept down the stairs, lower and lower beneath the sleeping city, until she came to the bottommost cellar. There was only one door. A sign above it read: "ALL WHO PASS HERE SHALL NEVER RETURN." She looked behind at the stairs that would lead her back to her warm feather bed. But she decided to go on. The girl turned the knob and, with all her strength, pushed open the great, groaning door and went through.

The air was freezing. Spiderwebs hung from ceiling to floor, and as she walked, spiders became trapped in her hair. But because she knew they meant her no harm, she helped each to safety. She heard rats rattling in the darkness and bats squeaking to one another, as though they were talking about her. Still, with her heart beating hard, she went on.

Then, she came to
a place where the passageway led in
several different directions. She chose her path
and pressed on until, finally, her candle burned
out. Alone in the darkness, she became confused
and could not tell which way was which. She
couldn't even guess how to return the way she'd
come. But she was determined to go on.

Then, just ahead, she spied a candle burning.
When she reached the candle, another suddenly
appeared beyond it. She had no idea what this
mysterious magic might be, but one by one the
candles led her through the gloomy passageway
to the other side of the wall. When she finally
came out, it was already morning. And what
she saw was terrible indeed.

There were people in ragged clothes. Some lay on the ground without bed or blanket or pillow, others cried of hunger. She saw houses too old to keep a body warm. And there were children who had run out of tears to cry.

She went on, expecting to see a dragon or something just as frightening as the Elders had led her to believe. But there was nothing of the sort. For days she walked, passing through more and more villages much like the first. There was unhappiness and helplessness everywhere. The world, she sadly realized, was not as she had thought it was.

Finally, tired, she lay down in a field to sleep. But when the girl awoke, she discovered that she'd gone so far she had no idea where her town was anymore.

"How will I ever find my way?" the girl wondered. "What will I eat?" Still, she knew she must be strong, and so, started on her way.

But the girl need not have worried. All along the way, she found that the people she'd been afraid of were kind to her. She learned that it wasn't them, but living in need that was frightful.

They were happy to help her in any way. If they had little in their pantries, they gave what they could. If they had nothing, they gave from their hearts.

Over the winding, rising road she traveled. When her fine shoes fell away in scraps, a passing girl asked her where she was going. After listening to her tale, she took off her own shoes, the only pair she owned, and gave them to the barefoot girl.

"But, I—I can't take your only pair of shoes," she replied.

"Oh, please," the ragged girl said with a smile. "I know what it's like to be far from home. I just hope they carry you there all the faster."

One day, as she trudged along, a junkman, pulling a cart piled high, stopped her and pulled out the only thing of value he carried.

"I have no bread or horse to help you on your journey. But I can give you this rose. When you feel tired or hopeless, its beauty will remind you that wonderful things may arise in the next bend of the road."

When she had gone longer than ever with nothing to eat, she found an apple tree with just a few pieces of fruit left on its branches. She gathered the apples in her skirts and, hungry though she was, decided to walk on and save them til night. But she'd not gone far when she passed an old woman sleeping beside the road. Her face was thin and her fingers crooked with age. The young girl felt badly for the woman, so she decided to leave an apple for her to find when she woke. Then, down the road, there was someone else, and then another in need. To each she gave an apple until she found that there was nothing left for herself.

But, the young girl now realized, she no longer felt hungry. Instead, it was as though she'd eaten a whole basket full of fruit, so full of happiness she felt from these little gifts she'd given!

Now, she saw the world as it truly was. And so she knew where her happiness lay. But before she could go find her new life, she must first face the town Elders and their lies.

She walked for many days. Although it seemed like the town would never appear, at last she saw it before her. It rose glittering and grand into the sky. Her return was the talk of the town and a majestic celebration was announced for that very day. But before it could begin, the young lady marched straight to the town hall. The Elders stood tall and stern before her. She spoke for a long time about all the people who lived outside the town, near and far, who needed their help.

"Oh, just ignore the poor," one of the Elders said.

"If they wanted to be rich, well, then they shouldn't have been born poor," added another.

"Now, my dear," said a third, "you should know that if you don't look at those people, then you don't have to think about them. That's why we built the wall around us in the first place."

"Well," she said. "I can never be happy here with so much when there are so many in the world with so little." The young lady then told them that she had decided to leave the town so she could help these people.

A clamor arose among the Elders. No one had ever dared leave the town before. At last, one spoke. "If you go," he said, "know this: You shall lose all that you own and never be allowed to return. You will be banished with nothing."

But she knew what was in her heart, and she knew what would finally bring her happiness. Her plan had been to use her riches to help those in need. Now, all she had to give was herself. So she walked away, from her friends and the only home she had ever known. And she carried nothing but the clothes she wore and the ring (which she had hidden away) that her mother had given her long ago.

Now, her bed was an armful of leaves, her comb a handful of twigs, her dinner a mouthful of whatever the earth would grant her.

One day, she came upon a man whose small field of corn would not grow. But she did not know how to help him.

Beside the wild ocean, she watched a fisherman whose nets caught no fish. But she did not know how to help him.

She met a family whose tiny old house was falling down. But she did not know how to help them.

She wandered on,
wondering what gift,
if any, was hers to give.
Then, early one dawn as she neared another
strange town, she saw a single candle burning
in the distance. She followed its light over field
and forest and eventually discovered a mother
and son huddled in a doorway, shivering in
their sleep. The young lady would have liked
to cover them with something warm, but she
had neither blanket nor coat.

And then at last she knew what she could do.

Early the next morning,
as soon as the shops opened
their doors, she sold her beloved
ring—the last thing her mother had given her.
Then she bought needles and thread and cloth.

Looking for just the right place to work, a
great mountain drew her up upon its shoulders.
The aspens' leaves had fallen and dressed the
forest in gold. The girl followed a path made
by deer, and was brought to a meadow near
the top of the mountain. Here, the trees gently
swayed and waved a welcome in the wind.
Beneath one she found the perfect place for her
work. Someone long ago had made a chair out
of stones and left it for whomever should pass
by the mountain. It was so high up that she felt
she could have a chat with the man in the
moon. Right away she set to work.

Now, the seamstress had taught her to make lots of pretty things—little pillows and handkerchiefs and such. But the young lady had decided to make a quilt for the mother and son. It had to be one, most certainly, that was very warm. But it had to be something else as well, and this was very important. It must be beautiful—so beautiful that the quilt would make the two feel loved, not forgotten, if only for just a moment.

The young lady was afraid that she wouldn't be able to make the quilt she'd seen in her dream. But as she worked and worked and time passed, it seemed as though something magical had touched her. The sun had never seemed warmer, or the sky bluer. Her hands, awkward at first for lack of practice, soon flew like young, darting sparrows. And all the while she felt as though invisible angels guided her eye and her needle. In this way the quilt slowly came to be.

Though she had
wondered how she'd be
able to live with nothing,
she need not have. One
morning, as she bent over her
work, a grandfather squirrel surprised her with
a gift of nuts. A wild, but mild, boar brought
carrots that it had gathered especially for her.
Another time, a bustling brown mother bear
presented her with a honeycomb. Then, a duck
arrived with her five well-behaved ducklings, all
waddling along in a row, quack-quack-quacking
their hellos. Each carried a big raspberry in
its beak.

And if rain should threaten, a flock of birds of every known kind would gather above the tree where she worked. Together they would spread their wings like a great, chattering umbrella above her.

And, sure enough,
out of the hours and bits
of cloth and cotton thread,
a lovely quilt came to be. It
had the colors of hopeful mornings
and rosy-cheeked children and gardens bursting
in bloom. The quilt was ready.

Though it was dark, she put the quilt under
her arm and stumbled down the path to look
for the poor mother and son. And then, the man
in the moon came out, as though he'd heard tell
of her plight and sought to light her way.

The quiltmaker found the two asleep in each other's arms. So as not to wake them, she carefully wrapped her gift tight and right around them. When they began to stir, the quiltmaker quickly hid.

Both mother and son woke with a start, and then cried with delight at so marvelous a gift. They looked all about to see who could have given them such a fine thing. But there was no one. And so, in time, they wearily closed their eyes and then slept, now warm, now hopeful, beneath their new quilt.

They would never know it was she who had made them this gift, though, because the quiltmaker didn't think it important. All they'd be sure of—like many, many others in need in the years to come—was that someone, somewhere in the world, cared for them.

And so, having found her way and her gift, the quiltmaker settled on the great mountain she liked so well. She worked steadily through the seasons of the passing years on her wonderful quilts. When finished with each, she left her gifts of warmth and hope in the hands of someone in need.

Now, after hearing the quiltmaker's tale, you still might look at her tiny house and faded clothes and feel sad for her. But her quick smile and knowing eyes would tell you that you must not have heard her story well. Because she might have had little, but she had everything she'd ever need to be happy.

KESTREL

BULLFINCH

LONG-EARED OWL

BARN OWL

GOLDEN EAGLE

Right and Left

Sunburst

Beginner's Choice

GREENFINCH

GOLDFINCH

MOORHEN

TUFTED DUCKS

WHITE STORK

BEE-EATER

Mariner's Compass

Wild Duck

PHEASANT

GREAT SPOTTED WOODPECKER

Honeycomb

Girl's Joy